STARK COUNTY
FOOD

From Early Farming to Modern Meals

Chloe —
Thank you for putting
Stark County Food
on the map !

BARBARA A. ABBOTT AND KIMBERLY A. KENNEY

AMERICAN PALATE

Published by American Palate
A Division of The History Press
Charleston, SC
www.historypress.com

Images courtesy of McKinley Presidential Library & Museum unless otherwise noted.

First published 2019

Manufactured in the United States

ISBN 9781467138963

Library of Congress Control Number: 2018963530

CONTENTS

ACKNOWLEDGEMENTS

My two great loves are food and history, which this book combines beautifully. Simply put, it has been a joy to work on. There are so many interesting ways to look at food, and we tried to cover every angle. I enjoyed diving deep to find any reference to food available and combing through files in the Ramsayer Research Library at the McKinley Presidential Library & Museum. There is no doubt more to be discovered, but that's what makes history so much fun!

Some of my most cherished childhood memories revolve around food. Although I am not Italian, I grew up in Rome, New York, where "everyone was Italian." My grandmother made spaghetti sauce every single Saturday night, and our entire family would gather around a rather small kitchen table to feast until our bellies were full. Years later, I would take detailed notes as I watched my mom make my grandmother's sauce because, of course, there was no recipe. I still use the same splattered scrap of paper today just to be sure I get it right. We also had elaborate Sunday dinners after church each week that would almost rival Thanksgiving. During the week, my grandmother would magically transform the leftovers into something completely different. When I moved into my first apartment, I could not boil water. But my mom said, "You like to eat, so you'll learn to cook." And I did. I just used Campbell's Soup recipes at first, but slowly I came into my own. Today, I'm an accomplished cook who actually enjoys grocery shopping and spending time in my kitchen.

Acknowledgements

I would like to thank my friend and co-author Barb Abbott for suggesting that we work on this project together. Our areas of expertise fit together like yin and yang, which I think has produced an amazing story. Thank you to everyone who loaned photographs, cookbooks, menus and recipe cards for this project. On a personal note, I would like to thank my amazing family for their support in all of my endeavors: my grandmother Marjorie Vanderhoof; my mother, Cheryl Beach; my sister, Kristen Merrill; and my husband, Christopher Kenney. You are the best team of cheerleaders anyone could ask for!

—KIMBERLY KENNEY

I thought I knew quite a bit about Stark County food. Owning a culinary tourism business affords me the opportunity to connect with growers, bakers, restaurateurs and people who love to eat! Culinary tourism connects people to community through food, but it wasn't until engaging in research for this book that I realized how food is so entwined in our region's history and economic development.

I would like to thank the many business owners who took time out of their hectic schedules to afford me an interview. These took place in various settings, from fancy corporate offices to home kitchen tables, replete at times with playful cats, patient dogs and, in one case, endless servings of homemade pizzelles and hot tea.

Special thanks to my friend and co-author Kim Kenney, who worked diligently on this project even while undergoing radiation for breast cancer. She showed tenacity, kept positive and not once did she say, "I can't work on this right now." Kim is a superb scholar and writer. I am grateful for the opportunity to work with her and, most of all, happy to report that Kim's cancer is in full remission.

I dedicate this publication to my late parents, Marge and Claude Fiocca. My mom instilled in me a love of cooking and baking, and some of my fondest memories include clouds of flour and bouts of laughter during marathon holiday baking sessions. Like Kim, I also grew up in an Italian neighborhood, North Hill, in Akron. My sister and I regularly feasted on bowls of pasta at various Italian social clubs and enjoyed pizza in between games of bocce ball at the Carovillese Club. My dad loved books and was an avid reader, as I am today. He also taught me to give back to the community.

ACKNOWLEDGEMENTS

He was well known in Akron for his genial personality and generosity. One of my earliest childhood memories was helping out in soup kitchens. Family, food and community—timeless pillars that form essential stories in this book. Enjoy!

—BARBARA ABBOTT

INTRODUCTION

Everyone has to eat. It's the one thing that every human being on the planet has in common. Whether you're an accomplished home cook or a regular at one of Stark County's many restaurants, there is *something* that makes your mouth water and your pulse quicken just before you taste it. Maybe it's the chicken potpie your mom made for dinner on cold winter nights. Or perhaps it's a perfectly cooked steak from Baker's Café that melts in your mouth. Or it might be frozen custard from the stand at Meyer's Lake. The memories stay with you for decades and serve to transport you back in time the next time you take that bite.

In spite of the fact that every single one of us has to eat, tracking down the history of the local food scene is difficult. Food is rarely studied, and what we eat is not usually recorded, so the historical record is sparse. You have to dig deep to find obscure references to food that are often hidden in letters, journals and advertisements in newspapers, yearbooks and event programs. Many of the obvious resources, such as restaurant and school lunch menus, are ephemeral. Who saves your child's school lunch menu once the week or month has passed? How many of us leave a restaurant with a menu in our hands?

Long ago, people were far more involved in their own food production than we are now. The pioneers who settled the region that would become Stark County had to rely on themselves to survive, which meant clearing the land, planting crops and trading with neighbors to put food on the table. Well into the twentieth century, many homeowners grew a garden

and canned its bounty to last through the winter months. Veterans of the Revolutionary War who were given land grants settled much of Ohio, while areas such as Stark County were plotted out by industrious surveyors. As pioneers moved from the East Coast inland, most kept the eating habits adopted by their forefathers. Cooking was done in iron pots over an open hearth. Hunting brought meat to the table. Baking was done once a week, typically cookies and bread first, followed by cakes and pies. Almost every farm had a bean separator, since beans were a major ingredient in the farm diet. This hand-made machine, which threshed beans, could be operated by dog power. Other items found in early Ohio kitchens included sausage stuffers and a lard press.

Many settlers brought their native customs and cuisines to Ohio. The transplanted New Englanders brought recipes for baked beans with salt pork and molasses, dumplings made with sour milk and chicken potpie. Some of these early settlers used bread stuffing for pork and beef, mainly to stretch a meal. The Germans brought their love of sausages, sauerkraut and hearty meat-and-potato meals. Czech immigrants brought one of their favorite dishes: fish boiled with spices and served with a black sauce of prunes, raisins and almonds. All of these traditions would lay the foundation for what Stark County residents eat today.

There was once a corner grocery store in every neighborhood, a meat market that supplied fresh chicken and beef and a milkman who delivered milk to your front door. As our population has migrated from rural areas to the cities and big business has taken over the grocery stores and agriculture, we are less and less connected to where our food comes from. "Today, almost all of our food is produced far from our homes by an astonishingly small number of professional food producers," wrote Michelle Moon in her book *Interpreting Food at Museums and Historic Sites*. "This industrialization of the food supply is one of the most profound shifts in American history."

The McKinley Presidential Library & Museum launched an initiative called Project EAT! in January 2017 to document foodways in Stark County by collecting food-related archival materials. Although many amateur cookbooks were loaned or donated for the project, there were surprisingly few restaurant menus and advertisements; banquet menus; grocery store circulars; handwritten "heirloom" recipes; newspaper articles discussing food served at family reunions, community gatherings and other events; and diaries, journals and letters that mention food. We turned to the newspaper clipping files, photograph files and digitized local newspapers online to try to tell these stories.

As we researched Stark County's culinary history for this book, we tried to include as much as possible about what, why and how we've eaten over the past two hundred years. We've combed through historical records, interviewed families who have shaped Stark County's food scene and posted inquiries on social media. There are definitely going to be things we've left out, usually because we could not find information or a photograph of a particular store or restaurant. But we did our best to make this book as comprehensive as possible.

This book traces the history of food in Stark County from the earliest orchards and farms to today's culinary tourism scene—and everything in between. It was written with different perspectives in mind. "Food builds bridges," wrote Moon, "crossing divides of class, language, culture, geography, gender, and age. We all eat, and in following the pathways of food production, we discover our interconnectedness." In these pages, you will explore how the rich soil in our region led to the development of agriculture, recall forgotten mom and pop grocery stores and favorite restaurants, discover bizarre recipes of yesteryear and learn about the organizations that are fighting food insecurity in our community. You will also meet some of the legacy families who have put Stark County on the map.

We hope that this snapshot of culinary history will inspire you to think more about the food you eat, how it transcends time and place and the ways in which it connects you to the people around you.

FARMING AND AGRICULTURE

Ohio has a unique and recognizable shape, in part due to waterway boundaries such as the Ohio River on the eastern edge and Lake Erie to the north. The formation and composition of the land within those boundaries has also been shaped over time by water, but in a different and dramatic form.

During the Pleistocene Ice Age (beginning around 2.6 million years ago and ending around 11,700 years ago), the climate was much colder and drier than it is today. When temperatures decreased for extensive periods of time, vast bodies of glacial ice formed in upper latitudes around the globe. The ice sheets that would eventually affect Stark County formed in Canada. They would grow and advance, retreating during warming trends, only to refreeze and advance once more as temperatures continued to fluctuate. Ultimately, four major glacial advancements would move into what is now the northern and northwestern parts of Ohio. The ice advanced into Stark County from the north but would not make its way to the county's southern border. In other words, part of our county is glaciated and part is not. This relates to farming because soil composition and water are two major factors in determining what can be grown in a particular area. Glaciers played a direct role in shaping both of these.

The southern boundary of the Wisconsinan glacier, the last glacier to make its way into our territory, came to a stop roughly halfway into Stark County, leaving a jagged east–west end moraine of sand and gravel that roughly runs parallel to Route 30. This is noticeable still today in the

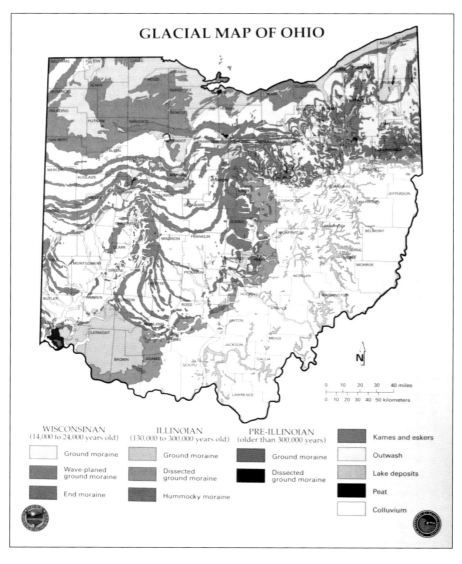

Glacial map, via the Ohio Geological Survey, showing glacial boundaries in Ohio. *Courtesy of Ohio Geological Survey.*

fact that numerous sand and gravel businesses operate along this edge. Connect the dots of these businesses and you have just roughly mapped out the end moraine of the Wisconsinan glacier laid down more than ten thousand years ago.

The fact that part of Stark County is glaciated and part of it is not has created unique soil formations. One of the most visibly striking features is situated in Hartville, a small town in the northeastern pocket of the county. A drive through the east end of the village, past Congress Lake Country Club, across railroad tracks and skirting around Quail Hollow Park, one suddenly comes upon flattened lands of jet-black soil stretching out on either side of the road. If you make this drive early in the morning during spring and summer, you'll find workers, rain or shine, bent over and busy—tidying, picking or planting row upon row of fresh produce. Young sprouts and ballooning leaves of lettuce appear neon green against the coal-black ground.

This rich black soil is known as "muck." Another term used for this dark, highly organic type of soil is "peat," which is created from a buildup of partially decomposed plants deposited from glacial lakes over thousands of years in oxygen-depleted, stagnant water. This results in soil that is rich in humus, is acidic and takes on a strikingly dark, black color. It's also a great producer of vegetables.

Even though pockets of swamp and grassland dotted Stark County, deciduous forest prevailed, as it did throughout much of the state. It has been said that when early European settlers moved into Ohio, a squirrel could travel across the state tree by tree without touching the ground. As white settlers moved west, they began clearing those trees and building farms and settlements. Pioneer life was not easy. In his book *History of Agriculture in Ohio to 1880*, Robert Leslie Jones described what a pioneer might find when he came to this region:

> On his arrival in the Ohio country, the would-be settler might start as a squatter or as a tenant contracting to clear a few acres. If better off, he might value an advantageous location or association with relatives or certain neighbors more than superior soil, or he might find that one or another speculator was willing to offer him good terms. Usually, however, if he had some capital of his own or had good credit, he would choose his land carefully by evaluating soils on the basis of what grew on them—applying criteria that in all likelihood went back to the days of the Roman Empire. Throughout the new West, bottomlands ranked the highest and the uplands, which supported the growth of certain hardwoods, next. The prairies ("barrens") in the early days were considered little if at all superior to the swamps, which might dry up during the summer, when both would furnish adequate livestock pasturage.

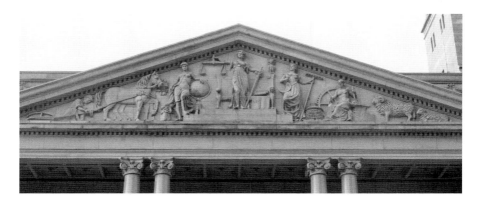

The triangular pediment on the Stark County Courthouse depicts early successful Stark County industries in the lower two corners. Agriculture is depicted on the left, with the raising of Merino sheep for wool on the right. *Authors' collection.*

The first white settlers came to Stark County in the early 1800s. "But as the land had to be cleared before it would yield crops, the pioneer found that he could not depend upon a livelihood from his farm until some five years of hard work had been applied to it," wrote John Lehman in his book *History of Stark County*. "In the meantime the fare furnished by the abundance of game and wild fruit was eked out with small purchases of corn and wheat from the older settlements." It was a struggle for these early settlers to survive, even after towns were established.

The area known today as Plain Township was flat prairie land, but early settlers believed that tallgrass soil was inferior, so farming did not come to Plain until later. One notable exception was the raising of sheep for Merino wool, which is depicted in the architecture of the Stark County Courthouse. Because of the high quality and yield of the region's soil for producing crops, livestock was never a major industry in Stark County. "The raising of live stock has always been supplementary to agriculture and the industries," said Lehman, "and in early times was generally undertaken for domestic purposes to eke out the family support or income."

The southern and southeastern parts of Stark County were ideal for fruit farms, particularly apples, peaches and pears. Early apple varieties are less common today, such as Pippin, Bell Flower, Blair, Roamite, Baldwin, Red Canada and King. "During the pioneer years apples were a luxury," said Lehman, "and found a ready sale when brought into the new settlements from the older communities. They were imported from Steubenville as early as 1809 and were on the regular bill-of-fare on such

special occasions as the training days of the militia. On these occasions the wagon loads of apples were hailed with as much enthusiasm as the loads of watermelons at later-day fairs, and were quickly sold at a shilling a dozen." Sandy and Pike Townships were the best places in the county to grow peaches. Pears were first cultivated "on the Oberlin place, the Fulton Road, in the northwestern portion of the county," according to Lehman. Popular varieties were Bartlett, Flemish Beauty, White Doyen and Siecle. With its poor yields, according to Jones, "pear growing was not an enterprise in which a thoughtful orchardist would invest much of his money and labor....Only once in a great while was there a good pear crop—as in 1874 when Stark County produced 10,458 bushels." Cherries, plums, strawberries, raspberries, blackberries and grapes were all easily grown throughout our region.

Wheat was the first cultivated crop grown in Stark County. Moravian missionaries settled in what is now Bethlehem Township in 1761, bringing with them knowledge of wheat planting from Western Pennsylvania. Stark County's first gristmill was established in 1806, just one year after Canton was founded. "In the early culture of wheat many discouragements were met," Lehman said. "The weevil and rust destroyed the grain year after year, and when it escaped these the frost often cut down the harvest. But perseverance and the adoption of precautions and methods advocated by the Government, agricultural literature, granges and other farmers' societies, gained the upper hand of these natural drawbacks and made wheat a fairly dependable crop." One of the largest wheat farms was three thousand acres, tended by the Andrew Meyer family, located west of Canton and stretching from Meyers Lake south to Lincoln Highway. Stark County became a leader in wheat production in Ohio for several years.

Corn and potatoes were also successfully grown in our early agriculture timeline. Although its northern latitude was not perfectly suited for corn crops, early Stark County farmers grew quite a bit of it, particularly because of the invention of the silo and the "utilization of all portions of the plant for fodder," according to Lehman. "Potatoes are raised readily and profitably in Stark County. The soil is well adapted to them, the average yield is good and the root is not often affected by disease or insects." The clay soil found in Louisville made it an ideal growing spot for hay.

Within twenty years of the first settlement, local farmers were producing an abundance of crops harvested from the region's rich soil. But with a finite local market, agriculture prices were extraordinarily low because of the surplus of goods. Eggs sold for four cents a dozen, and butter was only six

cents a pound. The more farmers produced and the harder they worked, the greater the surplus became—and the further prices dropped. Most of Stark County's farmers were living in abject poverty.

Inspired by the success of New York's Erie Canal, which was completed in 1825, the state began to investigate the possibility of constructing an inland waterway to connect Lake Erie with the Ohio River. The canal would create new markets for farmers to export their crops, as well as expand opportunities for business and industry. Without a water highway, Stark County's farmers had to travel to Lake Erie ports, a trip in wagons that might take an entire week. "On account of the wretched conditions of the road," said Jones, "four-horse and even six-horse teams were needed to haul a forty-bushel load, at an estimated cost of $.15 a ton per mile." A canal system would make the transportation of crops to market much easier.

State officials paid $6,000 for a feasibility study of five possible routes for the proposed canal. In the end, Ohio's first canal was built from Cleveland to Portsmouth. The original route was to go through Akron, Canton and Dresden. According to some accounts, the citizens of Canton decided that they did not want a canal running through their town. Some say Canton's doctors objected to the canal because of fear of "ague" (malaria) stemming from the unsanitary conditions near stagnant water, which often contained raw sewage. Still others believe that Captain James Duncan, who owned land west of Canton, lobbied hard for the canal route to go through his property. Ultimately, the final route was shifted eight miles to the west through the tiny town of Massillon.

The section from Cleveland to Massillon opened in 1828. Wagons came from miles around to empty their goods onto canal barges or in warehouses near the canal. Between 1826 and 1836, twenty-five new villages were founded in Stark County because of the canal, and the local economy prospered. With the opening of the canal, all the markets of the eastern seaboard were opened to Ohio's industries. It cost only $1.80 to send a barrel of flour along the canal route to New York City, where it sold for $8.00. Stark County was counted among the eastern Ohio counties that made up the "Old Wheat Belt," which flourished in the 1830s and 1840s. Thanks to the canal, Massillon soon became the most important grain-collecting point in the state. According to Jones, "In a five-day period in the spring of 1847, its receipts of wheat from wagons amounted to 126,411 bushels."

Wheat production was a relatively simple way to become a successful farmer, for the reasons Jones described:

Wheat had many advantages as a staple crop. It required little capital and no special equipment. It could be grown successfully on uplands, even quite hilly ones, as well as on bottoms. It was adapted to a wide variety of soils, even to certain kinds that the first farmers rejected out of hand, such as the eventually famous "oak plains" of Stark County. Its cultural techniques were simple as contrasted with those, for example, of tobacco. The grain could be stored indefinitely as long as it was kept dry and free of the granary weevil.

In 1849, Stark County was ranked first in Ohio in wheat production, with 590,594 bushels grown that year.

The Ohio & Erie Canal had been wildly successful, but the canal days were short-lived. By the 1850s, railroad companies were building miles and miles of track, which could easily connect areas of the country where there were no canals. Railroad tracks could be built almost anywhere, including places where it was impossible to dig a canal. It was only a matter of time before the canals would become obsolete. In a way, the canals were responsible for their own demise, since railroads were built in population centers—and many of those areas owed their existence to the canals. But the railroads were faster and cheaper, and that translated to increased profits for everyone—that is, except for the canallers.

The first railroad in Stark County was the Cleveland & Wellsville Railroad, which cut across the northeast corner of the county through Alliance. Canton had stood by and watched as Massillon blossomed when the canal came. The city leaders were not about to watch another city reap all the benefits of the railroad. *The Repository* started a campaign in favor of the railroad, publishing articles, letters and editorials on the subject. On March 2, 1852, the first locomotive of the Ohio & Pennsylvania Lines stopped in Canton. The first passenger trains would come later, when a regular route from Canton to Cleveland was established in February 1880. The railroad helped Canton's population soar in the decades that followed. In 1850, there were 2,600 people living in Canton. By 1860, the population had increased by 55 percent and, by 1870, 114 percent. New transportation routes helped all of Stark County's industries prosper, including our farms.

Surrounded by productive farmland, local inventors began to experiment with machinery that would improve the agriculture industry and make it more efficient. Companies started by Joshua Gibbs, Cornelius Aultman and the Russell brothers established Stark County as the "agricultural machinery capital of the world." Joseph Dick also contributed to the industry, most notably with his "Blizzard" feed chopper.

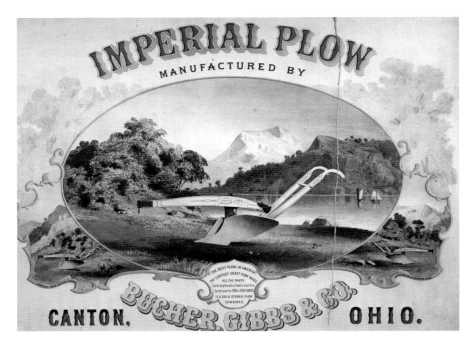

Joshua Gibbs patented the bar share plow in 1836. His son Lewis later patented the Imperial Plow, manufactured by Bucher, Gibbs & Company.

Joshua Gibbs invented his famous patented plow in 1836. Born a Quaker in Trenton, New Jersey, in 1803, Gibbs became a skilled blacksmith, cooper, woodworking expert and mechanic. He came to Ohio specifically to begin an agriculture business. He settled in Cleveland first but decided to move to Canton in 1824, which was already well known for its rich soil. At the time, Canton and Cleveland were roughly equal in population. Gibbs's improved metal plow was incredibly successful, serving customers in Ohio, Indiana, Michigan and Illinois. By the time Gibbs turned the company over to his sons Lewis, Martin and William in 1856, business was thriving. In 1870, Lewis formed a partnership with John Rex Bucher and founded the Bucher & Gibbs Plow Company. They manufactured the "Imperial Plow."

Cornelius Aultman was born on a farm east of Canton and traveled to Greentown as a young man, likely as the apprentice of a wheelwright. In 1848, he built five experimental Hussey reapers. Michael Dillman, a successful farmer who lived close by, used one and was so impressed he bought a partnership with Aultman. They went to Illinois to manufacture their reapers the following year, but Aultman soon sold his interest in the

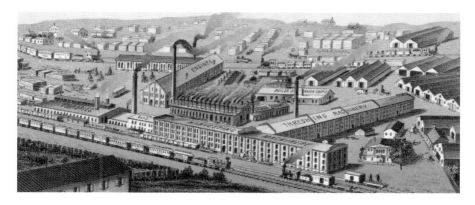

C. Aultman & Company's Agricultural Works, as it looked in 1890. It was later the site of the Hercules Motor Plant and has been recently renovated into modern upscale apartments.

partnership and returned to Greentown. Next, Aultman started working for Ephraim Ball in his small plow shop. The two men formed a partnership in 1851 and together built twelve Hussey reapers and six threshing machines to sell to local farmers. Their clients were thrilled with the machines. Ball and Aultman knew that they had a quality product that could be marketed nationwide. They were happy to hear that the railroad was coming to Canton and quickly bought land near the tracks and moved their operations. They built a two-story brick factory, with its own wood, finishing and moulding shops. In 1852, Ball, Aultman & Company built twenty-five Hussey reapers and worked out plans for the Ohio Mower. Its success led to a great expansion in production just three years later. Tragedy struck on May 5, 1855, when a fire destroyed much of the plant. But the owners persevered and managed to produce twelve Hussey reapers in time for that year's harvest. Then they rebuilt their plant.

By 1857, Ball, Aultman & Company had produced one thousand agricultural machines. Aultman, Ball and Lewis Miller worked out plans for a machine to cut grass. There were two designs: one that cut the grass in front of the wheels and one that had cutters behind. They built both and then took their show on the road, competing in "tests" with their reapers, threshers and mowers. The mower with cutting blades up front won first prize at a competition in Syracuse, New York, which improved the company's visibility and increased sales in other agricultural regions of the United States. Despite the win, Ball insisted that the better design housed the cutters behind the wheel, so he sold his interest in 1858 to go into business

for himself producing the alternative mower design. The original company became C. Aultman & Company. By 1860, it had become the largest reaper and mower company in the world and one of Canton's largest businesses, employing 350 men.

In Massillon, three brothers—Charles M., Nahum S. and Clement Russell—founded C.M. Russell and Company in January 1842 on Erie Street between Tremont Avenue and South Avenue. Soon it would grow into Stark County's first industry to sell its products across the country and around the world. The first threshing machines Russell produced were based on a standard contemporary design, nicknamed "knock-outs" because they "simply knocked the grain out of the heads," according to Stark County historian E.T. Heald. After studying the Pitts Buffalo Separator, Charles made some improvements on the design, and the company won an award at the Ohio State Fair in 1845.

After Charles M. died in 1860 and other relatives joined the company in 1864, the business was renamed Russell and Company. Until 1865, Russell focused solely on the manufacture of threshing machines, while the Aultman Company was developing reapers and mowers in Canton. W.K. Miller, who had patented the Peerless mower and reaper in 1857, joined Russell in 1865, adding a new line of products. Russell and Company was now the largest industry in Massillon. Soon the reaper and mower side of the business was outperforming thresher production by more than two to one. The owners of the company decided to divide the business, placing Miller in charge of a new company called C. Russell and Company, located in Canton.

On May 17, 1878, a catastrophic fire destroyed all the company's iron working machinery, wagon stock and irreplaceable patterns collected over thirty-six years of business. "With two thirds of the main building saved by the almost superhuman efforts of the fire department aided by citizens, 70 men were set to work on the ruins at daylight the next morning, and two of the partners started, one east and the other west, to procure machinery for replacement," said Heald. "By the kindness of C. Aultman and Company in Canton and Capt. H. Kauke of Wooster, machinery was promptly loaned to the firm until new machinery could be procured. Just one week from the time of the fire they were running the iron department double shift to make up for time lost, and within 20 days were turning out their full complement of machines."

By 1880, the company's facility had grown to cover seven acres, making it one of the largest manufacturing plants in the country. A second fire on May 8, 1899, caused $75,000 worth of damage and killed employee and

volunteer fireman Albert Bamberger. "The remarkable fire-fighting facilities of the plant, the heroic work of the fire department and the speedy action of the factory night shift in manning the company hose, prevented the spread of the fire to the other buildings," Heald noted. Insurance covered the entire loss, and all seven hundred workers reported for their shift the following day at noon.

By 1909, Russell had produced eighteen thousand farm, traction and stationary engines; twenty-two thousand threshing machines; and thousands of sawmills, feeders and steam road-rollers. As competition increased, the company began to decline. After unsuccessful attempts to diversify into steam shovels and tractors in the 1920s, the company eventually closed in 1942, one hundred years after it was founded.

Joseph Dick founded Joseph Dick's Agricultural Works in 1874. He was well known in Canton and active in

J. DICK'S SUPERIOR
HAY STRAW AND CORN STALK CUTTER, SPLITTER AND CRUSHER.
Fig. 4

Fig. 4 represents our No. 5 machine as arranged for Horse or Steam Power, it is precisely the same as No. 5 shown in Fig. 3, with the exception of having a pulley mounted on the main shaft to receive a belt, this style is a complete Hand and Power Machine combined, this Machine is well adapted for the General Market.

Send for Discriptive and Illustrated Catalogue which gives a detailed explanation of all our Manufacture. Address.

J. DICK & BRO,
Look Box 33, Canton, Ohio.

Joseph Dick founded Dick's Agricultural Works in 1874. Fifty years later, the factory occupied more than two and a half acres at 1407–27 West Tuscarawas Street. Dick developed a feed chopper designed to save farmers work, and it became popular instantly.

the community, serving on the local school board and the Board of Trade. He was also the vice-president of the Canton Home Savings and Loan Company. He donated a large altar to St. John's Catholic Church (now the Basilica of St. John the Baptist) in Canton, which is still in use today.

Joseph studied the problems of Stark County's farmers to develop his ensilage cutter, which was designed to save work. It became popular "instantly," according to a *Canton Daily News* article from June 6, 1926. Fifty years after its founding, the article described the scale of the factory, which occupied land at 1407–27 West Tuscarawas Street, approximately where Liberty Ford car dealership is today:

> *It is the world's largest industrial plant devoted to the exclusive manufacture of feed cutting machinery for farms....The gaunt frame building, with its drab walls facing Tuscarawas St. West, give little hint of the seething*

industry on the inside, little suggestion of the tremendous plant which covers four acres of ground in the very heart of Canton, and is turning out machinery for farmers in every part of the world.

The feed chopping machine was called the "Blizzard" because "the feed cut is forced out of it with such force that the flying pieces resemble a terrific blizzard." It could cut ten to thirty tons of feed in just one hour. Most silos of the era were thirty to forty feet tall, but the Blizzard could blow feed as high as one hundred feet. The machine was operated by horse or steam power and, later, by gasoline or tractor. Smaller farms could join together to purchase one on the "community plan" to share. Larger farms bought one on their own, even though it was only used a few days a year. Dick's shipped choppers worldwide.

In Stark County, farmers were indeed lucky to have so many locally produced farm machines readily available, which no doubt encouraged agriculture in the community. From 1879 to 1895, itinerant artist Ferdinand Brader documented the family farms that dotted Stark County's landscape in elaborate pencil drawings from a bird's-eye view of the properties. He traveled throughout Pennsylvania and Ohio, drawing family farms in exchange for room and board and, perhaps, a small fee. During the winter months, he checked himself into the Stark County Infirmary, but come spring, he would continue to wander the countryside looking for work. According to Bristol Lane Voss, who wrote the essay "The Life of a Traveling Swiss Artist: Known Facts and Times of Ferdinand A. Brader" in the book *The Legacy of Ferdinand Brader*, "Brader reached these farmers with promotional efforts that included reporting on his own movements and productivity to newspapers, having drawings hung in store windows and by word-of-mouth, as customers shared their delight in his drawings with neighbors and extended family." It is through Brader's work that we get a glimpse of what Stark County communities looked like during the golden age of agriculture.

Brader's drawings highlight fine details of the property, including all the outbuildings and livestock present on the farms. "He often personalized the drawings," said Voss, "showing the owner, family members, children, and pets." Although the artist occasionally took liberties with the scale and content of his drawings, most of the works remain true to the scenes he was attempting to capture. Brader's drawings include gardens, summer kitchens, farm equipment, barns and houses. The family names that appear in large, bold letters on the drawings themselves document Stark County's German heritage in the late nineteenth century. In her essay "The Architectural

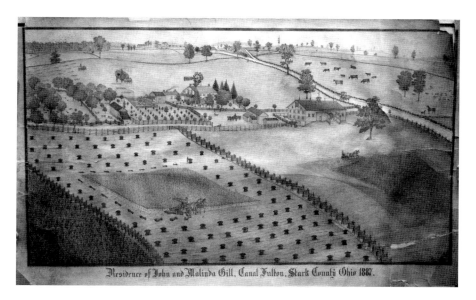

Residence of John and Malinda Gill, Canal Fulton, Stark County Ohio 1887.

Drawing of the John and Malinda Gill farm in Canal Fulton by itinerant artist Ferdinand Brader. To date, 124 Brader drawings have been identified, creating a unique snapshot of the region's late nineteenth-century farms.

Landscapes of Ferdinand A. Brader," also from *The Legacy of Ferdinand Brader*, Lisa Minardi wrote, "The prominent display of ownership reflected not only personal pride in one's property but also touted the very fact of land ownership itself, the reason why many German speakers had immigrated to America in the first place."

Serving a largely rural community in the mid-nineteenth century, the Stark County Fair was a focal point of social activities for residents of all ages. The Stark County Agricultural Society has organized every fair since its inception in 1850. The first county fair took place at Public Square in downtown Canton, making it one of the oldest annual events in the region. The county fair alternated between Canton and Massillon before the current fairgrounds was built in 1894.

A prominent section of the fair honored the accomplishments of the region's farmers, including animals, produce and agricultural equipment. The following cash prizes for the first fair in 1850 were listed in *The Canton Repository*: best managed farm not less than forty acres ten dollars, best stallion eight dollars, best Merino sheep three dollars, best pair of work oxen three dollars, best litter of six or more pigs three dollars, best crop of winter wheat six dollars, best crop of oats four dollars, best corn sheller one dollar,

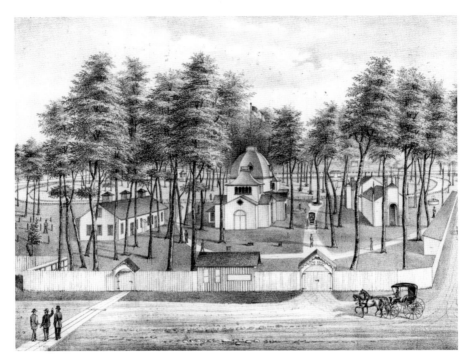

The first Stark County Fair was held October 15–16, 1850, at Public Square. After moving to various locations in Canton and Massillon, the fair found a permanent home in 1859 at Nimisila Park (now known as Crystal Park), shown here in 1875. The current fairgrounds at 305 Wertz Avenue in Canton has been in use since 1894. *Courtesy of the Stark County District Library.*

best ten pounds of wool one dollar, best bar share plow three dollars, best four horseshoes one dollar and best parlor stove two dollars. After moving to various locations in Canton and Massillon for a few years, the fair found a permanent home in 1859 at Nimisila Park (now known as Crystal Park). Dotted with oak and wild cherry trees, the fairgrounds provided plenty of space to display farm machinery, as well as host greased pig catching contests, pole climbing, wrestling and other spectacles.

The fair was also a place to display baked and canned goods. "The domestic and woman's departments call forth the pride, the anxiety and even jealousy of housekeepers and householders, who are competitive exhibitors," said Lehman. "Domestic and suggestive of comfort and appeased appetites are the breads, biscuits, cakes, cured hams and dried beef, canned fruits and preserves, jellies and jams, fruit butters and honeys." Women also displayed the fruits of their needles, including knitting, crochet work, needlepoint and tatting.

John Chapman, better known as Johnny Appleseed, planted Stark County's first apple orchard on the Daum estate and was a regular visitor throughout the county. He bought land for a nursery in 1809 on the corner of Cleveland Avenue and 5th Street in Canton. Chapman's exploits had reached legendary proportions before he died on March 18, 1845. A prominent Stark County resident would, decades later, pick up where Chapman left off. Harry Harper Ink would plant his own apple seeds, as well as the seeds for a new community theater.

According to E.T. Heald's *Stark County Story*, in 1892 Ink, a registered pharmacist, purchased a drugstore on East Tuscarawas Street. Ink was the originator of the drugstore soda fountain. He used real fruit flavor in his drinks. He was the first to make grape phosphate, which became a hit. About this same time, Ink began to make a product called Tonsiline. This was the first proprietary remedy for the relief of sore throats. By 1899, Ink had devoted his whole time to the business. Tonsiline was sold in the larger cities across the United States. He used the giraffe, with its long neck, to illustrate the remedy. "If you had a neck as long as this fellow and had sore throat all the way down, Tonsiline would quickly cure it," advertisements quipped.

In 1909, Ink was diagnosed with diabetes. Insulin had not yet been discovered, so he tried to improve his life with dieting and outdoor recreation. He also pursued his passion of fishing and raising fruit trees. Aplink Orchard was started with 233 acres purchased in 1914 with frontage on Fulton Road. About 157 acres were planted with fruit trees from 1915 to 1917. At its peak, there were 13,647 trees, mostly apple, but also crab apple and cherry. Ink hired architect Guy Tilden to build a mansion on the property.

Around 1918, fulfilling duties at the Tonsiline Company while his sons were away in military service, Ink was working in his laboratory and fell from a mixing platform, fracturing his shoulder. For the last seven years of his life, he was practically bedridden, rising for an hour or two at times to stroll among the trees at Aplink Orchard. He directed his enterprises from his bed and trained his children to take over management.

Aplink was a famous show place around Canton and a favorite meeting place for horticultural societies. But Ink's final and largest undertaking was a community theater. He purchased the three lots the Palace Theater sits on today between 1919 and 1925. On August 3, 1925, a thirty-year lease was signed with the Palace Theatre Company, whose owners were Ed Bender and Sol Bernstein of Canton, as well as two others from out of state. The excavation and part of the foundation had been finished at the time of Ink's

death in February 1926. Foreseeing the likelihood of his death before the completion of the building, Ink created a trust fund in the name of Harper Ink sufficient to provide for the completion of the building. The building was completed in the fall of 1926 and opened with Keith-Albee vaudeville, an orchestra and pipe organist, a silent feature and news reels.

Although the Palace is one of Canton's crown jewels, the orchard that Ink loved so much no longer survives. The construction of I-77 cut through the heart of Aplink Orchard acreage, but a small section was preserved as a park. In 2011, a five-mile section of Stark Parks trail system, the West Branch hiking and biking trail, opened. Part of the path meanders through a section known as Ink Park, north of Fulton Road Northwest, near the Pro Football Hall of Fame. Old fruit trees found in this vicinity, and in neighborhoods northwest of Route 62 and Fulton Road Northwest, are likely remnants of Harry Harper Ink's bountiful hobby.

The swamplands in Hartville were not recognized as a valuable agricultural resource until long after Stark County was settled. German immigrant Michael Graening was the first to clear the swamp in 1877. He would also become the first to grow celery in the region. When he arrived in Canton in 1872, Graening found work at one of the local shops. His family expanded from three to eight children in the next five years. According to E.T. Heald in *The Stark County Story*:

> *Michael decided that such a large family could be supported better by farming than by working in a shop, so he bought 85 acres of swamp land for taxes at $3 per acre about 1877. It was located at the end of the lane running north and south between Lake and Marlboro Townships, ending at the present [1952] Zellers-Duquette corner….The swamp land was then all covered with tamarack trees and tall huckleberry bushes. Graening built his log cabin alone. He walked the 18 miles out from Canton the first of the week and walked back again at the end of the week. Then Graening built a log barn, cleared the first acre of muck land and brought his family out. Plowing was first done by oxen—then horses and oxen were hitched together.*

Every year, Graening cleared more acres and planted more celery. In 1890, Jacob Machamer began growing potatoes in the area. In 1896 or 1897, Al Swartz also began clearing swampland. Just like Graening, he cleared more land each year, planting celery and onions. His brothers Oscar and Aaron also acquired patches of swampland and began growing radishes and spinach.

In the early 1900s, Emanuel Duquette became the first in the area to grow head lettuce and carrots. "He took his vegetables to Canton by horse and wagon," Heald said, "and later to Alliance from which point they were shipped by train to Pittsburgh and other cities. He was successful and soon all swamp growers were growing a large variety of vegetables." In the late 1890s, Frank P. Keener and his brother, George, purchased twenty-six acres each. During Keener's long career as a muck farmer, he saw the industry expand from just celery to twenty different crops, as well as horse and oxen give way to tractors and crop dusters. He also witnessed the change from home consumption to national distribution.

Charles Frederick established his farm in the swamp in 1918 and used it to develop a unique wholesale and retail business called Frederick's. In the 1950s, Frederick supplied storekeepers and hoteliers with fresh produce in Salem, Columbiana, Minerva, East Rochester, Canton, Waynesburg, Louisville, Alliance, Akron, Youngstown and Cleveland. Although he owned four delivery trucks, most of his customers came to his farm to purchase his vegetables directly. He was the first grower in the area to have a cold storage facility. He sold his farm to Lukens & Rohner, which continued to operate Frederick's without changing the business's name.

In 1915, W.M. Gressinger purchased 6 or 8 acres from U.I. Wagner, expanding to 90 acres by the 1950s. He specialized in growing peppers and sweet corn. D. Tope began his farming career with 8.5 acres of muck land he rented from Amish farmer Jake Miller in 1931. By the 1950s, Tope owned 185 acres of swamp farmland and 80 "upland" acres. He specialized in turnips but also grew beans, beets, celery and cabbage.

In 1880, there were 247,189 farms in Ohio, with an average size of 99 acres. Today there are very few family farms left in Stark County. One of the longest-lasting family farming operations in Hartville is the K.W. Zellers & Son Farms. This family still farms more than 1,200 acres and produces various types of vegetables, including staples such as lettuce, radish, beets, parsley, dill, onions and spinach. The Zellers family are featured in more detail in the "Legacy Families" chapter.

Located just minutes from the bustling retail hub of the Strip, Clardale Farms Inc. operates a fifth-generation seven-hundred-cow dairy farm in Canal Fulton. The unique name is a mashup of Dale and Claire Rohr, the third generation of the family. They own seven hundred acres and rent an additional two hundred acres to maintain their scale of operation. Clardale Farms employs fourteen full-time workers, about two-thirds of whom are family, each of whom works fifty to sixty hours a week. Farming

is a 24-hour/365-day enterprise, so the staff trade off working holidays. It takes a minimum of seven people to keep the farm running. Clardale Farms generates about $4 million in revenue annually, and 80 percent of its expenses stay right in Stark County.

In 2009, Clardale Farms built a new milk parlor that can accommodate twenty-four cows at a time, milking them three times a day. Frank Burkett, grandson of Dale Rohr and current co-owner of the farm, said that the cows are "creatures of habit" and like consistency in their lives. When the gates to the milk parlor open, the cows file in on their own, lining up in two twelve-cow lines. After an employee cleans the udders with an iodine solution, the cows are attached to the milking unit. An automatic sensor monitors the milk flow and detaches as soon as the flow decreases to a certain level. The actual milking process takes about three to five minutes, although the cows are in the milk parlor for about ten to twelve minutes because of the time it takes to set them up for milking. The "rapid exit" style of the milk parlor allows the cows to leave together in a group when milking is complete.

The cow's activity level is monitored with a tag worn on her leg, similar to a Fitbit used by humans. The tag is also part of a metering system in the milk parlor so the output of an individual cow can be tracked. Each cow produces about ninety-two pounds—or eleven gallons—of 3.7 percent butterfat milk per day. The milk is about one hundred degrees when it comes out of the cow. It is cooled through a radiator system to about sixty degrees and then further cooled to thirty-seven or thirty-eight degrees in holding tanks. The faster it can be cooled, the better the quality of the milk. All of the milk produced at Clardale Farms goes to Superior Dairy for processing and can be found on a grocery store shelf within twenty-four to thirty-six hours.

A large part of the activity at Clardale Farms is related to calving. On average, two to three calves are born on the farm every day, for an annual total of about eight hundred. There are about three sets of twins born each month. Cows have the same nine-month gestation period as humans, but they ovulate every twenty-one days instead of every twenty-eight days. They are artificially inseminated by an outside company that makes daily visits to the farm. When a cow is ready to give birth, the staff checks on her every thirty minutes. As long as the birth is progressing normally, the staff does not interfere.

At any given time, there are 650 "wet" cows producing milk and about 50 that are in the last two months of pregnancy and are "dry" during that period. The milk produced by a cow in the first three or four days after

giving birth is not saleable. About seventy to ninety days after giving birth, a cow can be impregnated again. A "fresh heifer," which is a cow that has given birth within sixty days, is valued between $1,800 and $2,000. Cows that are not good for milking are sold as beef cows, which are processed for hamburger and other lower-choice cuts.

In Ohio, cows do not have access to pasture for roughly seven months out of the year to graze. Clardale Farms grows its own corn and alfalfa hay for feed on about four hundred acres of surrounding farmland. For crop rotation purposes, it plants some beans and wheat, which it sells as a cash crop. Manure from the farm is used as fertilizer. After harvesting, the corn and alfalfa hay are ground up and stored in separate trench silos, where they are allowed to ferment, a process that makes the feed stable for up to eighteen months. Weather plays an important role in crop quality and yield, so it is important to have a six-month reserve of feed in place just in case there is a problem. Corn silage and alfalfa haylage makes up half of a cow's diet. The farm purchases protein in the form of soybean meal, canola meal, citrus pulp from Florida, brewer's grain from Anheuser-Busch or cereal from Kellogg's to make up the second half of the cows' diet.

Clardale Farms is operating on a business plan that will allow it to continue farming for at least another generation. There are limited opportunities for expansion in Jackson Township, due to the high cost of land, but the owners are not interested in running a farm with more than seven hundred head of cattle anyway. The EPA requires a lengthy permitting process for farms with more than seven hundred, which is an incentive to stay below that threshold. There are opportunities for vertical integration in the future, possibly in the form of a retail store or restaurant, agritourism or as a venue for parties and wedding receptions.

Stark County is also home to Park Farms, a large chicken processing plant located in Canton. The company has facilities in North Carolina and Winesburg, Ohio, but locally there is a hatchery at 3436 Lesh Street Northeast and a processing plant with administrative offices at 1925 30th Street Northeast. The company was founded in 1946 by E.A. "Tony" Pastore and Kenneth Miller, co-workers at Republic Steel, with just 50 chickens. Back then, it took several days to dress and sell all 50 chickens. Today, the Canton facility processes 840,000 chickens per week.

Miller dropped out of the enterprise early on, leaving Pastore the sole owner of the company, which became his full-time job in 1949. According to an article in the December 16, 1991 issue of *The Repository*, "Customers would come in and pick a live bird from cages. It would be weighed, slaughtered,

and cleaned while they waited." Pastore stopped dressing the chicken while the customer waited in 1956.

Today, Park Farms employs "strict biosecurity measures" to reduce the risk of contamination that could harm the chickens. In April 2006, a reporter for the *Alliance Review* described the process required to enter the facility. He had to step into a tray of sanitizer and put on shoe coverings. Viruses are spread through manure, but they can also spread through contact with equipment, clothing, shoes, cages and transportation vehicles. Staff change out of their street clothes and into surgical scrubs, which are laundered on site.

The safety precautions continue throughout the life of the chickens. First, a sample of day-old chicks are sent to a USDA-approved laboratory for testing. For many years, Park Farms has been performing double the industry-standard required testing. Instead of eleven samples per flock, Park Farms tests twenty-two samples. After hatching at the hatchery, the birds are sent to several "grow out" facilities located throughout the county. The chickens are isolated and kept indoors so they don't mix with wild migratory birds that could be carrying various strains of avian flu. According to former president Scott Stephens, the American poultry industry is very different from similar industries in other parts of the world. Chickens in Europe and Asian countries are taken to market live, where they "mingle with other birds, pigs, etc.," said Stephens. "If not sold, they are taken back home." This contact with other birds and animals creates an increased risk for the spread of disease in a flock.

The entire process at Park Farms is "all inclusive" and "vertically integrated," meaning the company controls the feed, environment and temperature inside the barns. No hormones or steroids are used. More than half of the chickens processed at Park Farms end up for sale within twenty-four hours of slaughter at retailers like Fishers Foods and Giant Eagle. The rest are sold to the food service industry or broker-dealers. Nothing is wasted in the processing; blood is used for fertilizer, and the liver and gizzards are sold to European markets as a delicacy.

Stark County today continues to benefit from our rich soil heritage, shaped by glacial ice so long ago. Superior agricultural conditions have inspired many inventors over the years to improve on existing designs and create new products to increase output and ease the workload of the farmer. Although farming is no longer a leading occupation, it is still a significant contributor to the county's economy and a major part of our history.

GROCERY STORES

Although today some Americans grow a small portion of their own food in backyard and community gardens, almost no family avoids a grocery store completely, according to Michael Ruhlman, author of *Grocery: The Buying and Selling of Food in America.* "We tend to use grocery stores without thinking about them, or if we do think about them, it's with mild annoyance, the thought of shopping itself a chore. What we rarely reflect on is what a luxury it is to be able to buy an extraordinary variety and quantity of food whenever we want every day of the year." We spend $650 billion annually in grocery stores. After housing and transportation, food is a household's largest expense, eating up roughly 10 percent of our income. But it wasn't always this way.

Grocery stores as we know them are a modern invention. As a fledgling community on the edge of the wilderness, Stark County's first settlers were largely self-sufficient. Pioneer life centered on survival: growing crops, raising animals and trading with others to put food on the table. It was not uncommon, even into the mid-twentieth century, for older properties to be covered with practical fruit trees and berry bushes rather than ornamental flowers and shrubs. Farm families routinely preserved foods after the harvest to sustain themselves throughout the winter months.

Once a town was established on the frontier, a general store was usually one of the first businesses to open. General stores carried items that were difficult for farmers to produce themselves, such as sugar, peanuts and coffee. A well-stocked general store also carried baskets, scales, grinders, medicines, shoes,

threads, dyes, tobacco and glassware. Abraham Kroft opened Canton's first store on the corner of Market and 5th Streets in 1807. He kept his goods in the back room; customers had to walk through the front room, which was used as his kitchen, dining room and bedroom.

By the 1820s, Stark County's population was about seven to eight thousand people, roughly twelve times the population of Cleveland at the time. As the community grew, more businesses of all kinds appeared on the landscape. Canton boasted seven stores, four taverns, four tanning yards, a bank, a brewery, a nail factory, a blacksmith, a gunsmith, two wheelwrights and chair makers, five shoemakers, three tailors, a pottery and several carpenters and joiners. Within four miles of town, there were seven gristmills, three sawmills, an oil well and two carding machines for wool and cotton. Within a few years, Canton had all the comforts of modern civilization.

James Hazlett and William Christmas were among the first general store owners in Canton. Hazlett built a two-story brick building in the 1820s, on the land that was later known as the McKinley Block. He ran a store there, selling groceries, hardware and dry goods. Money was scarce on the frontier, so he often let people "buy" his goods in exchange for butter, milk, eggs and other farm products. Deerskins were sometimes used as a form of currency as well. Hazlett was in business until around 1843.

At the age of eleven, Isaac Harter was indentured to William Christmas and worked in his dry goods store for more than ten years. "But that was the custom then," said John Lehman in *History of Stark County*. "A general store covered a multitude of details and many hours of the twenty-four, it was also the policy of the young men of those times to labor steadily and uncomplainingly." After his indenture was complete, Harter became a partner at age twenty-one, and in 1836, he took over the business when Christmas died and renamed it Isaac Harter & Company. He sold groceries, books, shoes, hats and caps. In an ad in the January 10, 1860 issue of *The Repository* for his store, Harter said, "I have good looking and honest clerks in my employ who take great pleasure in selling goods cheap. They solicit from everybody and their wives an examination and pledge themselves to do you justice. I devote my time to my business and ask a full share of your patronage." The following year, Harter went into banking full time and sold the store to David Zollars, a former employee. Martin Wikadal came to Canton in 1833 and opened a dry goods store on Market Avenue, later moving to the Courthouse block. By the Civil War, he was one of the leading merchants in Stark County.

In Massillon, John G. Warwick and Henry Pille were listed in the 1859 city directory as selling dry goods, boots, shoes and hats, according to Stark County historian E.T. Heald. Also listed that year was a grocery store on the south side of Main Street between Erie and Mill (now 1st Street), owned by Peter Dielhenn, who later went into the clothing business, as well as family grocery stores owned by Henry Knoblock and C.N. Oberlin. "J.F. Tschan was in the grocery business with the Schworm Brothers, Frank and Ed," Heald said. "It was a marvelous store in Frank Schworm's building, with a fountain where the vegetables were sprayed. There was a restaurant and bar in the rear, as with many grocery stores of a half century or more ago [Heald was writing in 1952]. Customers remained faithful for 50 years. Ed Schworm retired after 70 years in the grocery business. Three weeks after he retired he was taken ill and to the hospital and died. After he retired, Tschan sold out his interest."

G. Frank Schworm, W.B. Schworm, George W. Henrich and Frank Albright operated a grocery store and meat market called Albright & Company in 1887 at 25 East Main Street. "The store modestly advertised itself as having the largest and handsomest, most complete and best kept stock of general groceries, provisions and queensware in the city in 1887." Other early Massillon grocers included David Atwater, who established his store in 1832 on the southeast corner of Main and Canal Streets; James Harsh and Adam J. Humburger, who operated a dry goods and grocery store on the northwest corner of Main and Erie Streets in 1859; Charles Ricks and John Christman, whose grocery store was located west of Erie Street on Main Street in 1859; H.K. Dickey, who founded a grocery store in 1855 at 18 South Erie Street; R. Breed, who operated a meat store on the south side of Main Street near the canal in 1859; and Isaac B. Dangler, who started a dry goods store in 1846 and moved to 20 East Main Street in 1853.

General stores, dry goods stores or grocery stores were not the only source of sustenance in nineteenth-century Stark County. There were two early market houses in Canton, a tradition that is attributed to both the eastern influence of Canton's founder, Bezaleel Wells, who came from Baltimore, and the early German settlers in this region, who Stark County historian E.T. Heald said were known for their "love of good foods and sociability." When Wells was laying out the town, he provided an extra-wide north–south thoroughfare that he called "Market Avenue," with extra land donated in the center of town for a market, known as "Public Square." The first market house was located on the south end of the square, and the second was built

in the 1830s on the north end. No written records survive about either of these market houses.

The third market house stood on the southwest corner of Court and 2nd Street Southwest. In 1881, Judge and Canton mayor R.S. Shields presented the city council with a petition signed by 1,500 citizens who wanted a new market house and city hall to be built. At that meeting, a unanimous vote set plans into motion for both projects. The twelve-stall market opened on Saturday June 7, 1884. "The grocers and meat men arrived at 3:30 AM rubbing their sleepy eyes as they arranged their wares for the announced 4 o'clock opening," Heald said. "The first customer arrived at 4:18—a woman with the regulation size market basket on her arm. At 4:30 many people were picking out their Sunday dinners, and by 4:45 the shopmen were very busy. The rush continued for some time and then the stream of buyers decreased as steadily as it had grown, and by closing time at 9 A.M. all was quiet. The market was opened again at 5 P.M. for the evening trade, 5 to 10 P.M." The market was open on Tuesday, Thursday and Saturday. During the week, it was only open in the 4:00 a.m.–9:00 a.m. slot, but on Saturdays, it had the same morning and evening hours as opening day. Although the official closing time was 10:00 p.m. on Saturday night, it was not uncommon for the merchants to stay open until all their products were sold, which could be as late as midnight. Customers came on foot, by carriage and on the streetcars. All but one of the stalls were rented before opening day. Six out of the eleven original stalls sold meat, and there were one "fishman," two grocers and one caterer.

Heald noted that Mr. Bacon had the first ice cream and soda fountain store on South Market, which he described as "a noted place." Other stands were added later, including Montgomery D. Alexander selling homegrown vegetables and H.C. Jackson selling fruit, which was grown on a seven-acre farm at 1711 Maple Avenue Northeast. "They dealt in fruit as well as vegetables," said Heald, "but when they tried to introduce grapefruit, buying 12 at a time, they found that the people didn't care for the new fangled fruit." Alexander had a ten-acre farm on 12th Street Southwest. He was one of the first at the market to sell asparagus, as well as cultivated dandelions for greens. He was known for his lima beans and grew tomatoes to be canned at Dillon's canning factory. When the market moved to the Auditorium, Alexander went with it, adding Trail Bologna and dried beef to his stand. His son, T.H. Alexander, took over the family business in 1918, focusing mostly on processed meats, summer sausage and bacon. He ran it until it closed in 1942.

The new market quickly became a major event to look forward to in Canton. "Everybody who was anybody went there on Saturday morning," said Heald. "It became the meeting and visiting place of town. If you didn't get to market you didn't know what was going on. Men knew it as one sure place where they could meet their lady friends. The social function was so engrossing that it often interfered with the shopping." Mrs. John C. Welty, who was from the upper class of Philadelphia, would stroll through the market with her footman, who carried her basket. Customers bought everything from cinnamon cake to fresh-cut flowers. Heald compiled a list of the typical prices of the most common items sold in the market in the late nineteenth century:

butter	18 cents/pound
eggs	15 to 20 cents a dozen
bacon	8 to 10 cents a pound
peas	50 cents a peck
cucumbers	5 cents each
apples	75 cents a peck
chickens	25 cents each

The market closed in 1905, after the Auditorium Market opened in 1904 on North Cleveland Avenue between 4th and 5th Streets. "Tuesdays, Thursdays and Saturdays are the market days, and nothing necessary to a bountiful table is omitted from the articles on display," said John Lehman in *History of Stark County*. "Meats, vegetables, fruits, fish, butter, eggs and everything else to satisfy the human appetite." It had thirty stands when it first opened, but they had been consolidated to fifteen by 1949. Even at the Auditorium, the market was owned and operated by the city. In 1915, T.K. Harris built the Arcade Market at 323 North Market Avenue, which had twenty-two stands. Soon the modern grocery store would capture the mid-twentieth-century housewife's attention, and the markets would start to decline. Writing in 1949, Heald said, "Today, with the automobile changing marketing and shopping habits with the premium placed on parking facilities, and the rise of supermarkets, the old market houses are finding competition keener, but crowds and especially the people connected with the old families, still go to market with their baskets on their arms, and find plenty of friends and acquaintances with whom they continue the old tradition of visiting while shopping for their Sunday dinners."

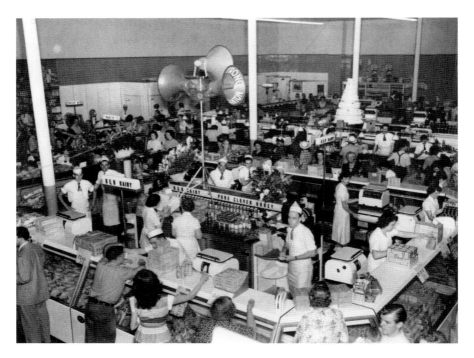

T.K. Harris built the Arcade Market at 323 North Market Avenue in 1915.

Corner grocery stores began to dot the urban landscape of Stark County's three major cities by the end of the nineteenth century. In 1876, the "new firm" of Sexauer and Miller placed several advertisements in the *Stark County Democrat*, providing a glimpse of what a local grocery store was carrying in that era. The store, located at nos. 14 and 16 in Canton's Public Square, sold coffees, sugars, prunes, canned fruits, dried fruits, vegetables, teas and syrups at "greatly reduced prices." The ad also mentioned that it carried a full supply of butter, eggs and produce, "always on hand and sold at lowest prices!" In 1880, H. Gotthsall's Excelsior meat market was located at 8 East Tuscarawas Street and had two wagons that ran three times a week offering free deliveries to anyone in the city of Canton. In Alliance in the 1880s, six brothers in the Rickard family owned different grocery stores all on Main Street, which historian E.T. Heald suggested could be a "national record." James I. Rickard owned the store next door to the Alliance Opera House, which collapsed in 1886.

Although Acme Fresh Market is a grocery store chain based in Akron today, its roots stretch back to nineteenth-century Massillon. In the 1860s,

F.G. Albrecht was operating a grocery store. His son, Frederick Wilhelm Albrecht, was born in 1861 and, once old enough, ran his own grocery store until 1891. At age thirty, young Frederick left Massillon for Akron, believing there would be more opportunities for him in a larger city. He purchased an existing grocery store and ran it for a decade, earning a reputation as a "quality-minded, progressive, efficient, and honest grocer," according to Acme Fresh Market's company history. In 1900, he traveled to Philadelphia to visit one of the first grocery chains, the Acme Stores. When he returned to Akron, he closed his store for a week, painted it yellow like the stores he had seen in Philadelphia and reopened it as Acme No. 1. By the early 1930s, he owned 126 small neighborhood stores. As the grocery business shifted toward the supermarket model in the mid-twentieth century, the regional chain changed with the times. By then, Acme had expanded into Stark County, where F.G. Albrecht first started out.

William H. Kagey and his brother opened a grocery business in Louisville in June 1893. The following year, they purchased all the grocery stock from Mrs. Peter C. Newhouse, whose husband had run a grocery store. Kagey purchased his brother's half of the business in 1897. In an article that appeared in the *Louisville Herald* around 1931, an unnamed journalist reminisced about Kagey's store:

> *The writer, in his "newsboy days" well remembers what a haven the Kagey store was on cold winter nights. The newsies would gather 'round the old heating stove and thaw out, while listening to what was perhaps the first phonograph in Louisville. It had a little tin horn, perhaps a foot long but in those days it was a marvel. Back in the nineties it was Ada Jones and Len Spencer doing their stuff in "Sanderson and Crumit" style.*

Kagey remained active in his business until his death in October 1948. His obituary in the *Louisville Herald* acknowledged his lifelong career in the grocery business:

> *Until May of this year when he retired and turned the business over to his son, Lowell, Mr. Kagey had been the active proprietor of the store for 55 years. At the time of his retirement he said he expected to be on hand at the store to help out. He followed this custom daily. Mr. Kagey had been in business so long he counted time by presidential terms rather than years and enjoyed saying he had been a grocer since Ben Harrison was president of the United States. One of his favorite pastimes was to meet customers in*

the store and talk of his early business career and how he had opened the grocery each morning at 6 and remained until 11 at night to take care of late customers. He said the late customers were usually farmers who came to town after chores were done on the farm.

Kagey had certainly seen many changes during his long career as a grocer. In the late nineteenth and early twentieth centuries, the average grocery store carried only about two hundred different products. At the time of his death, Kagey would certainly have been aware of the new trend of the "supermarket" that was completely changing the way Americans shopped.

Born on a farm three miles outside Canton in 1887, A.B. Flory was not yet thirty years old when he established a grocery store in Canton at 221 2nd Street Northwest in 1910. "This enterprise occupies the unique position of having the youngest executive (28), head of three stores (all in Canton, the business having been established by the proprietor) not only in Stark County, but the state of Ohio, and probably in the United States," noted an article in the May 4, 1912 issue of the *News-Democrat*. Before opening his grocery stores, Flory worked at a newspaper, in real estate and in fire insurance. He had tremendous success early in his career as a grocer, and he was willing to share his knowledge with others in the grocery business. "He says he can sell 15 per cent cheaper than any competitor, and make a profit, and that the better business methods his competitors use, the more stable will the grocery business become," said the *News-Democrat* article. "In his system of business, no money is wasted (being for years in the circulating department of a newspaper, where the debit side of the ledger is affected by a penny), every mill is being watched as carefully as if it were a dollar."

In the same article, an unnamed senator described Flory as optimistic:

He tells of his plans, and what he is going to do. He laughs and jokes with everybody. He stands at the front door of his stores to be the first to smile when a customer comes in. He is living a life, where worries are trodden underfoot, and where only optimism exists. When he added two new stores this year, in a city of over 50,000 inhabitants, the news went around swiftly. He is now doing the greatest business he ever did, and people around town are talking of his stores and are watching for the advertisements. The clerks are with him....All know that with the proprietor they are a big family. The reason his places are so heavily patronized is summed up in one woman's remark to another on a street car. "Oh, yes, I always buy there. They treat me so nice."

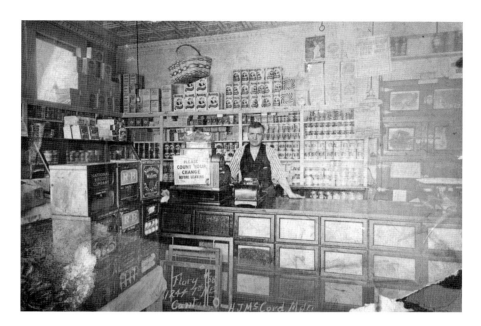

Above: Between 1910 and 1927, A.B. Flory built a regional grocery store empire of eighty-five locations across Stark County and surrounding counties. For a time, he even operated a mobile grocery store inside a truck to reach rural areas.

Right: This ad for Flory's grocery stores appeared in the September 12, 1913 issue of *The Repository*.

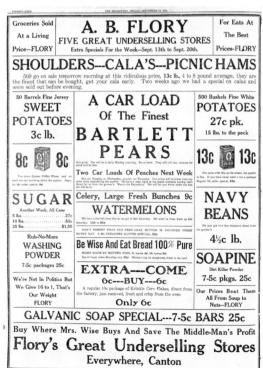

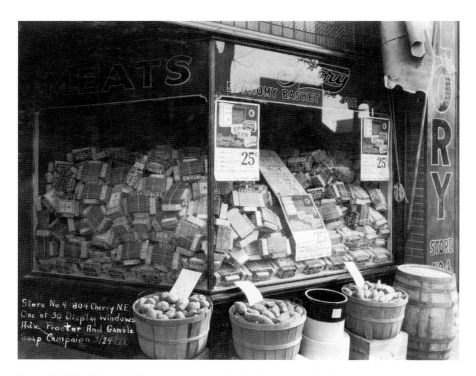

In April 1921, thirty of Flory's stores advertised a Proctor & Gamble soap campaign, including the location at 804 Cherry Street Northeast, shown here.

Flory's stores carried "staple and fancy groceries," including flour, butter and vegetables and fruit in season. Each was equipped with a coffee roaster to make fresh coffee beans. The *News-Democrat* article listed the brands available: Flory's Special (twenty-five cents), Old Dutch (thirty cents) and Golden Blend (thirty-eight cents).

Flory's Auto Grocery truck was featured in the *Magazine of Business* in April 1920. The truck "carried supplies every week-day to the doors of people in villages and on farms near Canton. This store, built upon a truck, measures 16 feet 6 inches in length, and 6 feet 6 inches in width; stocked, it weighs 13,000 pounds. It is well lighted and equipped with bins, shelves, a refrigerator, scales, a cash register, and a counter." Customers boarded the truck to make their selections. "'I reckon that Flory will be placing food upon our tables ready to eat before long,' says the farm wife as she hurries with her basket to the road side to halt the 'auto store': she heard its loud siren call three or four minutes before. She enters by the side door, makes her

purchases, and withdraws." The article noted that the company as a whole had done $2 million worth of business in 1919.

Flory was committed to selling direct from the producer, and his business was strictly cash-only. The bakery, a new addition to his company, made ten thousand loaves per day. "Calls come every week," Flory said. "People want us to open new stores in this county and adjoining counties. It was in answer to this demand from the villages and rural communities that we started the auto grocery on its daily rounds."

Flory believed that the customer should be treated fairly and respectfully and instructed his employees on the matter:

> *The customer should be our friend. It's your business to make him our friend. If he is dissatisfied, return his money without a quibble. Give 16 ounces to the pound—no less, no more. To give less would cheat him, to give more would cheat us. Treat every customer as you would want to be treated if you were in their shoes.*

Flory also prized cleanliness, offering cash prizes to managers whose stores were the cleanest and the highest in sales and profits. "Cleanliness," he said, "brings larger sales, and that means more profit." His advertising was also designed to grab the attention of his customers. The article noted that the "orange-yellow stores and trucks awaken the casual passerby and link the name of 'Flory' to the 'direct from the producer to you' idea."

By 1927, Flory had eighty-five locations across the county and beyond. Most of the locations were grocery stores, but some were booths at various marketplaces, patent medicine stores, specialty meat shops and even a lunch counter. In addition to locations in Canton, Massillon, Alliance, North Canton, East Canton, East Sparta, Hartville, Robertsville, North Industry, Minerva and Brewster in Stark County, there was a "Flory Chain System Store" in Wooster, Dalton, Orrville, Strasburg and Sebring. At one point, he also owned the Flory Hotel.

On October 17, 1927, the *Canton Daily News* reported that the A.B. Flory Company had gone into receivership, although the stores were to remain open. The following year, things looked much worse for the Flory empire. In the March 2, 1928 issue of the *Canton Daily News*, a notice appeared announcing the bankruptcy of the A.B. Flory Company and public sale of all the store locations in the chain. "Said sale will take place on Wednesday, the 7th day of March, 1928, at 10 o'clock A.M.; and the sale shall be for cash, and shall be subject to the approval and confirmation of the court," the

notice said. "The various stores of the company will be offered separately, and the stock of groceries, merchandise, etc., will be offered in lots and as a whole. The right is reserved to reject any and all bids." Flory's home at 1523 Cleveland Avenue and fourteen trucks were also sold at public auction. In spite of the family's financial situation, the *Canton Daily News* reported on February 1, 1928, that Flory; his wife, Dora; and their daughters, Marguerite and Gladys, "left by motor Tuesday for Jacksonville to spend the remainder of the winter." Flory is not listed in the 1929 Canton City Directory, but he appears again in the 1930–31 edition as an auditor and in the 1932 edition as an accountant. In 1933, he was living in Cleveland with his new wife, Marguerite Ross, who was also from Canton. According to his obituary in *The Repository*, "After retiring from business in Canton Mr. Flory went to Florida to make his home." He died in Miami on August 29, 1950, at the age of sixty-five.

Gilbert M. Lemmon opened his first grocery store, which also sold car tires, in Wooster, Ohio. He moved to Canton in 1926 and opened a grocery store and outdoor produce stand at 1101 12th Street Northwest, in front of his home, on the site where Sparta Steak House is located today. If you look up, you can still see the roofline of the original house. "My father would take us to the store on weekends and in the summer to do various chores, such as sorting strawberries, bagging potatoes, and stocking shelves," said Dick Lemmon, Gilbert's grandson.

We were 10 and 12 years old, but my parents said we had to start some time. We lived on a small farm at that time and I guess we thought the store work was the lesser of two evils. [Itinerant door-to-door salesmen used to come through Canton with produce items from southern states, such as tomatoes, peaches and berries.] *But the most important product was the watermelon. That signified that summer was almost here. In my grandfather's store, there was a small cooler that we kept cold melons available for sale. When a customer would select a watermelon, we would plug the melon. This entailed cutting a triangular piece out of the melon so the buyer could taste it if they wished or else see if it was red and ripe. The best part was when my brother and I were helping unload the melons from the truck. Watermelons were much larger and heavier than the ones sold in the store now. Some weighed over 70 pounds. We would always find a way to drop one or two on the ground and then enjoy a "watermelon break," literally.*

LEMMON'S

12th and OXFORD, N. W.

A Full Line of Groceries, Fruits, Vegetables and Meats
Week-End Specials for Cash Only

WE DELIVER

DIAL 5342 - 5341

CASH - Friday and Saturday, Dec. 6 and 7, 1931 - CASH

Groceries
Where Quality Rules

MELO Water Softener—4 cans **29ᶜ**

SOAP FLAKES Snow Boy Brand—Pure and White as Snow—2 lb. **19ᶜ**

Campfire MARSHMALLOWS—1 lb. Box and a Box of Cracker Jack for **21ᶜ**

PRUNES Those Large, Sweet Santa Clara's—2 lbs. **19ᶜ**

Peanuts Fresh Roasted Salted Peanuts—lb. **9ᶜ**

COFFEE BREAKFAST BLEND—lb. 23c CIRCLE F—None Better for the Price **19c** C. W. Brand—lb. **25c** OUR SPECIAL—Makes a Fine Cup of Coffee—Try it—lb. 29c

Golden Bantam Corn Premier—McLain's or Lily of the Valley—2—No. 2 cans **25ᶜ**

Hunts Pineapple 8 Slices Per can—In Rich Syrup—2 No. 2 cans **29ᶜ**

Tomatoes Red Ripe—Good Pack—3 No. 2 cans **25ᶜ**

CORN MEAL Pure Golden Yellow Meal—5 lb. Bag **15ᶜ**

PECANS Fresh from Georgia—Large Thin Shelled Pecans—Per lb. **29ᶜ**

Fruits and Vegetables
See Our New Glassed-in Fruit Market

POTATOES Good Sized—Wonderful Cookers or Bakers—15 lb. Peck **19ᶜ**

ORANGES—California Sunkist—Thin of Skin—Sweet and Juicy—2 Doz. **35ᶜ**

GRAPE FRUIT Med. Sized—Thin Skinned Full of Juice—5 for **25ᶜ**

Sweet Potatoes Genuine Jersey SWEET POTATOES—6 lb. **25ᶜ**

APPLES Spitzenburg's—Fine for Eating or Cooking—Lg. Apples—12 lb. Peck **25ᶜ**

FLORIDA ORANGES—Large Sweet Balls of Juice—Dozen **35ᶜ**

Dry Cooking ONIONS—5 lb. **15ᶜ**

FLORIDA ORANGES—Those Sweet Juicy Florida's—2 Dozen **31ᶜ**

DATES—Fresh—A Rich Wholesome Food—2 lbs. **25ᶜ**

Rice Krispies For Breakfast—2 Boxes **19ᶜ**

Peas Dannemillers Royal Brand—Tender—Extra Fancy—Reg. 20c—Special **15ᶜ**

Hershey's Sweet Milk Coating CHOCOLATE—lb. **25ᶜ**

Meats
The Best Meats Money Can Buy

Chuck Roasts—Prime Steer—Very Tender—Pound **23ᶜ**

PORK LOIN ROASTS—Center Cuts—No Ends—Lean—Small Loins—lb. **19ᶜ**

Pork Loin Ends 2—2½ lb. Average—Lean and Meaty—Fine to Cook with Kraut **13ᶜ**

CHICKENS—Springers—Home Dressed—lb. **35ᶜ**

Country Sausage BOWERS—Fresh or Smoked—lb. **23ᶜ**

Fresh Ham Roasts ½ or Whole—Lean and Fresh—lb. **18ᶜ**

STRING END HAMS—Pound **12ᶜ**

Sliced Bacon Sugardale, Canton Provision or Swifts Premium Bacon ½ lb. Pkg. **16ᶜ**

BACON IN PIECE—Mild Cure—lb. **18ᶜ**

Beef Veal and Pork For Meat Loaf—Fresh Ground—lb. **20ᶜ**

Pop Corn That Large, Yellow Jumbo—Pop Corn—2 lb. **25ᶜ**

Navy Beans Hand Picked—Fancy Grade—4 lb. **19ᶜ**

Pork and Beans With Tomato Sauce—McLain's—4—1 lb. cans **25ᶜ**

Grocery store circulars are exceedingly rare because they were often thrown away. This circular for Lemmon's grocery store is dated December 6–7, 1931, when the nation was deep in the throes of the Great Depression. *Courtesy of Dick Lemmon.*

After high school, Dick went to work for his grandfather. One of his jobs was running an egg and cheese pickup route through Amish country every week. Dick's father, Paul, built a new store about a block away from the original location at 1007 12th Street Northwest, which he sold in 1954. Dick bought it back in 1958 and operated it until 1990 as Lemmon's Super Market.

By the 1940s, there was a grocery store selling dry goods—non-perishable items like canned goods, boxed foods and flour—in every neighborhood, within walking distance for most homemakers. In addition to the grocery store, a woman went to several other stores to buy what she needed, including the butcher, the bakery and the produce market. At the neighborhood grocery store, the employee stood behind the counter, with most of the products displayed on shelves where only he could reach them. The customer would ask for the items she wanted, which were totaled and packaged for her. Most of these corner grocery stores were very small and only lasted a few years, making it extremely difficult to track down much information about them. Bate's Grocery, for example, was located in a garage behind a home on Woodward Place between 25th and 26th Streets Northwest. Judy Gouge's grandparents Charles and Ollie Bate ran it in the 1940s and '50s. They carried the typical variety of products found in a mom and pop store of that period: canned goods, flour, sugar, bread, breakfast cereals and a few household goods, such as toilet paper and laundry soap.

Keeping food cold at home was challenging before refrigeration. In the nineteenth century, women shopped often and cooked three meals each day since there were limited ways to keep leftovers fresh. The Canton Ice Company was organized in 1898 and supplied natural and artificial ice to the city's households. Natural ice came from Congress, Silver and Brady's Lakes, and the artificial ice plant was located on Navarre Road. Blocks of ice kept foods cool in an icebox, a precursor to the refrigerator. The Canton Electric Company, founded in 1885, became the first provider of electricity to businesses and homes in Canton. The company's power plants were located on 2nd Street Southeast, between Savannah Avenue and Elm Street, and on South Walnut Avenue near the Pennsylvania Railroad. Once refrigeration was available in the home, fresh meats, fish and leftovers could be safely stored and consumed at a later date. This new technology changed the way women cooked and shopped, but early refrigerators were quite small by today's standards and still could not accommodate a large amount of food. And it would be a while before home freezers became available. "The ice cream department was almost nonexistent since all ice cream had to be hand packed and most homes did not have freezers to keep it," said Dick

This page: Gilbert Lemmon's son, Paul, built a new grocery store about a block away from the original location at 1007 12th Street Northwest, which he sold in 1954. Paul's son, Dick, bought it back in 1958 and operated it until 1990 as Lemmon's Super Market. *Courtesy of Dick Lemmon*.

Above: Many neighborhood grocery stores were nothing more than a backyard garage stocked with staples for the people who lived nearby. Judy Gouge's grandparents Charles and Ollie Bate ran Bate's grocery store at 1315 Woodward Place Northwest in the 1940s and '50s. *Courtesy of Judy Gouge.*

Right: PJ Bordner & Company first appear in the Massillon City Directory in the 1911–12 edition. Located at 1803 South Erie Street, the owners were Perry J. Bordner and Mrs. Clara J. Bordner.

P. J. BORDNER & CO.

ALL THREE STORES

Amherst Park Center
West Side Store
South Erie Store

Open Mon. thru Sat.
9 a. m. to ª p. m.

Lemmon. "Cones were very popular. There were very few popsicles and ice cream bars. These were mainly sold in drug stores at the soda counters along with sodas and sundaes."

In the mid-twentieth century, shopping for food began to change dramatically. Nationwide, the first chain grocery stores were started by companies like the Great Atlantic & Pacific Tea Company, better known as A&P. Starting out in New York City as Gilman & Company in 1859, within a few years A&P opened a small chain of retail, tea and coffee stores. By 1912, A&P had grown dramatically by introducing the "economy store" concept. But grocery stores still had an issue that public markets did

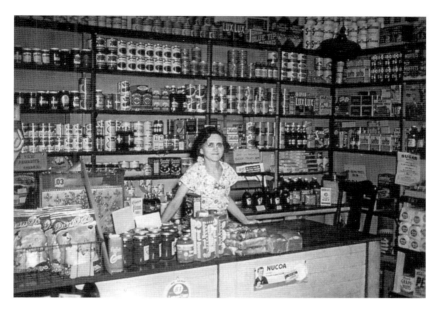

Ollie Bate stands behind the counter of her grocery store. *Courtesy of Judy Gouge.*

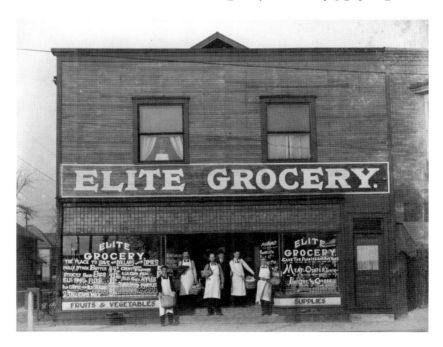

The Elite Grocery was located at 1401 East Tuscarawas Street for just a few years in the 1920s. The men in the center of the photograph are holding live chickens, and the window on the left is advertising Molly Stark Butter for forty-four cents per pound.

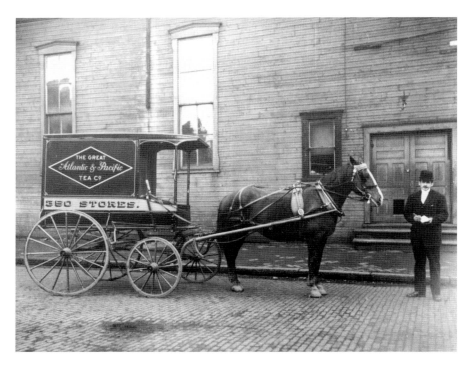

The Great Atlantic & Pacific Tea Company, better known as the A&P, opened on May 28, 1931, at 322–24 East Tuscarawas Street. The store's grand opening ad in *The Repository* noted, "A complete, modernly equipped, downtown food market will be opened for the convenience and service of the housewives of Canton."

not. Numerous employees, known as "clerks," took orders from customers and then scrambled around behind the counter to fill the order while the customer waited. As more products became available in grocery stores, this practice took way too long and proved to be very costly.

Clarence Saunders solved this problem in 1916 when he opened the first Piggly Wiggly grocery store in Memphis, Texas. He billed it as the first "self-serve" grocery store and even patented the process in 1917. For the first time, instead of placing orders with the clerks, shoppers were able to move freely among the products. They were able to view and handle the products themselves, collect what they wanted and then take their own items to checkout counters. The modern grocery store was born.

As families increasingly moved out of the cities and into the suburbs, the nature of grocery shopping also changed. Rather than walk to several local providers to gather ingredients for a day or two of meals, consumers

preferred driving to a single location where they could purchase everything they needed under one roof. In *Paradox of Plenty*, Harvey Levenstein wrote:

> *From 1948 to 1963 large chains increased their share of the nation's grocery business from 35% to almost half. As early as 1956, the independent corner grocery store, while still visible, was a relic of the past. Full-fledged supermarkets accounted for 62% of the nation's grocery sales, while smaller, self-service "superettes" took in another 28% of the food dollar, leaving the 212,000 small food stores to share 10% of the market.*

In 1948, the Canton City Directory listed 353 grocery stores in the city. By 1970, that number had shrunk to just 119. In 2010, there were only 76 grocery stores listed in all of Stark County, but that list now included convenience stores at gas stations, such as Circle K, Speedway and Hall of Fame Fuel Mart.

Naturally, the footprint of the grocery store had to expand to accommodate the increased demand for a "one stop" shopping experience. According to Ruhlman, the typical grocery store of the 1960s and 1970s grew from three thousand feet to thirty thousand feet. Today, large grocery stores can measure up to ninety thousand square feet and more. The typical store in the 1970s sold about nine thousand products. Today, the modern grocery store stocks around forty thousand items. Early supermarkets had four main departments: meat, dairy/frozen, produce and grocery. Depending on how you define them, today's grocery stores have ten to fourteen departments, including grocery, produce, frozen/dairy, meat, deli/prepared foods, beer/wine, seafood, bakery and floral. Bigger stores usually have a pharmacy and a bank as well.

Small, independently owned grocery stores could no longer compete with large chains, which could sell goods cheaper because they relied on volume to make a profit. One by one, family-owned neighborhood stores across Stark County closed. Fishers Foods, Kishman's IGA and Belloni's are notable exceptions. All three are family-owned grocery stores that still operate with multiple generations of the same family running them.

Joseph Fisher came to America from Russia with his family when he was just six years old, and as a child, he and his brothers helped roll cigars at home after school for his father's cigar making business, Fisher's Tiger Tails. After graduating from Central High School, Fisher put himself through college at Ohio State University by selling flowers and shrubs. When he came home after serving in World War I, Fisher worked in his father-in-law's

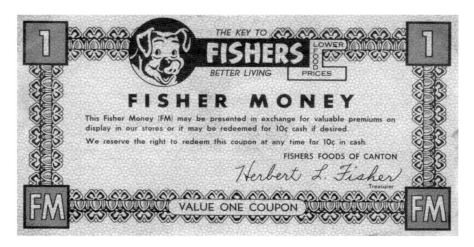

Fisher Money, sometimes called "pig money" because of the cartoon pig on the front, could be purchased at the checkout for ten cents on the dollar for each dollar you spent in the store. You could spend your Fisher Money on items that were generally discounted from retail prices, including luggage, lamps and radios. Some customers used them as a "Christmas club," saving them all year to purchase holiday gifts.

clothing business, where he discovered his love for merchandising. With the Depression crippling the economy, Fisher decided to carry food in addition to clothing, reasoning that "everyone had to eat." It was a family business from the start. Rose, his wife, made all the salads sold in the deli, and their sons, Herb and Jack, delivered groceries on order.

The first store, on the corner of Navarre Road and Garfield Avenue Southwest in Canton (1933), sold both groceries and clothing. The second location, which opened at the corner of Tuscarawas Street and Whipple Avenue Northwest in 1951, was a modern-day supermarket. At twenty thousand square feet, it was quite different from the original mom and pop neighborhood store. Soon more locations followed: Harrison Avenue Southwest (1953, closed in 2018), Cherry Avenue Northeast (1954, closed in 2018), 44th and Cleveland Northwest (1958), Fulton Road and Frank Avenue Northwest (1979), Lincoln Way East in Massillon (1986, closed in 2018) and Cleveland Avenue Northwest in Plain Township (2002). Fishers Foods in Stark County has never been affiliated with Fisher Foods Inc. in Cleveland.

Fishers Foods has always preferred to carry products made locally, from companies like FreshMark, Superior's and Nickles. Over the years, the stores have added more specialized services, including an optical shop at the Massillon, Jackson and Plain Township locations, a catering department,

Jack Fisher (*left*) and Alex Fisher (*right*) walk through the Fulton Road store. They represent the second and fourth generations of the Fisher family to operate Fishers Foods, founded in 1933. *Courtesy of* The Repository.

a health food section in Jackson and Plain, beer growler stations at four locations, Fishers to Go online ordering/curbside grocery pickup and Chef Kits by Fishers, which contain ingredients and directions for a "dinner for two," similar to services such as Blue Apron and HelloFresh that have become popular in recent years.

When Alex Fisher recently joined the family business, he became the fourth generation of the family to work for Fishers Foods. Each generation brings new ideas to the table, some of which are a bit outlandish for the older folks. "Jack Fisher [founder Joseph Fisher's son] said they waited until their dad was out of town to test some of their initiatives," wrote Tim Botos in a June 19, 2017 article in *The Repository* profiling the family. "It was safer that way." Cutting-edge ideas—such as hot prepared Asian cuisine and an in-store liquor store—have helped Fishers stay relevant and competitive in today's market.

Alex Fisher, fourth-generation owner of Fishers Foods, never met his great-grandfather, but he has plenty of childhood memories of the stores Joseph founded. "My grandfather [Jack Fisher] would offer to take me to lunch," Alex said during a 2018 interview. "I could go anywhere I wanted—but before we did that, we had to go to a store, or sometimes two. We'd take a cart and walk up and down each aisle. I'd help grandpa straighten up shelves, collect stray items, whatever was needed to tidy up the place. By the time we got to the front of the store my cart would be pretty full. I'd hand it over to one of the employees, and grandpa would

pull out a pad that he had been taking notes on. He'd rip the page out of the notebook, and hand it to the manager. Then we'd go to lunch!"

Alex worked in the store as a teenager. At fifteen to sixteen years old, he would come in for the 6:00 a.m.–2:00 p.m. shift and worked in the warehouse unloading products from incoming trucks. Then he would sort and reload the products into Fishers trucks to send the merchandise out to the stores. "I may have been late a few times," he said, chuckling about being a teenager having to wake up early, "but I learned a lot. It was a good experience. Hard work. I got to know the guys in the warehouse. Eventually needs came up. We might have a deli clerk or other worker that called off, so I was slotted into those positions. It gave me a lot of experience. My parents 'made me earn it,' and I appreciate that now."

Another early memory was when, as an eighth grader, Alex attended the ribbon cutting ceremony for the North Canton store. Alex recalled the experience as being really cool, "but probably more for getting out of school, or to have my picture taken," he said, laughing about it now. As middle school turned into high school, thoughts turned to career and college, but neither involved the grocery business. "Did I have my eyes set on going into the grocery business? Absolutely not," he said.

After starting out at Stark State College, Alex moved to Florida to get away, see the world and be out on his own for a while. As a college student at the University of Southern Florida, Alex noticed that Fishers Foods didn't have a social media presence. He started a Facebook and Instagram page. He worked on the pages from one thousand miles away. He was surprised that people responding online were interested in the history of the store. That made Alex begin to dig into his family's story. Working on the social media pages would be his first step back into the business. Alex began flying back to Ohio more frequently and then eventually stayed.

Fishers stays relevant in the sea of big grocery stores through customer service, niche products and responding to consumer trends. Fishers is one of the last grocery stores to make bakery items from scratch in-house. It employs three to four master bakers. The popular Smiley Faced Cookies are hand-cut and hand-dipped. The store still has its donut machine from Italy. "A lot of our recipes are from life experiences," Alex said, "which is pretty cool. We'll be out somewhere, traveling in Europe, taste a bread, and be like, 'We *have* to make this.'" They develop a similar recipe, and it eventually ends up on Fishers' shelves.

In the grocery business, staying relevant is key. The craft beer movement has swelled nationwide, and stations very similar to a bar in a restaurant

allow shoppers to taste samples of fresh beer on tap and then fill a "growler" (glass jug that holds beer) to purchase the beer to take home. "Sometimes I'll walk downstairs, and the bar is packed—at 3:00 PM on a Wednesday!" said Alex. A staff member stands at the ready to explain what's on tap and to answer questions regarding the different profiles of the featured beers. "We showcase craft beers as a whole, and also events that bring in local craft brewers. They respect what we do and want to work with us," said Alex. It makes grocery shopping fun and gives customers the opportunity to sample the beer before purchase.

It is notoriously difficult to make money in the grocery business today. On average, a store can expect to profit 1.7 percent, which is less than two cents on every dollar spent. Fishers Foods is in competition with other national chains, such as Giant Eagle and Walmart, plus two new organic grocery stores that have recently moved into the area: Earth Fare and Fresh Thyme. It is critical to keep your finger on the pulse of what consumers want and need in order to stay competitive. "It's all changing so fast," Jeff Fisher told *The Repository*. "Part of being successful is knowing what to change and what not to change." And part of that change is allowing the next generation to tap into trends. The fourth-generation Fisher family member is ready to take on the challenge. "As long as I'm doing right by the company and my family, that's all that matters," Alex said.

Kishman's IGA in Minerva is the last IGA operating in Stark County today. When George Kishman purchased the store from the Sauvin family in 1954, according to an article in the *Minerva Leader* dated July of that year, it was one of 5,500 IGA stores in North America. IGA stood for "Independent Grocers Alliance" and offered "Everyday Low Prices." The McClain Grocery Company, based out of Massillon, was the supply hub for all Stark County IGAs, which numbered more than thirty at one point in time.

George Kishman grew up in Vermilion in northwestern Ohio. He attended college at Ohio State University, and upon graduation, he worked for General Mills before moving to a large supermarket in Cleveland, where he was in charge of the meat department. During World War II, George served with the merchant marines and was stationed in both the Atlantic and Pacific Oceans. After returning from service, George made the move from urban Cleveland to small-town Minerva and started a family. He and his wife, Patti, had two boys, Tommy and Jeffrey, who were just ages five and one when their father opened the store.

The community anticipated that George would bring "big city" concepts to rural Minerva. The article in the *Minerva Leader* reported that "packaged

foods that are nationally advertised can readily be found in this modern store." The article also noted many changes to the store layout. "Self-service" options were touted in every section, including and especially in the meat department, where shoppers were encouraged to take it upon themselves to get what they wanted: "If you don't see a cut you like, the door is always open to the packaging department. Simply walk in and ask for what you desire!"

George proudly conveyed in the article that "all cuts of meat are ready for the oven and table" since "excess fat and bone are already removed, thus giving maximum economy." Regarding the ground beef, "due to heavy turnover, meat grinding is done hourly or oftener and is of 100 percent beef." George was so particular about his meat department that not only did the meats carry a U.S. government stamp of quality, but they also bore Kishman's own quality assurance label, which read, "Kishman's Naturally Tender Meats."

George's son Tom took over from his father and today operates the grocery store with his wife, Jan, and their three children, Tom Jr., Matt and Kristen. The store hasn't moved since 1954, but it has expanded conceptually and physically over the years. In 2008, the store underwent a major renovation, including lighting updates and the installation of new frozen food display cases. Five years later, in 2013, its physical footprint had increased by ten thousand square feet. The deli and bakery were moved to the front of the store, aisles were lengthened and each department benefited from more room.

In a 2018 interview, the family sat down to talk about their grocery business. The interview began in the recently added seating area, a pleasant and sunny space near the deli and prepared foods cases. However, the group didn't sit for long. Most of the interview took place while walking around the store.

The store certainly doesn't look or feel like a small-town space. A large photo of President William McKinley, depicted at his country home in Minerva, is one of the first things that catches a shopper's attention in the entryway foyer. Once inside, space and signage are well appointed, bright and easy to navigate. Matt, as he was leading the tour around the store, talked about the changes over the years. "It took us 60 years, but we finally got a wine and beer section," he said, chuckling, but "it's done really well." That section is extensive, with an entire aisle devoted to beer and wine, with more wine featured on main aisle end caps. A map of Ohio hangs prominently in that section, showing where local beer sold in the store is brewed.

Owners of Kishman's IGA in Minerva, Jan and Tom Kishman, are depicted in a cardboard cutout featuring the "Minerva Monster," a popular sub sandwich named for the legendary bigfoot-like creature said to roam southern Stark County in the 1970s. *Authors' collection.*

This photo of young Walter Kishman hangs in the meat department at Kishman's IGA. He is a fourth-generation family member of Kishman's IGA in Minerva. *Authors' collection.*

In the meat department, one can get a feel for both the past and future all at once. Above the meat cases, a sign reads, "Preferred Angus: The Standard for Tenderness." This harkens back to founder George's focus on quality meats. Below that sign is a photo of a smiling little boy, seated in chair, fork extended and hovering over a large juicy steak on his plate. The boy is Matt's son, a fourth-generation Kishman. He's looking into the camera, or rather, looking at store customers who walk by, seemingly ready to tackle that steak and, perhaps one day, carry on the business his great-grandfather started nearly seventy years ago.

The oldest family-run grocery store in Stark County, Belloni's, occupies an inconspicuous yet handsome brick building on Route 93 in Brewster.

The store has been in this location since the building was constructed by Marion Belloni in 1925; the business itself began in neighboring Tuscarawas County.

In 1908, Marion and Annunziata Belloni opened up their grocery store in Dover, Ohio, but in less than a year, they were influenced by talk of a "new" town springing up twenty miles to the northeast. Intrigued, in 1909 they picked up their belongings and moved their family and grocery business to Brewster, which was incorporated as a village in 1910.

Belloni Grocery Store started out in a small house. A single, enigmatic black-and-white photo of the original store shows a sign reading "Groceries—Shoes" painted over the front door, but family members are stymied as to where the location of that store would have been. The location of the second store is still evident today, which exists as a duplex on 2nd Street. The large, sprawling house was constructed in 1911. The family lived on the top floor, operated the grocery store at street level and rented out the other dozen or so rooms, largely to boarders who worked or traveled on the nearby railroad.

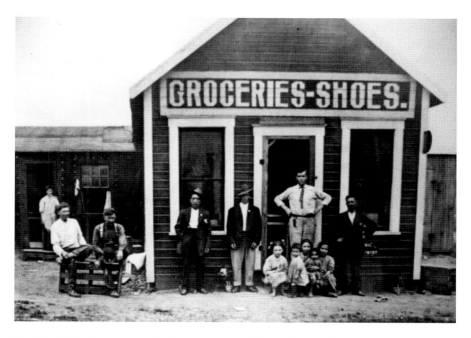

The first Belloni grocery store in Brewster, street address unknown. *Courtesy of the Belloni family.*

In 1925, a brand-new building was constructed specifically to house the grocery store, as well as to allow space for other retail entities such as a drugstore and barbershop. Marion Belloni, during construction, added the keystone "M. Belloni" at the top, which can still be viewed on the building today.

Marion had a theater built next to the store, and the family operated both businesses for many years before shutting the theater down and incorporating it into the grocery store. Undergoing several more expansions since, the store is now operated by Marion (Buzz) Belloni and his son, Chris. In a 2018 interview, the two talked about being the third- and fourth-generation family members to run the grocery store.

The Belloni family has a rich history in Brewster. Chris said, "My great-grandfather was instrumental in the formation of the town. He was on council, and helped to get it founded in 1910. His son, my grandfather Dominic, also contributed. He was very involved in the American Legion, and at one point he was commander of the Ohio American Legion."

A stone embellishment at the top of Belloni's grocery store in Brewster reads "M. Belloni," for the company's founder, Marion (Mike) Belloni. The building was constructed in 1925 at 258 Wabash Avenue South and is still operated from that location. Belloni's was founded in 1908. *Authors' collection.*

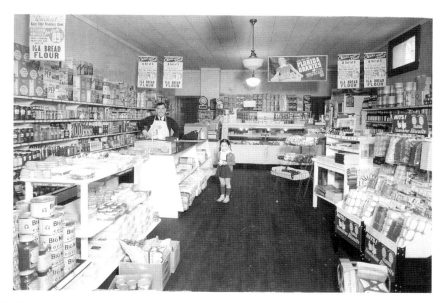

Early photo of Belloni's grocery store at 258 Wabash Avenue South. *Courtesy of the Belloni family.*

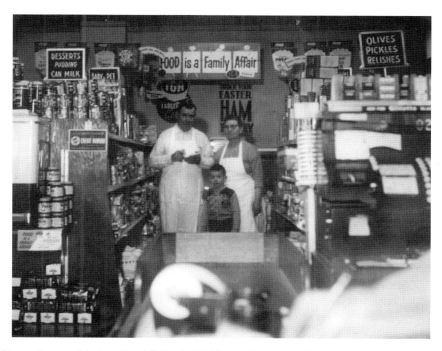

Photo of young Marion (Buzz) Belloni with his grandparents in Belloni's grocery store. *Courtesy of the Belloni family.*

Chris Belloni and his father, Marion (Buzz) Belloni. *Courtesy of the Belloni family.*

Chris said that the family has always been loyal to the community. "We've always called Brewster our home. My mother was a teacher at Brewster Elementary. My oldest daughter is a cashier at the grocery store, so that technically makes 5 generations working at the business."

Chris and Marion noted some "firsts" about the store: "We were one of the founding IGAs, one of the first ones to sign on as an IGA," and at one time they were billed as "the oldest continuously run IGA in the country," stated Marion. Chris and his father estimate that sometime in the 2000s they stopped being an IGA. "The name didn't mean as much to people any more. Then Fleming's [the distributor who purchased McLain's] closed, and a lot of the IGAs in the county closed at that time." Chris also noted that Belloni's was one of the first stores in the county to have bar code scanners. That was around 1979.

Marion added, "The one thing we are positioned well for is twofold: People like to come to a smaller store. They don't want to hassle with a big parking lot. Also, more people are shopping day-to-day. It used to be a situation where dad would get paid every 2 weeks, he would bring mom to the store, and she would buy 1–2 weeks' worth of groceries. Now people can purchase what they want on a whim."

"A big cultural change was that people used to eat all of their meals at home," said Marion. "Today, Belden Village has so many restaurants. It used to be, if you went out to eat it was a pretty big deal. Now people eat out quite a lot."

Chris recalled some of his early duties. "When I was little, I used to play in the boxes, play hide-and-seek," he said, pointing to the shelves in the warehouse. "In high school I was a cashier. I was also the price changer. Every week we'd get a list of items that needed changed, and run them through the register." Then Chris went away to college at Ohio State University. "I got a degree in computer engineering, then came back to

work at the store as a manager. I enjoyed what I was doing and didn't need to look further."

Marion recalled, "At age 16 I got to drive a station wagon and deliver groceries….Interestingly enough, we are back to delivering groceries to people." Chris added, "When great-grandpa started back in 1909, he would deliver groceries in a wheelbarrow." Marion nodded in affirmation.

As far as where their customers come from, Chris said that they pull from the Dundee area, from Mount Eaton, but "most of our customers are local. We're convenient for them and they like to support us. We also give back to the community." Marion added, "We are very lucky, what we get to do. We don't look at it as work. We get to spend time together as a family. A lot of people don't get to do that."

It has been a long time since Stark County residents were able to walk to a neighborhood corner grocery store, no matter where they lived. The automobile fueled the flight to the suburbs, and the national chains took over, leaving just a few family-owned grocery stores dotting the landscape. The transition to our modern way of grocery shopping provides us with fresh produce, regardless of the season. We expect to be able to buy fruits that were once considered exotic, like pineapples and bananas, year round. What isn't shipped from halfway around the globe can be grown in greenhouses in colder climates. Shoppers can choose from any cut of meat, a mind-boggling number of prepackaged foods and canned goods and fresh-baked breads and desserts. The nineteenth-century housewife would hardly believe the enormous variety that we often take for granted.

BAKERIES AND DAIRIES

While corner grocery stores provided the shopper with dry goods, canned items and sometimes fresh produce, specialty stores, like dairies and bakeries, provided fresh milk products and baked goods to round out the weekly shopping list. Some bakeries, such as Leibermann's, Johnnie's and MaryAnn Donuts, have stood the test of time and remain favorites today. But many of the small dairies, most of which were originally delivery routes, merged together and eventually disappeared altogether as the nature of the milk industry changed. Today, milk, butter and cheese are readily available at supermarkets and convenience stores, but three local dairies—Brewster Cheese, Biery Cheese and Minerva Dairy—continue to thrive. And while we can also purchase baked goods at the chain stores, there is nothing quite like a fresh donut or cupcake from one of Stark County's bakeries.

Leibermann's Bakery has been a fixture in Massillon since Johann George Liebermann moved from Cleveland in 1882 and opened his bakery at 27 East Lincoln Way. In 1916, the bakery moved to its present location at 49 1st Street Southeast. Until the 1930s, the bakery was also a seasonal ice cream parlor and confectionery. The Great Depression, combined with increased competition from dairies and ice cream companies, forced the company to focus only on the bakery portion of the business. In 1950, it dropped the wholesale business to concentrate exclusively on retail, although it still supplies baked goods to some of Massillon's downtown restaurants. With the fifth generation currently running the business, Leibermann's is one of

the oldest continuously operating, family-owned businesses in Stark County. There were once twenty-three bakeries in operation in Massillon, and by 1970, Liebermann's was one of only five.

The pastry chefs at Leibermann's use recipes that are at least as old as the business itself. In 2014, George Leibermann told the *Independent*, "We have a recipe book that you can't even read some of the recipes anymore. Most of them, we know by heart." Some of the bakery's most loyal customers have been buying their baked goods at Leibermann's since before the current owners were even born. Baking begins each day at 1:00 a.m., so customers can purchase the highest-quality, fresh-made baked goods around, including donuts, cupcakes, pastries, brownies, cookies, cakes and—during football season—their famous "Tiger Tails," black and orange striped cream sticks. If there are any baked goods left over at the end of the week, Leibermann's donates them to the soup kitchen at St. Joseph's Catholic Church in Massillon.

A contemporary of the original Leibermann's, A.J. Rickheimer's Bakery, was located at 38 West Main Street in Massillon. It was the "joy and delight of the town," said Stark County historian E.T. Heald. "Rickheimer learned the restaurant business working for DeKlyn's, caterers, at their marvelous restaurant in Cleveland. Rickheimer's made wonderful pastry shells and cakes and were great freezers of ice cream which they delivered in buckets. They branched out with an east side store in the old Coleman block, succeeding Thompson's."

In 1916, an advertisement for the Pastry Shop alluded to the fact that the pace of life was already changing in the early twentieth century. "There is always more or less bother connected with baking," Gary Brown quoted from the original 1916 ad in the April 13, 2016 issue of *The Repository*. "And after—the cleaning up. Usually, too, for just one cake or pie. The time it takes, and the material that's used, if the cost is considered, brings the price of your baking very high. To bake a single cake or pie, when you want it, costs more than you are justified in spending. And to make a larger supply is wasteful, as well, because baked goods quickly grow stale and no one cares for stale foods." The rather lengthy advertising copy was typical of the era and made a case for purchasing your baked goods from the shop instead of making them yourself. The ad goes on to list products such as pies, French pastries, cakes, whipped cream goods, cookies, rolls and breads, which are "always fresh." Homemakers were encouraged to order special baked goods for dinner parties rather than slaving away in the kitchen themselves. Home delivery was available, and the bakery promised that orders placed by 9:00 a.m. would be delivered by noon.

Left: The Kaase Company opened a pastry and candy shop at the Hotel Onesto in 1930.

Below: Named for Peter and Mary Edna Welden's first child, MaryAnn Donuts opened its first location in 1947 on McKinley Avenue. Today, there are five stores located throughout Stark County.

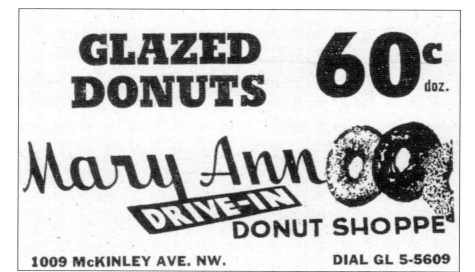

The Kaase Company, which opened a new pastry and candy shoppe at the Hotel Onesto in 1930, had been in Canton since the early 1920s. "The Kaase Co., baker of cakes and pastries, buys only the finest ingredients that can be purchased," noted an article in the February 1, 1933 issue of *The Repository*. "The firm never buys bargains unless they are of the best first quality. Approximately 25 tons of butter and 75,000 dozens of eggs are used each year. Kaase bakers are master bakers, many of them having been with the company since its organization." Kaase specialized in cakes for birthdays, weddings, parties, Valentine's Day and even Washington's birthday. Other baked goods included Christmas cookies, pies, cheesecake, plum pudding and coffeecake.

In Stark County, the name "MaryAnn" has become synonymous with the word *donut*. In 1947, Peter and Mary Edna Welden started a donut shop at 1009 McKinley Avenue Northwest in downtown Canton. They named the business after their oldest daughter. MaryAnn Donuts started from that small shop and now delivers fresh products "all over Ohio, Michigan, and Pennsylvania every day," according to company history.

Freshly made donuts on a conveyor belt at MaryAnn Donuts' production facility, 5032 Yukon Street. *Authors' collection.*

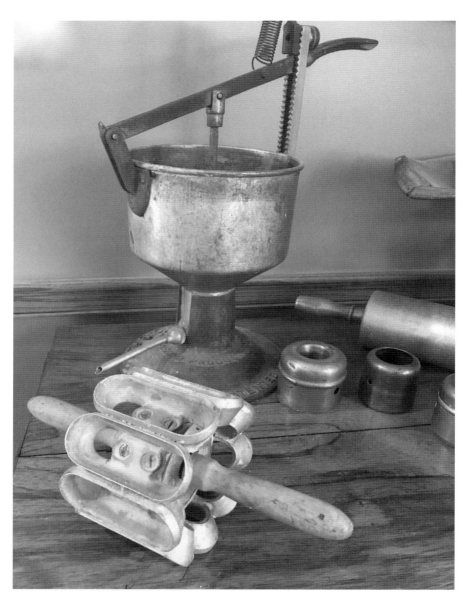

Early donut making equipment. *Courtesy of MaryAnn Donuts.*

When Peter retired in 1983, his children, Pat and Dorothy, took over, and major expansions occurred. In 1984, a second MaryAnn Donuts opened on West Tuscarawas Street. This location would end up serving as the production hub for all stores. A third store opened on Hills and Dales

Road in Canton in 1990. They continued to expand retail shops around the county, with the most recent addition in 2012.

The third generation is now at the helm: Patrick Welden II, Amanda Welden, and Danielle (Welden) Brickwood. In a 2018 interview, Danielle talked about being a kid growing up in a household where her parents owned a donut shop. "It sounds like every kid's dream," she stated, "but those donuts don't just hop in the fryer by themselves. We officially started working the Hall of Fame Day Parade when we were 10 years old."

MaryAnn's makes an average of thirty thousand donuts per day, including eight thousand cream sticks alone. Donut-making shifts start around 1:00 a.m. The production facility runs 365 days per year, and the shop goes through five hundred pounds of cream per day. There are four hundred wholesale accounts, in addition to the retail stores, which keeps everyone on staff busy. As a family-based business built upon delicious treats, the Welden family looks forward to serving Stark County for years to come.

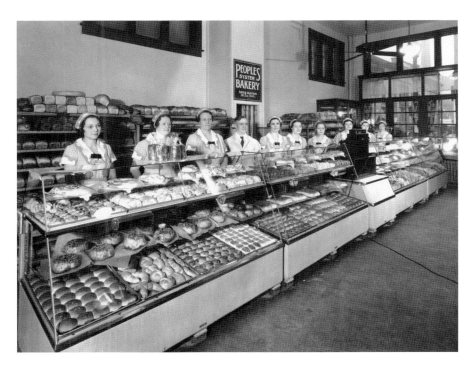

The People's Bakery was located inside the Arcade Market, which was built by T.K. Harris in 1915 at 323 North Market Avenue. The Bakery was originally located at 134 Fourth Street Northwest. Advertising at the Arcade first appears in *The Repository* in 1932.

Located at 109 Wertz Avenue Northwest, Johnnie's Pastries has been family-owned and operated since Billy D. and Georgianna C. Berkshire opened it in 1946. According to an article in the January 4, 2011 issue of *The Repository*, Johnnie's "uses at least 1,500 pounds of flour every week. An average of 165 dozen glazed crullers and creamsticks—bakery specialties—are sold every week along with 700 pounds of cake." There is also a Johnnie's Bakery at 6652 Wise Avenue Northwest in Plain Township.

Stark County has been home to several dairies over the years, but in the early days, every farm in Stark County produced its own butter. According to Robert Leslie Jones, author of *History of Agriculture in Ohio to 1880*, butter was "one of the few products of the farm that would at all times be taken by the country storekeepers in trade. By the 1840s, butter had become the chief medium of barter between the farmers' wives and the traveling hucksters. Such men went through the settled areas with a load of groceries, dry goods, and odds and ends, and took butter in exchange, usually allowing a cent or so more a pound than did the storekeepers." In 1849, Ohio produced 34,449,379 pounds of butter. Jones also described how butter was made in those early days:

> The "Pennsylvania farmers," specifically those in Stark County, proceeded in this manner as quoted in the Patent Office Report in 1852: Our best butter-makers have what we call a "spring-house"—a small building of stone or brick, with large shallow troughs, through which run streams of spring-water. After milking and straining, the pans or crocks of new milk are placed in these water-troughs, and the cream soon rises to the top. The barrel churn is the kind in general use here. To preserve butter in warm weather for a week, it must be worked over until the milk is all expelled; to

preserve it for winter use, it may be packed in stone jars, containing about 20 pounds each, with 1 pound pulverized rock salt, ½ pound loaf sugar, and ½ ounce saltpeter. The crock or jar should then be covered, first with a clean white cloth, and then with drilling or heavy muslin, dipped into a preparation of melted tallow and beeswax, and bound round tight with wire, to exclude the air, and then deposited in the spring-house for winter use.

Although butter and milk were easier to keep at home in early iceboxes at the turn of the twentieth century, ice cream remained a rare treat for most people since it was difficult to keep ice cream at home before electricity reached everyone. One of the earliest local ice cream manufacturers was Noaker Ice Cream Company. In 1905, Lloyd Noaker purchased the ice cream branch of the Walter Andrews Baking Company and moved operations to his basement, where he made 50 gallons of hand-churned ice cream per day. He called his product Velvet Ice Cream, which would become a locally famous high-quality frozen delight. His business grew rapidly, partially

Lloyd Noaker purchased an ice cream business in 1905 and began hand-churning ice cream in his basement. By 1921, the Noaker Ice Cream Company had three ice cream hardening rooms.

because Canton was "setting the pace nationally in ice cream freezing equipment and ice making machinery," according to Stark County historian E.T. Heald, and this allowed Noaker to begin using the latest technology as soon as it was available. In 1909, *The Repository* highlighted Noaker's automobile delivery wagon, noting that it was the first of its kind in the city. By the 1910s, the company's new factory could produce 125 gallons an hour for a total of 3,000 gallons a day. Its slogan was, "It's not quite as cheap as some, but just a little bit better."

When Noaker sold his business to the Borden Company in 1929, it had the capacity to produce 350,000 gallons of ice cream annually, with distribution plants in Canton, Alliance, New Philadelphia and Ravenna. It was one of the largest ice cream manufacturers in the state of Ohio. Noaker received a check from Borden at three o'clock in the afternoon on February 19. That night, at 11:00 p.m., he suffered a fatal heart attack. He was just fifty-two years old and had no known health problems.

Stark County was also home to "Cheese King" John A. Martig, a Swiss immigrant who established a veritable cheese empire in a classic "rags to riches" story. Martig came to America in 1893, alone, at the age of sixteen. As an apprentice in Switzerland, he had learned the cheese making trade, which helped him secure a position at the Moser cheese factory in Greentown in 1894. The following spring, he went to work for the L.H. Oviet cheese factory in Hudson, Ohio, which was cooperatively owned by area farmers. Impressed with his business abilities, the farmers made him the manager of the company in 1896. In 1897, he had saved enough money to start his own cheese making business.

At the time, most of the cattle farmers in Stark and surrounding counties were raising beef cattle. Martig convinced many farmers to start raising dairy cattle, providing them with a market for their milk in his cheese making enterprise. His business grew each year, adding two or three cheese factories, until he owned, operated or controlled a total of eighty factories by the age of thirty-five. By 1905, he was well-known as the leading cheesemaker in the entire state of Ohio when he married Mary Matti and made Louisville the headquarters of his business.

Martig paid the dairy farmers to haul the finished product by horse and buggy to the nearest railroad station for shipment. With better roads in place and the invention of automobiles and trucks, the dairy industry began to change by 1920. The modern dairy business was now supplying milk to the exploding city population, which drove the cost of milk up. Cheesemakers like Martig had to raise the price of cheese, even though

In 1911, Noaker took out a full page ad in *The Repository*, advertising that its ice cream was "made in the most scientifically and perfectly equipped plant in the United States" and emphasizing that no human hands ever touched Velvet Ice Cream. Employees even had dressing rooms where they changed from their street clothes into crisp, white suits to create a clean and sanitary environment on the factory floor.

demand was not growing. As a result, he had to close many of his factories. In 1928, there were only fifteen left. Martig had already made millions of dollars by this point. He sold the remaining factories and turned his attention, and fortune, to other business interests, such as Central Steel in Massillon and the Sanitary Milk Company. In 1924, he had been part of a group that organized the Canton Pure Milk Company, and later he became the principal stockholder and president. By the 1950s, the Canton Pure Milk Company was the largest milk processor in Canton.

Although Martig's cheese empire has come and gone, there are still dairies in Stark County—such as Brewster Cheese, Biery Cheese Company and Minerva Dairy—that are distributing dairy products across the country and around the world. Brewster Cheese, located in southwestern Stark County, is the largest manufacturer of swiss cheese in the United States. That's saying a lot for a small village whose population tops just

over two thousand people. The company takes up space on both sides of Route 93, the main road through town and the artery by which fresh milk continuously flows in from nearly four hundred dairy farms throughout Northeast Ohio. In addition to production facilities, the fifty-acre campus also houses the company's corporate offices, distribution plant and cheese cutting facility. Beyond the campus of pavement, brick and steel lies a bucolic setting of rolling hills and tranquil, fertile countryside. These hills reminded early Swiss immigrants of their hometowns, and these hills are what brought the company's founder to Stark County.

John Leeman emigrated from Zurich, Switzerland, in 1929 and became manager of the Stark County Milk Producers Brewster plant in 1933. In 1965, the plant was put up for sale. John and his son, Fritz, purchased the business. It was then incorporated as Brewster Cheese. Today, Fritz is CEO of the company.

Brewster Cheese started small. In the first few decades of operation, the company focused on the production of a variety of cheeses for a regional base of local customers. Throughout the 1970s and 1980s, as convenience foods became popular, Brewster supplied cheeses to well-known deli brands. In the 1990s, the company shifted focus in a major way. It cut back on the varieties of cheese produced and focused solely on swiss. Around the same time, the company purchased a second production plant, in Stockton, Illinois, doubling Brewster's capacity and making it the largest producer of all natural swiss cheese in America. Brewster Cheese produces 90 million pounds of swiss cheese annually. To emphasize what a large quantity that is, company marketing states, "If you're eating Swiss cheese anywhere in America, there's a 35 percent chance it was made in Brewster." With that output and reach, products from Brewster Cheese end up on the ingredient list of well-recognized, top national brands.

One of Brewster's major innovations occurred with the development of whey, a byproduct of cheese making. At one time, whey was considered by the dairy industry to be of low value and simply something to be discarded. Today, thanks in part to innovations put in place by Brewster, whey products are used in a variety of commonly known items, such as infant formula, ice cream, adult nutritional beverages and even chocolate.

Brewster Dairy employed 180 full-time employees at its Stark County location in 2017. The company values its employees and shows appreciation by scheduling various social activities and outings throughout the year. The company also supports the community and Stark County through

Right: Hans (John) and Marti Leeman. John Leeman founded Brewster Cheese in 1965. *Courtesy of Brewster Cheese.*

Below: John Leeman's son, Fritz, with a plug of cheese. Fritz Leeman is CEO of Brewster Cheese today. *Courtesy of Brewster Cheese.*

Grading two-hundred-pound swiss cheese wheels. *Left to right*: a professor from Ohio State University (name unknown), Calvin Stockley and Harold Biery. *Courtesy of the Biery family.*

donations and sponsorships. Brewster executive team employees regularly take part in shaping our community by actively participating on various boards and committees.

Like the Leemans of Brewster Cheese, the Biery family's history can also be traced back to Switzerland. Ben Biery emphasizes that ancestry is an important part of company history. In a 2018 interview while sitting in the conference room at Biery Cheese headquarters in Louisville, a bright red-and-white Swiss flag hung on the wall above Ben's head, seeming to echo that point. While Ben described the family's ancestral home in Zweisimmen in the Canton of Bern, Switzerland, from memory, he didn't have to be very descriptive about their settlement in the United States. He turned around and pointed out the window: "That's my great-grandfather's original barn."

Many families of Swiss descent brought their family's cheese making skills to the United States, although for the Bierys, cheese wasn't the first product. In 1929, as the Depression began, the Norman Biery Farm didn't want to waste extra milk. They used it to make swiss cheese, and Biery Cheese was incorporated that same year. The family focused on cheese but later set aside nine acres for apple trees in the mid-1930s. A decade

Laura Biery disc plowing the fields. *Courtesy of the Biery family.*

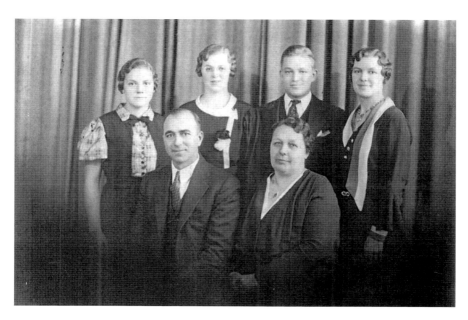

Biery family photo. *Front row, left to right*: Norman Biery and Laura Biery. *Back row, left to right*: Fern Biery (Oyster), Chloe Biery (Von Wyl), Harold Biery and Edna Biery (Conrad). *Courtesy of the Biery family.*

later, the orchard had increased to fifteen acres, and the company's title was both Biery Apple Orchard and Biery Cheese. By 1949, the company moved in a different direction altogether. Biery stopped making cheese and stopped growing apples. The company found itself better suited as a selling and distribution arm of the cheese industry. Initially, the company worked with producers in Amish country, who had excellent products but couldn't move them efficiently. Over the next several decades, Biery continued to diversify and explore various packaging and shipping options. The timing was perfect. Postwar America was all about convenience, with new food trends such as TV dinners and women wanting to save time in the kitchen.

Into the 1960s and 1970s, grocery stores reacted to these trends by moving cheese into its own section of the store, away from the meat department, where it had been sold during Ben's great-grandfather's and grandfather's times. Back then, the grocer would cut blocks of cheese for the customer, wrap it in paper and hand it over without further ado. Simple, but the cheese wouldn't stay fresh very long. Innovations in packaging evolved and enabled companies, including Biery, to prepackage foods and sell it in convenient sizes. Ben talks about how workers at Biery originally hand-sliced the cheeses, much as you would today if you want a few slices of cheddar for a sandwich. In 1968, all that slicing by hand moved pretty slowly, but demand didn't let up, so Biery explored automation. Over time, the company could produce five hundred slices of cheese per minute. Today, in sixty seconds, four thousand slices are ready to be packaged. "We do blocks [of cheese], diced, shreds, snacks, party packs," said Ben. "Convenience, snacking, and portion control. A lot of what we produce today is based around those consumer demands." As trends change, Biery is able to establish new product lines quickly.

Private label products take up much of the company's business. As retailers began to show growth, demand for products led to the expansion of Biery's Louisville location. In 2013, Biery acquired Kickapoo Valley Cheese in Sherry, Wisconsin. The facility was landlocked and not in a suitable position for growth development. An empty property at the former Basic American Food Company thirty miles away became available. After renovating the facility, they moved the Sherry operation to Plover in 2015. These acquisitions led to significant growth and the addition of employees. When Ben took over the company, there were 80 employees. In 2017, the company employed 525 in Ohio and 140 in Wisconsin.

One of the biggest innovations in the company's ninety-year history was the development of branded items. Placing the Biery label on products came from the realization that one of the company's assets was coming up with new ideas, like bacon-stuffed cheese or the addition of hot pepper to a number of cheese products. Biery converts large blocks of cheese into what the retail market demands, "assembling varieties together to create a portfolio of flavor profiles." Most of Biery's cheese comes from Wisconsin, which is the largest producer of specialty cheeses in the United States. Biery Cheese is sent to forty-nine states and twenty-three countries. "A lot of our customers have been with us 40–60 years," Ben said.

Ben grew up next door to the plant. The house is still there. He recalled coming over to the plant when he had to sell magazines for sports or school. He was consistently the top seller—who could say no to the boss's son? By age twelve, he was running some of the lifts in the shop. He went away for college, played baseball and came back full time in 2001. Ben's father, Dennis, retired in 2010. "You have to earn the trust of every consumer that touches your product, gain confidence from consumers," noted Ben. "We're guardians of this business. We're just another chapter in the story. Our employees have worked hard to build the business where it is today. My goal is to continue the success."

Although the dairies that still exist today produce products such as cheese and butter, many of the dairy businesses in Stark County's past

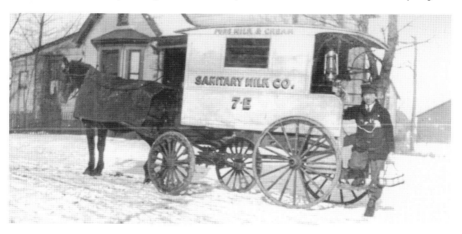

An ad in the September 21, 1924 issue of *The Repository* explained the processes of the Sanitary Milk Company: "The Sanitary organization is complete from the farm to your doorstep....The Sanitary delivery system is extraordinarily efficient. Every morning before you get out of bed the large crew of Sanitary Milk Men have called all over the city and left the milk at your doors."

have focused on the production and delivery of milk itself. In the early twentieth century, there were many small-scale dairies delivering milk to porches in all corners of the county. The 1945–46 Annual Report of the Dairy Council of Stark County lists the following dairies as members: Acme Dairy Prods. Company, Barr Dairy, Bircher's Farm Dairy, Canton Pure Milk Company, City Dairy, Denny's Purity Dairy, Eckert's Dairy, Firestone Farm Dairy, Grand View Dairy Company, Hol-Guerns Dairy Inc., Lesh-Himes Milk Company, Lippincott's Dairy, North Canton Dairies Inc., Oberlin Dairy, Sanitary Milk Company, Sterling Dairy Company, Sunnyside Dairy, Superior Dairy Inc., Supreme Dairy and J. Howard Taylor Dairy. In 1950, E.L. Cavitt, manager of a milk bottle supply company, reported that his company had lost more than 1 million glass bottles the previous year, through breakage and customer hoarding. Cavitt acknowledged that most of the lost bottles were broken but pointed out that thousands per month were attributed to customers who kept them for one reason or another. A milk bottle typically lasted for twenty-five to thirty-five trips from dairy to doorstep by milkmen, or roughly three years if the cleaning and refilling process between uses took about 1 month. Although there were laws in place about the proper use of milk bottles, they were not generally enforced. On January 31, 1950, the Canton Pure Milk Company announced that it would switch from glass milk bottles to disposable cardboard cartons, eliminating the headache of trying to get customers to return their bottles.

In 1922, Joseph Soehnlen purchased the L.K. Miller Dairy, essentially just a milk delivery route, which would eventually become Superior Dairy. The company included one horse-drawn wagon, a vat, a two-hundred-gallon pasteurizer and a supply of bottles. During the Depression, Soehnlen continued delivering milk to families who could not pay him, a generous gesture that was never forgotten. Through the acquisition of other local dairies, including Canton Pure Milk Company and Hol-Guerns Dairy Inc., Superior began to grow. According to an article that appeared in *The Repository* in 1989, Superior was the first in the region to bottle chocolate milk, and in 1929, it was a pioneer in adding vitamin D to milk. The same article reported that by 1989, the company produced nearly five hundred different products, including milk, ice cream, sherbet, cottage cheese, sour cream, snack dip and fruit juice.

Although the company's primary market has always been Ohio, by 1997 it boasted customers in Southern Michigan, Western Pennsylvania and parts of New York, West Virginia and New Jersey, adding up to

more than one thousand grocery stores, convenience stores, food service companies and ice cream shops. More than half of all sales was milk, which Superior could bottle at the rate of eighty-five gallons per minute. The company also has a history as an innovator in product packaging, becoming one of the first to use plastic ice cream containers and one-gallon milk containers, as well as improving the paper milk container to reduce tearing when the customer opened it. In 2000, Superior introduced a three-liter milk jug that was lighter and shaped more like a pitcher. The same year, it started selling ice cream in the shape of nine-inch-square cake pans, to make the ice cream easier to scoop.

In 1939, James "J.J." Lawson opened Mr. Lawson's Milk Store in Cuyahoga Falls, Ohio, which became famous for its "fresh and delicious milk." At the time, most people were getting their milk by delivery. J.J.'s grandson, Jim Lawson, told the *Akron Beacon-Journal* that his grandfather was trying to compete with larger corporations in the 1930s. One day, he saw an Amish woman take a pitcher to a farmer, who filled it for her, and the idea of selling milk from a store rather than a delivery route was born. The Lawson Milk Company would eventually become a chain of nearly two hundred stores across Ohio. The Lawson's sign, a white milk bottle against a turquoise background, was a familiar sight. Longtime Stark County residents will recall the store's famous Chip Dip, as well as the catchy jingle "Roll On, Big O," about getting fresh-squeezed Florida orange juice to Ohio within forty hours.

Lawson sold his business to Consolidated Foods in 1958. Through an agreement with Daiei Inc., the first store in Japan opened in 1975. The company was sold to Dairy Mart in 1984, and the U.S. stores changed names. After a 2002 bankruptcy, the chain was sold again and renamed Circle K. Today, Lawson's Original Chip Dip is still available at Circle K. The chain has flourished in Japan under the name Lawson's Station, with more than ten thousand locations. In 2012, Lawson's returned to the United States, with more than twenty stores opening in Honolulu, Hawaii.

Throughout the twentieth century, communities across America saw a dramatic shift from home-delivered milk to a well-stocked dairy aisle in the supermarket. With universal electricity today, anyone can keep ice cream in their home, making it a household staple for many instead of the rare treat it used to be. Although most of the dairies have long since disappeared, the legacies of Brewster Cheese, Biery Cheese and Minerva Dairy (Minerva Dairy is highlighted in the "Legacy Families" chapter) continue. And even though most grocery stores today have a bakery department, small family-

owned bakeries like Johnnie's, Liebermann's and MaryAnn's continue to thrive, providing an important connection to the housewives of previous generations, who picked up fresh-baked goods and had milk delivered to their front porches.

WHOLESALE FOOD COMPANIES

Although wholesale grocers in Stark County did not sell products to consumers directly, they were an intricate part of the food chain that stocked the retail stores where customers shopped to feed their families. Some, such as the C.L. McLain Grocery Company in Massillon and B. Dannemiller & Sons in Canton, carried a wide range of products that they warehoused and distributed to retailers. Others, like Sugardale in Canton and Nickles Bakery in Navarre, specialized in a specific type of product. Well-known brands today—such as Shearer's potato chips, Dick's horseradish and Mid's spaghetti sauce—are also produced here. Over the years, all of these wholesale companies have contributed to the selection of products that were available in neighborhood corner grocery stores and, later, the regional and national chains.

There was a wholesale grocery business in Massillon as early as 1830. The company changed hands several times over the years, eventually becoming the C.L. McLain Grocery Company in 1919. According to a company history written in January 1940, the wholesale business was founded in response to the opening of the Ohio & Erie Canal. Massillon soon became the largest wheat shipping point in the United States for about twenty-five years, until the railroads came to Stark County.

When C.L. McLain, G.L. Albrecht and W.H. Kreiter purchased the business in 1884 for $18,000, it was located at 42 South Erie Street. It was "an ordinary room of twenty-one feet frontage and two and one-half stories high, with a basement." There was one hand-powered freight elevator,

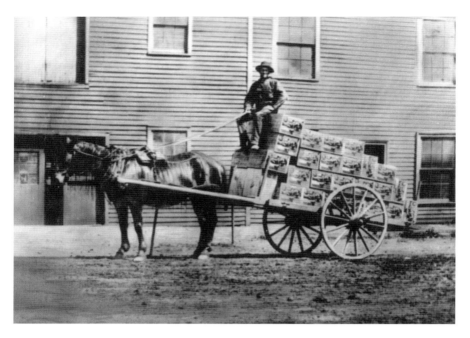

The McLain Grocery Company was the leading wholesale grocer in Massillon beginning in 1884. After a series of sales and mergers, the company closed for good in 2003.

which was operated by a rope and pulley system that moved a few inches per minute. McLain served as the head of the office and bookkeeper; Albrecht as the buyer, city salesman and sales manager; and Kreiter as the county salesman. In addition to the owners, there was one billing and shipping clerk, two other salesmen, four warehouse men and one drayman, making for a total staff of eleven people. In 1887, the company moved to a larger building on South Erie Street. At that time, "All clerical work of every description was done with pen and ink or pencil by hand," according to the company history. "Every salesman wrote out his own price book by hand and made his own price changes every week in the same manner." Most of the Massillon customers used a "pass book" to make purchases, which were recorded and entered into a large ledger in the office.

McLain sold products such as barrels of molasses and coal oil for lamps, jelly in fifteen-pound wooden pails and prunes, mostly from Turkey, which were purchased in casks that weighed one thousand pounds each. Canned oysters were purchased by the carload, as they were a popular food item in the late nineteenth century. The company built a new building in 1894.

Sales steadily increased after the turn of the century, with annual sales of $500,000 in 1904, $750,000 in 1911 and $1 million in 1916. They purchased the company's first "auto truck" in 1912. The first typewriter had appeared in the office a few years earlier. By 1940, the company had a fleet of fifteen trucks and eighty employees. An article in the *Massillon Independent* on June 19, 1956, reported on an expansion of the company, which made it "the most modern food warehouse in this area." McLain supplied about 150 IGA (Independent Grocer Alliance) grocery stores within a sixty-mile radius of Massillon. The new space included accommodations for frozen foods, dairy perishables, dry goods, shipping and receiving and a truck repair shop. According to the article, "Merchandise, after arriving, is handled by the latest in material handling equipment. Electric pallet jacks remove the incoming freight from trucks and freight cars after it has been stacked on wooden pallets. The warehouse Superintendent and his staff must have the facility of juggling 100 problems in their minds at once. Non-perishable item loading and delivery must be coordinated with that of the perishable items. A constant flow of information about this movement must be moved in and out of the IBM room." Employees handled 50,000 cases of food every week, or 2.2 million every year.

In 1966, McLain was purchased by Universal Food Service, a company started in 1946 by Jack Clasper of Massillon that serviced about 500 restaurants and schools in Northeast Ohio. In 1981, the company was again sold to Fleming Companies. At the time, Fleming was the largest wholesale food distributor in the United States, providing groceries to more than 4,800 stores in thirty-six states. McLain became known as Fleming's Massillon Division, serving 140 supermarkets and 60 convenience stores in Ohio, Western Pennsylvania and northern West Virginia. In 2003, Fleming filed for bankruptcy and sold its business to four different companies in bankruptcy court. Supervalu purchased Midwest operations but was only interested in the customer supply agreements. Essentially, it "bought the customer base." Since Supervalu already had distribution plants in the region, it did not need to keep the Massillon facility open. An estimated nine hundred local employees lost their jobs.

Benedict Dannemiller, a German immigrant and blacksmith by trade, opened Canton's premier wholesale grocery business in 1853, which grew to become the largest in Ohio. At sixteen years old, Dannemiller wanted to come to America, but his father said he was too young and worried that the stories young Benedict had heard about the promise of America were only exaggerations. Former neighbors had settled in Canton and wrote to

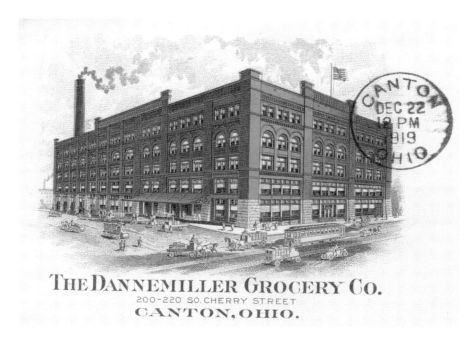

The Dannemiller Grocery Company opened in Canton in 1853 and would become the largest wholesale grocery company in Ohio.

the Dannemillers, saying that "advantages awaited any young man with an ambition to succeed in life." In September 1830, at the age of seventeen, Dannemiller sailed to America with his uncle, Philip Betchel, who opened a blacksmith shop at the corner of Walnut Avenue and 5th Street Southeast. Young Benedict trained under his uncle for five years before starting a shop of his own in July 1834. In 1859, he closed his blacksmith operation and purchased a lot south of the Canton city limits, where he started a warehouse and began buying and selling grain. Ten years later, he purchased the wholesale grocery business of Thomas Kimball and Bros. on South Market Avenue near Public Square. He rechristened it B. Dannemiller and Sons and began selling coffee as a specialty. Advertising trade cards—featuring rosy-cheeked children, adorable dogs and cats, tranquil birds and even paper dolls—boasted about the quality of Dannemiller's Cordova brand coffee.

Downtown Canton became known for the aroma of roasting coffee that wafted from the Dannemiller building. In addition to its well-known coffee blends, it also sold peanuts, packed spices, teas, canned goods and tobacco. The company outgrew its space several times over the years before moving

into a multistory building at Cherry Avenue and 2nd Street Southeast, eventually serving the retail grocery business in eastern Ohio, West Virginia and Western Pennsylvania. It became the Dannemiller Grocery Company in 1902 and merged with the Canton Grocery Company in 1925. It was sold to Consolidated Goods Corporation in 1943 and continued as the Dannemiller Division until it closed in 1960. Nearly fifty years later, downtown would again be filled with the aroma of roasted coffee when Alex Haas opened Muggswigz Coffee and Tea Company in 2003. He filled a business niche that Stark County had never seen before: a shop that served coffee from beans roasted on-site.

While brewing coffee as soon after roasting as possible produces superior tasting coffee, roasting takes skill and financial investment, and that's why most coffee retailers leave it up to independent experts. Coffee roasting plants invest heavily in expensive equipment and skilled workers who concentrate solely on roasting beans according to retailer preferences. There are many great regional roasting plants that distribute quality beans to shops, restaurants or grocery stores.

Alex didn't start out to forge new paths, and he didn't consider himself a connoisseur of coffee. In fact, it was a nudge from a friend in his junior year of college that spurred the path he would follow. Alex attended the University of Rochester and University of St. Andrews. He earned a degree in molecular genetics, but he kept thinking about something else. "While in college a friend mentioned to me the idea of opening up a coffee shop. The concept grew on me," he said in a 2018 interview.

Muggswigz Coffee Shop, at 137 Walnut Avenue Northeast, opened in 2003. Muggswigz was the first dedicated coffee shop in Stark County to serve coffee roasted on-site. *Authors' collection.*

Alex Haas, owner of Muggswigz Coffee, judges coffee at a coffee producer competition in Antioquia, Colombia. *Courtesy of Alex Haas.*

The goal was simple: Alex wanted to open up a shop that sold really good fresh coffee, espresso and tea. "When I opened up the business, I didn't have the money for a big roaster. Heck, I didn't even have money for an ice machine. We were literally pouring water into small trays. It was a real pain." The ice machine came first, and it would take a few years of using a small roaster before Alex was able to invest in a Diedrich Roaster that turned out to be "a perfect size roaster for us. We are able to control the roast profile and get good depth and clarity." As far as the name of the business, Alex said Muggswigz infers "a sip from a mug."

Once the large roaster was put in place, Alex continued to pursue high standards of quality by learning as much as he could. "There's so much science behind roasting and brewing good coffee," he said. "It's both a science and a craft. You can't just buy a roaster and roast coffee well. It's not as simple as heating a bean and watching the color go from green to brown."

Alex has visited coffee farms and tea plantations in various parts of the world but most often works with an importing company, which narrows down

the selection process. Alex knows that what he does can make a difference beyond the bottom line. "We're able to impact what farms are doing. We're buying green coffee. We're in the industry talking to producers. We can use our knowledge of coffee and what the consumer *and* the market want, then be able to provide useful feedback and suggestions for producers" that benefit both. "Additionally," Alex stated, "we are performing real industry research and innovation to not just create the best coffee and tea for ourselves, but we publish a lot of it so the whole industry can benefit." Good roasting only goes so far, and then the brewing process comes into play. "Baristas are unique. They are very skilled. They craft specialty coffee drinks. It takes a lot of training to get new employees ready for their job."

The climate in 2003, when Alex started his business, wasn't exactly a culture of foodies or beverage experts. Alex said that early customers weren't very knowledgeable about specialty coffee, but "they were curious. They wanted to learn more about what makes the coffee and tea different." The atmosphere and concept of a coffee shop was also unique. Alex said, "There wasn't another coffee shop when I came downtown. We saw a lot spring up since then."

Today, there are numerous coffee shops in Stark County, such as Tremont Coffee in Massillon, owned by Mark and Michelle Kemp, and Carpe Diem Coffee Shop in downtown Canton, owned by Patrick and Cathy Wyatt. The Wyatts get their beans from Caruso's Coffee Roasters in Brecksville. Caruso's beans are custom roasted to order, packaged the same day and shipped within twenty-four hours after roasting.

Alex said that business has seen steady progress, and he's happy with that. Muggswigz has received numerous awards since opening, but the ones Alex is especially proud of include taking third place in "America's Best Coffee House" competition and also being listed as one of the top ten coffee houses featured in *USA Today*.

Alex made allusions during conversation that his business is a "third wave" coffee shop, a reference that has to do with the specialty coffee movement after the popularization of espresso beverages by Starbucks. It's a movement that appreciates coffee as an artisan or craft beverage. Coffee, from origin of harvest through to the roasting and brewing processes, is viewed in the same way as the creation of craft beer or fine wine.

First-wave coffee is characterized by affordability and mass production capabilities. In the United States, coffee became popular during the Civil War era. In fact, as a commissary sergeant during the war, William McKinley disobeyed orders and took supplies, including coffee, to the troops fighting

on the front of the Battle of Antietam. Later, his political opponent would call him "Coffee Bill" to make light of his service. Around that time, out west, brothers John and Charles Arbuckle began selling pre-roasted coffee to gold miners in California. Folgers, Maxwell House and Hills Brothers coffee became household names. Quality was sacrificed to get coffee in the hands of the masses, but innovations in processing and packaging would carry the industry into the future. Instant coffee and Mr. Coffee automatic drip coffee makers are also associated with first-wave coffee.

Second-wave coffee is known for the movement to better understand roasting styles of what would be known as "specialty coffee." In this movement, coffee drinking advances from simply "drinking a beverage" to becoming an "enjoyable experience." Words like *espresso*, *latte* and *French press* are introduced into popular vocabulary with this movement. The coffee business most often associated with the second wave is Starbucks.

Third-wave coffee is relatively new. It is focused on purchasing fresh, origin-specific coffee, developing the craft of roasting, providing truly fresh-roasted coffee and celebrating the skills of the professional barista. The product takes center stage. The majority of roasters and coffee shops associated with the third wave are small, independently owned businesses that roast beans in-house. They are entrepreneurs who make an impact on their local communities and in the coffee industry.

When asked what he thinks about Starbucks, Alex said he is grateful. "Starbucks is great for popularization. It gets people educated on espresso and specialty coffee. It's an entryway into the third-wave coffee movement." Alex added that "Starbucks opened the door for learning and the education of specialty coffee drinks. They also opened the door for customization."

Alex noted that the coffee industry is still evolving and has a lot of room to grow. "I think the industry is still maturing. There are now a bunch of third-wave coffee places, and they are evolving into something else. Fun, welcoming atmospheres are now consistent." Muggswigz stands by its products, which also include house-made syrups and baked goods. It offers discounts on coffee that is more than ten days out of the roaster.

While many of the products sold in the early wholesale grocery business were shelf-stable, some were not. Meat refrigeration arrived in Canton in 1888 when Armour & Company of Chicago opened a plant at 91 3rd Street Northeast. Before that, the retail meat markets bargained with local farmers for livestock, which they slaughtered and prepared for market themselves. "Refrigeration and sanitary cleanliness was unknown," said E.T. Heald in *The Stark County Story*. "Meat wagons stopped at the homes

with meat exposed to the heat and swarming flies." After Armour came to town, two other companies—the Cleveland Provision Company and Swift & Company—soon arrived. The local independent provision industry grew slowly, eventually eclipsing the outside meatpackers.

The Canton Provision Company was organized in 1901. After an unprofitable first year in business, the company was sold to "experienced cattle and meat men," according to Heald. Abraham Buckwalter owned a retail meat market on East Tuscarawas Street near Walnut Avenue. George Wade was in the cattle and livestock business near Richville. His sons, Curtis and Frank, grew up on the farm, slaughtering livestock and selling the meat from their shop in Massillon. The new reorganized Canton Provision Company sold beef, pork, veal, bologna and wieners. About twenty employees processed fifty cattle and two hundred hogs weekly. At first, the company delivered only to meat markets in Canton, but it soon expanded throughout Stark and Tuscarawas Counties. In 1906, the growing company moved to a site along the railroad tracks between 8th Street and Carnahan Avenue Northeast. Several additions were built over the next twenty years as the company continued to expand.

Cleanliness was an important part of the business from the beginning, as described by Heald:

> The new plant made its own electricity and ice, the latter being used to keep the temperature uniform in the half dozen cold storage rooms. The chief products in 1909 were sausage, bologna, knockwurst, frankforts, lard and mildly cured hams and bacon. Six to eight carloads of livestock were being delivered at the plant each week. With its up-to-date machinery and sanitation, the Canton Provision Co. made the small, hand operated slaughterhouse a thing of the past.

The company added luncheon meats to its product line in 1927 and frozen foods in 1942. By the 1950s, the company had a fleet of forty-seven trucks that delivered 30 to 35.5 million pounds of meats and frozen foods to 3,500 businesses in thirty-three counties in northeast Ohio.

In 1920, Harry Lavin and his sons, Leo and Arthur, formed another local business called the Stark Provision Company. The year before, Lavin purchased the property of the Moreland Brewery Company, which went out of business with the passage of Prohibition, on the south side of the railroad tracks at McKinley Avenue Southwest in Canton. At first they sold specialty products, such as smoked and luncheon meats. In 1926, the

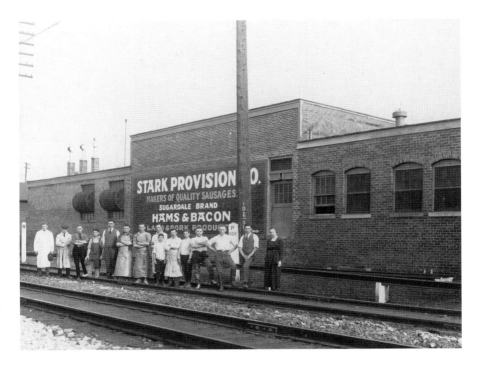

The Stark Provision Company changed its name to Sugardale in 1926, highlighting the sugar flavor of its hams. Today, Sugardale Foods and Superior Brand Meats are owned and operated by Fresh Mark.

company began processing pork. That same year, Stark Provision changed its name to Sugardale Provision Company, highlighting the sugar flavor of its hams. In spite of the Great Depression, Sugardale was in a position to expand in the 1930s. In 1931, it began processing beef and lamb. In 1936, the Frostdale Company, a frozen food subsidiary of Sugardale, was founded.

In 1916, Nathan Genshaft came to Canton from Russia, where he had learned the butchering and slaughtering business. First he worked at Canton Provision and later at F.W. Renner's slaughterhouse. In 1933, Genshaft founded the Superior Provision Company in Massillon with Harry Smuckler, Harry Appelbaum and Sam Cohen. The first plant was just a small killing floor for cattle, two thirty-foot-square coolers, a small sausage room, two small smokehouses and a curing cellar in the basement. Over the years, the business grew, employing 225 people by the 1950s.

As grocery stores and supermarkets added meat counters to their stores, the number of meat markets began to shrink. In 1932, there were 153 meat markets listed in the Canton City Directory. By 1940 there were 43, and by

1950, there were just 15 left. The provision companies were now supplying the larger stores instead of the neighborhood meat markets.

Two of the local wholesale meat processing companies in Canton—Sugardale Foods and Superior Brand Meats—combined in 1976 and were rebranded with Fresh Mark as their parent company in 1987. When announcing the new corporate name, chairman and CEO Neil Genshaft told *The Repository* that it was "part of an ongoing modernization process within our corporate structure to clarify and build on the identities of Superior's and Sugardale brand names." First introduced in the 1940s, Frankie the Keener Wiener is still Superior's mascot, appearing on many of the product packaging. Today, Fresh Mark has three locations in Stark County: 1600 Harmont Avenue Northeast in Canton, 1888 Southway Street Southwest in Massillon and 950 Cloverleaf Street Southeast in Massillon, plus a facility in Salem.

In 1974, Superior broke ground on additional space to produce a new product called "Supak," a wholesale boxed beef line. With a shortage of

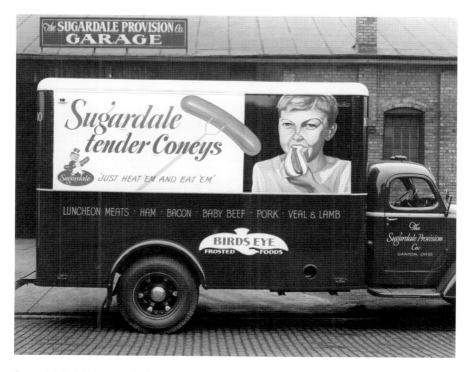

Sugardale's delivery trucks featured lively advertising of its wide variety of products, including coneys and luncheon meats.

skilled labor in the butcher departments of local grocery stores, this new product transferred the cutting and trimming process to the meat processing facility. Previously, Superior would deliver beef quarters directly to the grocery stores, which would be responsible for dividing the meat into portions for sale. The new addition allowed Superior to process beef into chuck, loin and rib cuts before delivering them to the stores. According to a May 15, 1995 article in *The Repository*, the company was producing "300 different types of meat products for grocery stores, wholesale food distributors, restaurants, institutions and other customers in 42 states." Products included hams, wieners, bacon bits, dry sausage, pepperoni, luncheon meats and other specialty meats.

As a locally owned company, Superior was competing against very large conglomerates. "We have to spend every dollar like it's our last one," spokesperson Harry N. Valentino told *The Repository* in 1995. "We have to spend money in areas where we can do a better job than the big people. Then we have to outperform them in all areas." For example, Fresh Mark spent more than $10 million between 1992 and 1994 to upgrade to state-of-the-art equipment for ham and dry sausage processing at the Harmont Road plant. In 1995, Fresh Mark spent another $7.5 million to modernize the sausage and wiener equipment and to construct a new distribution facility in Massillon.

In the March 5, 1997 issue of the *Sun-Journal*, Genshaft said, "Fresh Mark began as a one-on-one business and has sustained this personal service philosophy in its regional branded markets, its nationwide food service operations, and its extensive private label business. The result is exceptional responsiveness in meeting product design, promotional, and packaging needs. Fast-moving developments characterize today's markets. Fresh Mark personnel, experienced in specialized marketing, are quick to respond to these needs on behalf of Fresh Mark customers." For example, the company can easily alter the size or flavor of its hot dogs to suit changing customer tastes. New products can be developed quickly, and they can scrap old products that are no longer working without navigating the bureaucracy found at larger corporations. In the early 1990s, Fresh Mark was one of the first companies to produce precooked bacon, a consumer favorite for its convenience, less mess and lower fat.

Another major wholesale food company in Stark County is Shearer's Snack Foods, headquartered in Massillon. The company's roots go back to the early 1900s, when William Shearer opened a meat market at the corner of 9th Street and Dartmouth Avenue in Canton. Sons Nelson and Howard

took over the market when their father retired. In the 1950s, Nelson's son, Jack, opened a grocery store, which he operated with his wife, Rosemary. According to the corporate website, "In 1974, Jack and Rosemary bought a snack food distributorship, and their sons Bob and Tom joined the growing family business. The Shearers wanted to offer a complete line of snacks, but couldn't find products that met their high standards. In 1979, the family launched its own snack food manufacturing operation to ensure their high standards of quality would be met. In a small rental facility on Harrison Avenue in Canton, they began hand-cooking kettle potato chips and selling them under the 'Kettle-Cook'd' label. And with those chips, Shearer Perfection was born."

The original extra-crunchy kettle chip recipe has not changed since it was first introduced in the 1970s, when the chips were sold in one-pound bags with a twist tie. "Quality. That's our key ingredient," said President Robert Shearer in an article that appeared in *The Review* on March 28, 2005. "We don't do anything to take short cuts." With the health craze of the 2000s in full swing, Shearer's promoted snacking in moderation in combination with regular exercise, rather than creating a line of low-fat snack options. "If you're going to indulge, you want it to be the best," Shearer said.

Over the years, Shearer's has regularly expanded its manufacturing facilities to increase output, by adding new product lines or building state-of-the-art equipment. For example, the company installed an automated stirring system for its kettle fryers in 1992 and transitioned to an electrostatic seasoning system in 1995. By 2005, Shearer's was producing 50 million pounds of snacks per year, stocking stores and vending machines within a six-hundred-mile radius of Stark County. One key to the company's success has been a "co-pack" deal to produce snacks for competitors like Kraft and Frito-Lay at a profit. In addition to the Shearer's brand name, the company also produces product lines under the names Riceworks, Barrel O' Fun, Beer Chips, Delicious Bakery, Granny Goose, Larry the Cable Guy, Rachel's, Salveo, Thin & Crispy, Vic's Popcorn and Vista.

Another wholesale operation in Stark County was Leo A. Dick & Sons, producer of gourmet horseradishes and mustards and locally owned until 2016. While unemployed in 1921, Leo Dick started manufacturing salad dressing to support himself. His obituary in the March 25, 1949 edition of *The Repository* described his humble beginnings: "He began by carrying one eight-ounce jar of the dressing in his overcoat pocket as a sample to show prospective customers. He obtained an order for a dozen jars which he delivered in a half-bushel basket. Merchants encouraged him and his

business grew. A short time later he obtained a second-hand truck, which he learned to drive." Eventually, Dick converted ten garage stalls near his home into a refrigerated warehouse space. At the time of his death, Leo A. Dick & Sons had a five-thousand-square-foot building and five large delivery trucks.

Dick's products are still a consumer favorite in Stark County and beyond, including its famous horseradish, specialty mustards and cocktail sauce. In the April 2010 issue of *About* magazine, Dick's new horseradish mustard was featured in an article about "must try" local products.

Lipari Foods acquired Leo A. Dick & Sons in 2016. In an article in *Deli Market News*, Leo Dick, grandson of the founder, said, "This will benefit our current customers by increasing our product offering more than tenfold and enable Lipari Foods to represent a broader and more innovative product selection." Dick was also inducted into the Specialty Food Association's Hall of Fame in 2017. According to an article that appeared in the July 17, 2017 edition of *The Repository*, "The honor is presented to individuals whose accomplishments, innovations and contributions in the specialty foods industry merit recognition. The association selected Dick because of his success expanding the family business into an operation that supplied 400 manufacturers and 1500 retailer across Ohio and three other states." Under Dick's leadership, the company grew from five employees in 1975 to sixty-five.

Mid's Spaghetti Sauce has been manufactured in Stark County for nearly seventy years. Scott Ricketts and Steve Kress purchased the company, located at 620 Main Street in Navarre, in 1997, and soon it started to grow. Mid's distributed to fifty stores in and around Stark County in 1999, and by 2009, it had expanded to more than one thousand stores, reaching as far as Minnesota, New York and Florida.

In an article called "Eating Local" from the newsletter *Word of Mouth* in 2009, the writer visited the facility to observe the manufacturing process: "The modern, well equipped plant seems a far cry from the small Navarre restaurant where Mideo Octavio, an immigrant from Sicily, first began making sauce from his family's recipe in 1939. The sauce became so popular that Mideo, nicknamed Mid, began selling the sauce to customers in the 1950s and opened a small plant, where Mid's sauce continued to be hand made from the family recipe." The website describes a "stained, well-guarded recipe for red tomato sauce," given to Octavio's mother by her mother, as one of the few possessions that traveled with the family to America.

Octavio was born in Massillon in 1908 and grew up eating his mother's old-world cooking. His mother taught him how to make the now-famous

spaghetti sauce, stressing that it was to be cooked slow in an open pot and never steamed. The result is a thick sauce that "sticks to pasta."

Repository food writer Saimi Rote Bergmann visited Mid's in 2001. "At 5 a.m., Tim Aranda dumps about 600 pounds of lean ground beef into a frying 'pan' the size of a Jacuzzi," she wrote. "With a broom-sized spatula he stirs, flips and chops the meat until it's browned, then adds a bit of sauce. He tends it carefully as it simmers, pausing only to walk over and stir the meatless sauce in an even bigger Jacuzzi—more like a swimming pool." There is no automation at Mid's. Everything is still done by hand the old-fashioned way. Mid's current product line includes Traditional Meatless, Meat Sauce, Tomato Basil, Italian Sausage, Meat & Mushrooms, Extra Thick & Chunky, Italian Sausage & Peppers, Mushrooms & Roasted Garlic, Three Cheese and Garlic & Onion. The company also makes pizza sauce.

Also located in Navarre, the Alfred Nickles Bakery has been baking bread since 1909. Alfred Nickles came to the United States from Switzerland in 1903 at the age of nineteen. In 1909, he opened the Navarre Bakery and Ice Cream Company, employing just his wife, Emma, and her sister, Ida Baumgardner. They sold their baked goods door to door in hand-carried baskets and served ice cream in a corner of their small building. Early on, the ice cream part of the business was dropped, and the company was renamed Alfred Nickles Bakery.

In 1925, Alfred's son, Ernest, joined the family business as sales manager and launched a plan to expand the company from home delivery routes to a wholesale distribution company. In 1927, Nickles opened their first distribution branch in Canton. Ernest became president of the company after his father's death in 1949. Throughout the twentieth century, Nickles acquired Ohio bakeries in Warren, Lima, Martins Ferry and Fremont, as well as in Elkhart, Indiana.

Around 1940, Nickles published a small booklet called the *Nickles Sandwich Book*, by Demetria Taylor. Each page featured the recipe for a different sandwich in paragraph form, with a photograph of each above. Some of the recipes included the following:

BOX LUNCH SANDWICHES
Box lunch parties are fun—did you ever give one? Every guest brings a box packed with food for one person. Boxes are numbered and lots are drawn—then everyone eats a lunch someone else prepared. Naturally you want the person who gets your box to be pleased, so you do your best. Fill the White Bread with a mixture of chopped chicken, cucumber, radishes and

mayonnaise; the Wheat Bread with equal parts of ham and cheese which are put through the food chopper and combined with a little grated onion and enough mayonnaise to hold together.

TEEN-AGE SANDWICHES
Turn the house over to the teen-agers. All you have to do is to set out the sandwich fixings and let them concoct their own, to rival Dagwood himself! Provide plenty of bread—Rye, Wheat, Raisin, White—a variety of cold cuts, sliced tomatoes, bowls of sandwich fillings—tuna fish or chicken, jam, cottage cheese, etc.; put soft drinks in the refrigerator—and don't forget mustard and mayonnaise! Then go to the movies, and let the youngsters dance and eat to their heart's content.

Naturally the recipes each featured Nickles Bakery's main product: bread.

An article in the *Massillon Independent*, published on November 25, 1969, listed some statistics regarding the company. Each year, Nickles used more than 27 million pounds of flour, 5.72 million pounds of granulated sugar and 850,000 pounds of non-fat milk solids in the production of bread. The sugar and flour arrived in bulk by tanker truck, which was connected to a pneumatic hose to pump the product into one of ten huge bins at the rate of 800 pounds per minute. The system was completely enclosed, protecting the flour and sugar from contamination by moisture in the air or flavors and odors nearby. At that time, the company could bake five thousand loaves per hour at the Navarre bakery.

By 1994, Ernest Nickles had expanded his father's business to become the largest family-owned bakery in the United States. He died the following year. The American Society of Baking inducted Ernest into the Baking Hall of Fame in 2013 in recognition of his leadership in modernizing and expanding the family business. "He had flour in his veins," the ASB said in an article about the induction at BakingBusiness.com. According to an article in the April 2, 2013 edition of *Milling & Baking News*, company president David A. Gardner, Ernest's nephew, said, "His greatest accomplishment was transitioning the company from home service-oriented retail delivery baking company with over 600 routes to a grocery and restaurant wholesale delivery baking company with over 5000 routes serving 7 Midwestern states with products made in 5 bakeries." Ernest reportedly worked seven days a week and checked on the bakery almost every night. Regular meetings—including a four-hour production meeting on Tuesdays, a three-hour planning meeting on Fridays and daily three-hour sales meetings—were held every week of the

year. Under his guidance, Nickles expanded its product line to include buns, dinner rolls, pies, sweet rolls, Danish, cake donuts, croutons and stuffing mix, bread crumbs, cookies, snack cakes, layer cakes, angel food cakes, fruit cake, puff pastry and yeast raised donuts.

Garner said that Nickles had extraordinary sensory skills. "Ernest Nickles had the greatest sense of taste that I have ever seen," he said in *Milling & Baking News*. "I sat in on thousands of taste-test meetings and production meetings with Ernest. He was the only one in these meetings who could identify ingredients like honey and other flavorings in baked goods." Ernest spent seventy years at the bakery, working until the day before he suffered a debilitating stroke that eventually led to his death.

Although the brands produced by Nickles, Sugardale and Shearer's are household names in Stark County, these wholesale companies do not sell directly to consumers, except in a few outlet stores. Production is on a scale far bigger than a retail operation, and in many cases, these products end up on shelves in grocery stores across Ohio and beyond.

RESTAURANTS

Memories of good food shared with family and friends stand out strongly in our collective memory. Everyone seems to have a favorite restaurant dish that simply cannot be replicated at home, and when the beloved restaurant closes its doors, that dish is lost to the ages. Some of these favorites over the years have included the creole-inspired "Singing Shrimp" at Castamall; hot dogs steamed in beer at Lum's; blue moon ice cream at Thompson's Dairy Land; cinnamon rolls and fresh-baked Italian bread at City Bakery; shrimp in lobster sauce and French silk pie at Bally Hai; prime rib at Bubba's; clam chowder at Packard's; turtle soup at Bender's, Frieg's or the Village Inn; pork chops at Rolando's; horseradish dip at the Little Forest Inn; stuffed green pepper soup at Pete's Restaurant; the Spanish burger and stuffed pizza burger at the Polar Bear; rice pudding at Halton's; beer-battered fish at the Hide-A-Way; a fish sandwich and strawberry pie at Lujan's; crab soup, onion rings and coconut cream pie at Knight's; French onion soup, green goddess dressing, stuffed hot peppers and broiled scrod at Campo's; steak on a stick at Leprechaun Inn; the Whipple burger with curly fries at Whipple Dairy; the Preston plate at Kapp's; dessert crepes and tempura veggies at Ebeneezer's; and peanut butter pie at Walkers.

Throughout most of the nineteenth century, eating out was not common. Saloons and taverns usually sold food, but in the early days, customers were primarily travelers who needed sustenance on the road. The saloon was largely a place for men to gather to drink alcoholic beverages, play cards,

hear the local news and listen to music. You could also cash a check, borrow money and use the public toilet.

Early settler Garret Crusen constructed Canton's first building on the east side of North Market Avenue in 1806. It was a small log cabin, about eighteen feet square, where Crusen ran a tavern. There was a main room that was used as a bar, a dining room and a kitchen. Two small additions were used as sleeping quarters. In 1808, Philip Dewalt opened the Spread Eagle Tavern on the southwest corner of South Market Avenue and West Tuscarawas Street. It was considered the finest eating establishment on the stagecoach route between Pittsburgh and Mansfield. Dewalt was famous for his beer and "pepper cakes." Between 1809 and 1812, he often had as many as twenty guests per night as people flocked to Canton to examine land for purchase. In 1827, Philip sold the business to his son, George Dewalt, who would become Ida McKinley's grandfather on her mother's side, and he tore down the original building and built a new one, renaming it the Eagle Hotel. On August 7, 1934, *The Repository* imagined what a traveler would have experienced at the Eagle:

> *Let us roll back the curtain of time and picture ourselves journeying in a four-horse post coach from Pittsburgh to Mansfield. We left Pittsburgh the day before, right after dinner, and are on the outskirts of Canton, where we are due for a dinner at the Eagle hotel which "supplied the best in everything."*
>
> *As our stage coach reaches the present site of the First Lutheran Church on Tuscarawas Street E, the driver begins blowing his horn…*[which] *continues until we reach Cherry Street. Here the driver tightens the reins, gives a fancy crack with his whip, and the horses, arch-necked, take the gentle slope leading to the tavern with a royal prance. We dismount to accept the landlord's invitation to have dinner, noticing that the coach's arrival is an event attracting everybody of leisure within convenient distance. But we are to make another observation when we reach the dining room.*
>
> *Here, indeed, we find the hotel serving the "best in everything." For dinner we may have either "chicken roast, roast beef or kidney, roast of veal, roast turkey, vegetable sauces of all kinds, tea or coffee." We learn that had we been there that morning, we could have breakfasted on "ham and beefsteak, fried potatoes, warm cakes, waffles, spreads of all kinds, and excellent coffee with cream." Supper consists of "steak and ham, mashed potatoes, sauces, and tea or coffee." We learn, moreover, that each meal is only 25 cents, and lodging for regular boarders costs only $2.50.*

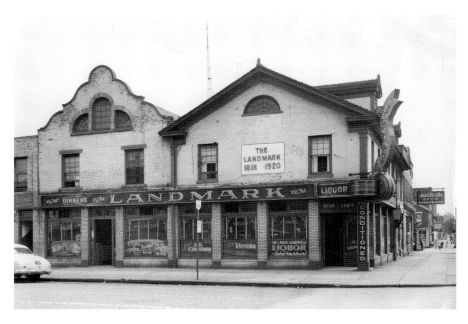

The Landmark is the oldest surviving commercial building in Stark County. It was built in 1818 by George Stidger, who operated Travelers' Rest, a stagecoach stop along the main route.

In 1818, George Stidger built the Travelers' Rest, later known as the Landmark Tavern, at 501 East Tuscarawas Street, which was located along the main stagecoach route. According to the Canton Preservation Society, the business was "a lucrative enterprise, which eventually passed into the proprietorship of Jacob Hentzell. Hentzell's Travelers' Rest was a popular stop for weary travelers throughout much of the nineteenth century."

As more people settled in Stark County, a few early restaurants sprung up that were not associated with travel. According to Stark County historian E.T. Heald, the 1859 Massillon City Directory lists two eating establishments, including a coffee shop owned by Henry Spuhler on the west side of Erie Street between Main Street and Charles and Herman Pietscker's confectionery store. In her book *Cross Keys, Carpet Bag and Pen*, Kathryn Hardgrove Popio includes a letter M. Hardgrove wrote to her granddaughter Margaret, dated June 29, 1963: "Yesterday Minerva come down with me. Her and Hariet went down the street and after dark Minerva and I went down to the confectionary's [Pietscker's] and got some ice cream thare were three ladies come in while we was eating ours and

got each a plate full of ice cream." She mentioned getting ice cream there again in August 7, 1864.

By the late nineteenth century, eating in a restaurant had become more common. What had begun as an elaborate—and expensive—dining experience for the wealthy was now affordable for the average person, creating a new industry in the American economy. However, the restaurant business is notoriously difficult to break into—and even more challenging to sustain. Stark County's city directories are full of restaurants that appear and disappear quickly, although a select few became fixtures in the community for decades. Information about restaurants are scarce in historical records, so it is impossible to include every one that ever

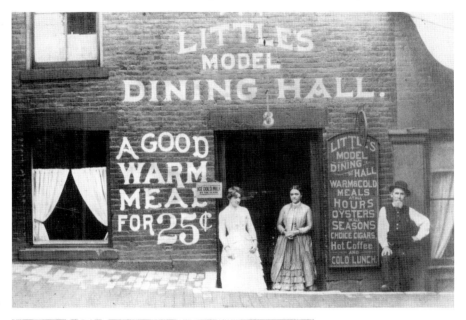

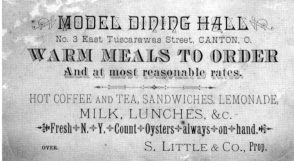

This page: Little's Model Dining Hall featured some of the delicacies that were popular during the Victorian era, especially oysters.

Bender's Tavern, at 137 Court Avenue Southwest, was founded by Ed Bender in 1902. *Authors' collection.*

operated in Stark County. But the information that survives provides a glimpse into the palate of our community over time.

There were several restaurants in Stark County that catered to the needs of the average person's wallet. Little's Model Dining Hall was located at No. 3 East Tuscarawas Street and appears only in the 1895 edition of the Canton City Directory. The business's sign advertised a "good warm meal for 25 cents." It also offered meals "at all hours," choice cigars, hot coffee, cold lunches and ice-cold milk by the glass. In the Victorian era, oysters were a popular menu item at many restaurants. Little's advertised "fresh NY count oysters always on hand" in all seasons. Oysters were also available in Massillon at John Baker Thompson's store and dining room at 42 East Main Street. "He received oysters every day and served them in every style in the dining rooms connected with his store," said Heald.

Ed and Anna Bender opened their well-known restaurant, Bender's Tavern, in 1902. Its present location is situated in the red brick Belmont Building, designed by architect Guy Tilden, at 137 Court Avenue Southwest. Saturday nights in the 1910s were often described as "nightmares" by the staff, who dreaded it all week long. Downtown stores were open late, and businessmen had wives and children meet them for dinner. After an evening of shopping, they all came back for "chili and beer" and stayed well into the night.

Bender's Cafeteria, a second restaurant, opened very soon after the main restaurant opened, following nationwide trends. At 118 South Market Avenue, the "cafeteria" stretched along an entire city block and was open seven days a week from 6:30 a.m. to 7:45 p.m. A *Repository* article titled "Selectivity of Food Feature at Cafeteria" described the typical customer as "persons who are dieting or eating scientifically," because they could select their own foods. Manager L.B. Russell explained the appeal of the cafeteria further:

Many of our patrons walk along the serving tables and choose not only the things they like but the things their systems need as well. The scientific eaters are in the ascendency and are finding the cafeteria system to their liking. For that reason we always keep a large variety of salads, fruits, and fresh vegetables on the serving tables in addition to the other meal staples.

ANNOUNCING THE OPENING OF

BENDER'S CAFETERIA

118 MARKET AVENUE SOUTH
AT 10:30 O'CLOCK A. M.

WEDNESDAY, MARCH 10th

OPEN SEVEN DAYS A WEEK

Breakfast 6:30 to 10:30 a.m. Continuous dinner and supper service 10:30 a.m. to 7:45 p.m., closing hour

"GOOD WINE NEEDS NO BUSH"-----

said a great man, many years ago. It is true now as in the time of old Falstaff. It will be doubly true of Bender's Cafeteria, once it is opened to the public. For excellencies such as will characterize Bender's Cafeteria will need no further telling---they tell themselves. What we want you to know now, is, very briefly, about the whys and wherefores of this institution of public service, and a word about the equipment, capacity and so on---all of which we will invite you to inspect and pass judgment upon.

ONE OF THE LARGEST, MOST MODERN CAFETERIAS IN THE STATE

We open this Cafeteria with a feeling of great pride, for it is to be an institution of service that will fill a long-felt need

A GROUND Floor Cafeteria, large, spacious, cool, airy with ample capacity for serving 800 persons at a meal, **Can Serve** and all facilities for quick and thoroughly **800 People** pleasing service. The rooms are decidedly attractive, with their lofty ceilings, tiled walls, floors in black and white., Large exhaust fans, buzz fans and overhead fans will make the place a cool delightful retreat on a hot day. The Steam and Serving Tables, 69 feet in length, of vitrified glass---are snowy white, with trimmings of nickel-silver ---the Salad Pans of the same, and every other feature has been chosen with an eye to sanitation as well as to attractiveness.

WE believe you will feel an added zest in eating at Bender's Cafeteria when we tell you about the kitchen, **The Kitchen** just how it is fitted up for the work of pre- **Equipment.** paring the delicious foods that are to make Bender's Cafeteria famous; of the battery of pastry ovens, the big Garland Ranges, the mammoth Refrigerators, the Dish Washing and Sterilizing Machines---the tables and shelves, etc., of metal, for the greater sanitation. And, best of all, the ample storehouses where all the goodies are to be kept,

WHETHER a man was born north or south of the Mason and Dixon line, east or west of the Mississippi, **Genuine Home** he likes old-fashioned Home-Style Cook- **Cooking** ing---they all get together on that particular question. Ergo, the cooking of Bender's Cafeteria is to be true Home Style of the highest order---the same style of cooking that has made Bender's Restaurant famous. There will be expert meat cooks, incomparable salad and cake makers---a world of dainty and appetizing sweets, frozen dishes and fruits. Everything, in fact, in the way of choice and tempting viands to satisfy an honest appetite, or to coax a jaded palate.

L IKE pie? (If not get a specialist to examine you, there's something wrong.) Your quest for luscious, juicy, soul- **If You** satisfying PIE will end here. We have an expert **Like Pie** French pastry maker for five years with Halle Bros., Cleveland, who bakes PIES even better "than mother used to make!" PIES of the purest and best ingredients, made with flaky, crumbling crusts, and juicy, fine fillings---in short, they're poems, gastronomic symphonies, that will make every turning of your face toward Bender's Cafeteria a happy one.

S OME of you will want to serve these excellent pies and French pastries in your homes. They will be on sale in special show cases at the exit, with convenient packages furnished in which to carry them.

I N this day of practicalities and of thrifty turnings of many minds, the self-serving cafeteria is the plan that makes **And, Economi-** the greatest appeal. It is the ideal way **cally Speaking** for business men and women, who must be served quickly, and many of whom have a limited amount to spend for breakfasts, dinners or suppers. Here you serve yourself---no delay; you get exactly what you want, whether a glass of milk and a piece of pie, or an elaborate meal---"soup to nuts." A system of self-service that benefits all---and appeals greatly to thrifty folk.

Please Note:

The Bender Cafeteria will serve three meals daily---breakfast, dinner and supper.

Mr. E. C. SMITH, Mgr. **BENDER'S CAFETERIA** 118 MARKET AVE. S

Important-- The Bender Restaurant–Court Av And Second St SW Will It Close? No! The Bender Restaurant will continue to operate exactly as it is now---with no change whatever in its plans or purpose of service to the public. ED. E. BENDER

Bender's Cafeteria, when it opened at 118 Market Avenue South, in 1903, was billed as "one of the largest most modern cafeterias in the state."

Another factor in the popularity of the cafeteria is the fact that it has what we, in the business, know as eye-appeal. In other words, the impression of seeing the prepared food is much different from that obtained by looking at a menu and making your selections....

Many persons apparently hold the idea that the name Bender's is synonymous with high prices. All that should be necessary to refute this mistaken idea is the stating of the average cost of eating here. The actual check average for breakfast is 29 cents. The average check cost for lunch is 47 cents. And this is for the very best food we can procure, prepared by the best chefs we can obtain.

The cafeteria proved to be a fad, but fine dining at Bender's has endured. The Jacob family purchased the restaurant from Anna Bender in 1932. To celebrate the fiftieth anniversary of Jacob family ownership in 1982, Bender's sold one menu item each night at its 1932 price. For example, a frog legs dinner cost only $1.32. Today, the restaurant is run by the fourth generation of the family. After Prohibition ended in 1933, Bender's was the second business in Ohio to obtain a new liquor license. "We had [a party] to celebrate the end of Prohibition," said Wilbur Jacob in the September 3, 1972 issue of *The Repository*, "and wound up having to get bootlegged beer because the brewery could not deliver the 50 cases it promised us in time." The Jacob family and Bender's Tavern are detailed further in the "Legacy Families" chapter.

Founded as an exclusive businessmen's club, the Canton Club was originally located in the St. Francis Hotel. In 1923, it moved to the top floors of the First National Bank Building, later known as the Chase Building, across from the Stark County Courthouse on West Tuscarawas Street. Membership was limited to "men only" until 1983. In the 1970s, the Canton Club had "Family Night" on Fridays, with entrées specially prepared by the chef for each night. The weekly menus were printed in a monthly newsletter that was sent to members. In November 1977, the bulletin announced some changes with regard to side dishes:

NOTICE
Reduced prices—Saturday Gourmet Nights
For the past several months, our Chef, Dale Weisent has been keeping a close watch on side dishes, potatoes, vegetables, being returned to the kitchen without having been touched. Also, Jim Judy, our Maitre D' has received many comments about there being too much food served.

It is quite obvious that in a year's time there is a substantial amount of food wasted and an unjustified amount of money being spent uselessly.

The Club's produce bill for the past twelve months was in excess of $11,000. This was not all potatoes and vegetables, to be sure, but certainly those items constitute a healthy portion of the total cost.

Thusly we have decided to offer Gourmet selections on an A la Carte basis, with lowered prices. This means that for the stated menu prices (all lower than before) you will receive your main entrée, choice of salad with dressing, relish tray, rolls, butter and beverage. Should you desire a potato or vegetable, that will be your option, and you will be charged accordingly. Usually the price will be about .50 per side dish.

We would appreciate your comments on this. Plus any suggestions you may have.

As the twentieth century drew to a close, membership declined, and the Canton Club closed. Five years later, it reopened as an event center but closed again in 2018.

Over the years, many restaurants have tempted the palates of Stark County's diners. Some are still around today, but most have come and gone, falling victim to the fierce competition of the restaurant industry. Others just couldn't survive the deaths of their founders or disasters such as a fire. In spite of the thousands of customers who ate at these restaurants, little remains in the archival record to document them. A few snapshots are re-created here.

Emmanuel "Mike" Elite and George Bourlas ran the Elite Restaurant at 206 West Tuscarawas Street from 1932 until 1957. It was open twenty-four hours a day, with each partner taking a twelve-hour shift. Tommy Dorsey, Guy Lombardo, Desi Arnaz and Howard Hughes were just a few of the familiar names who ate at the Elite. During the Depression, the owners were known to feed people who were down on their luck from the back door.

Dick Logan's was located at 201–3 12th Street Northeast. The family's original name was Lougash, but it was Americanized to Logan when they came to this country. In 1969, the booklet *Around Town* noted, "The piano

Dick Logan's was located at 201–3 Twelfth Street Northeast. This ad appeared in the 1963 Perry High School yearbook.

bar at Dick Logan's is alive nightly under the talents of Gene Wygant. The personable pianist covers the gamut on the musical scale from blues, jazz to old-time favorites. If you feel like singing, join in, everybody else does."

The Dutch Oven, located at 314 Cleveland Avenue Northwest, opened in December 1948, serving dinner in the "traditional Dutch style." The original restaurant could seat 60 guests, but a 1949 expansion increased seating to 125. The new design featured Pennsylvania Dutch decorative pieces honoring some of the area's original settlers. It appeared for the last time in the 1966 Canton City Directory.

Named for a Lewis Carroll quote from *Through the Looking-Glass*, Cabbages & Kings was located at 4220 Belden Village Avenue Northwest in Canton from 1974 to 1976. It was founded by Henry Belden, Glen Blake, John Teeple and Clive and Pat Webster. Henry's son, Dennis Belden, was the restaurant's manager. The first page of the menu explained its curious name:

The Time has come,
The Walrus said,
To talk of many things,
Of shoes—and ships—and sealing wax—
Of Cabbages and Kings…

From the immortal pen of the beloved English writer Lewis Carroll we take our name, CABBAGES & KINGS. Symbolic of both food and royalty, it thus bespeaks our dedication…to the all-too-rare Regal Way of Dining.
And so we bid you welcome, Honored Guest, to our merry Manor House!
Here lives the good cheer and abundant victuals that were Olde England.
Here, there is always a fire in the fireplace, always a hearty toast!

The high-end restaurant was decorated in the English style, with stucco, stained-glass windows, a suit of armor and a large fireplace that was open to both the dining room and the lounge. On the weekends, a musician played Old English music on a guitar or mandolin. Pewter chargers decorated with the restaurant's shield, featuring a cabbage and four crowns, were set at each place. Other pewter items—such as goblets, mugs, pitchers, sauceboats, wine glasses and sugar bowl and creamer sets—were available for purchase. Sourdough, made from an old and expensive starter that originated in California, was baked fresh daily.

The menu was printed in an Old English–style font, creating a feeling of old-world formality. The house specialty was prime rib and steaks. The

kitchen would go through ten to twelve prime rib roasts a night. Normally, it was served boned, so they would save the ribs and freeze them for a once-a-month "three rib" lunch special. Many of the entrées were named after royalty, such as "Henry III" Prime Rib, "King's Filet" Filet Mignon, "The Hearty Kingsman" New York Strip, "Regal Splendor" Lamb Chops and "The Gamesman" Golden Ring-Necked Pheasant.

The salad bar was called "The Queen's Table," of course. The menu read, "Along with your entrée comes an invitation to personally visit The Queen's Table. Here you will create your own Salad from a tableau of garden delights. And you'll find all the 'extras' befitting royalty—real bacon bits, homemade croutons and dressings, fresh grated cheese…even chilled salad plates! If you wish, your attendant will be pleased to visit The Queen's Table in your stead." Before the seafood options, the menu said, "For the discriminating taste in seafood, our seafood is brought in fresh and prepared in our kitchen as would be in the days of the Kings."

Cabbages and Kings was the right idea at the wrong time. First, the economy was generally not doing well in the mid-1970s. Second, the proposed exit to Whipple and Belden Village Avenue from I-77 North was in the planning stages when the restaurant opened. The owners expected the exit to be built and drive traffic to their location. But it would be several years before the exit would funnel traffic past the "back" side of Belden Village Mall. Cabbages and Kings was sold to Ralston Purina, which opened a Whaling Station seafood restaurant in that location. After that, it was Damon's for several years and was eventually torn down.

In 1957, Tim Triner, a former professional baseball player, opened Tim's Tavern at 3323 Parkway Street Northwest near Meyers Lake. In the early 1960s, Triner introduced a beer-battered fish recipe that soon became legendary in Stark County. Back then, it sold for just ten cents apiece. The restaurant's website describes the popularity of his fish: "People would line up at the door on Fridays to have a basket of fish and a draft beer. To accommodate more people Tim would put a 4'x8' sheet of plywood over a pool table with folding wooden chairs. The fish dinners were served on paper plates with plastic forks. A 'real' neighborhood bar with a friendly atmosphere." Indeed, the cover of an undated menu reads, "Famous for Fish."

A gold sticker affixed to that section of the menu reads, "We Fry in High Quality 'No Cholesterol' Wesson Products." The sandwich menu included fish, steak, Italian sausage, hot ham, hot ham and cheese, hamburger, cheeseburger, hot dog and coney, although most options were not available

on Fridays after 3:00 p.m. Today, Tim's Tavern is run by the third generation of the family, serving almost two thousand pounds of North Atlantic cod every week.

Before shifting gears and starting an all-you-can-eat restaurant called Town & Country at 5079 Lincoln Way West, Mary and Tully Foster ran the Club Casablanca at the same location from 1942 to 1957, hosting such big-name stars as Lawrence Welk and Patti Page. Once television began to replace live shows, the Fosters decided to switch gears. They had seen a buffet in a hotel in Toronto where the chefs served the food cafeteria-style and decided to give it a try here. When the Fosters opened their famous buffet Town & Country in 1957, it was the first of its kind in the area. With the buffet serving fantastic food and charging just $2.50 per person, the crowds started to become a problem. They actually raised their price to try to reduce the number of customers. Town & Country closed in 1987 when the Fosters retired, and the building was razed in 2001.

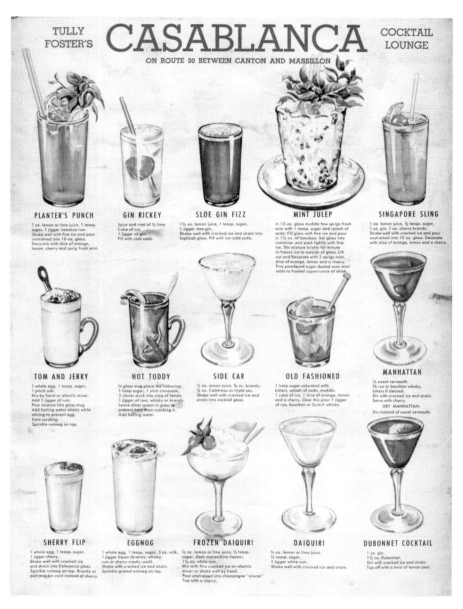

Above: Mary and Tully Foster ran the Club Casablanca at 5079 Lincoln Way West from 1942 to 1957, hosting such big-name stars as Lawrence Welk and Patti Page.

Opposite: The Fosters opened the area's first all-you-can-eat buffet restaurant, Town & Country, at the same location as the Casablanca. This image appeared in the 1960 Perry High School yearbook.

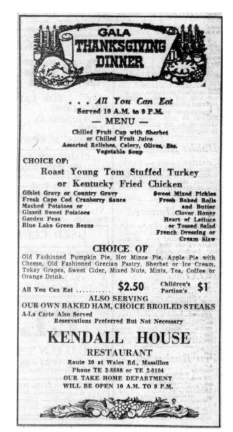

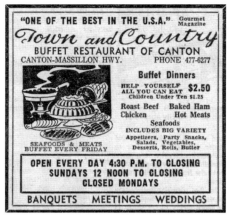

Above: This ad for Town & Country appeared in the November 22, 1964 issue of *The Repository*.

Left: This advertisement for a Gala Thanksgiving Dinner at Kendall House in Massillon appeared in the November 25, 1964 issue of the *Independent*. Today Kendall House Inc. is a franchise for KFC (Kentucky Fried Chicken) and Taco Bell, with a main office in Massillon and eighteen stores across Ohio.

Over the years, several local restaurants earned reputations for being the perfect settings to celebrate special occasions, including Mergus, Nick's Place Topp's Chalet, the Lakeside Restaurant and The Pines. A native of Greece, Frank Michael Mergus began his career as a kitchen boy in Boston's Hotel Touraine when he was just fourteen. Shortly after coming to Canton, he started working at Bender's in 1923. In 1930, he went to work at the Onesto Hotel as a caterer. In 1943, he opened Mergus Restaurant at 225 West Tuscarawas Street. One ad stated that Mergus was "known everywhere as one of Ohio's outstanding restaurants." The most popular dishes at Mergus were prime rib, lobster and charcoal broiled steaks. The restaurant became known as a special place to host wedding receptions, engagement dinners, banquets and other special occasions. After Mergus's death in 1980, the restaurant was sold. It continued to operate under new ownership for three years before closing permanently.

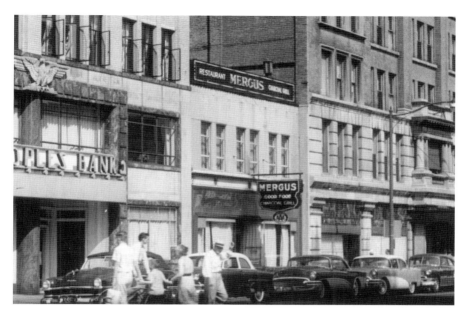

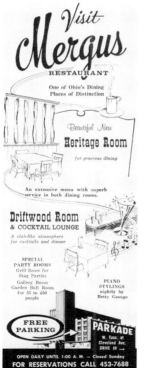

Above: Frank Mergus opened Mergus Restaurant at 225 West Tuscarawas Street in 1943.

Left: Mergus became known as a special place to host wedding receptions, engagement dinners and banquets. After Mergus's death in 1980, the restaurant was sold. It continued to operate under new ownership for three years before closing. *Courtesy of Linda Todd.*

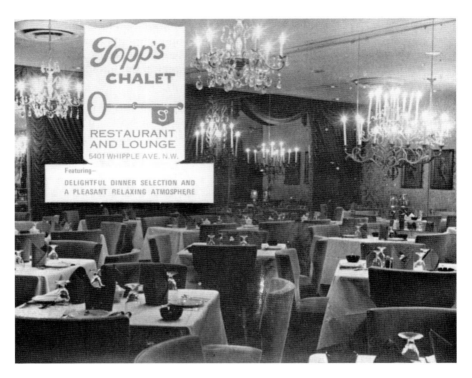

Nick Zenallis operated Topp's Chalet at 5401 Whipple Avenue Northwest from 1956 to 1994. It was a favorite restaurant to celebrate a special occasions.

Founded by Nick Zenallis in 1956, Nick's Place Topp's Chalet was another fine dining establishment where people often went to celebrate special occasions. It was one of the first businesses built in what would become the bustling Belden Village area at 5401 Whipple Avenue Northwest. In addition to the delicious entrées, diners enjoyed Caesar salads prepared tableside. The restaurant burned down in May 1994 and was not rebuilt.

With a beautiful view of Meyers Lake, the Lakeshore Restaurant was conveniently located adjacent to the Moonlight Ballroom, providing the setting for an ideal date night. George C. Sinclair opened the restaurant in August 1961. It was open all year round and featured dining and cocktails. The restaurant closed in August 1976 but later reopened as Clancy's. It was destroyed in the January 1979 fire that engulfed the Moonlight Ballroom.

Located at 2231 44th Street Northwest, The Pines was a favorite spot for weddings from the 1950s through the mid-1980s. John Salby, the original owner, lived upstairs and later built a house next door. From 1984 to

Right: The Lakeshore Restaurant was located adjacent to the Moonlight Ballroom at Meyers Lake from 1961 to 1976. It had reopened as Clancy's when it burned to the ground in January 1979.

Below: The Pines was a favorite spot for wedding celebrations from the 1950s through the mid-1980s. Today, it is the banquet hall Chateau Michele. *Courtesy of Chateau Michele.*

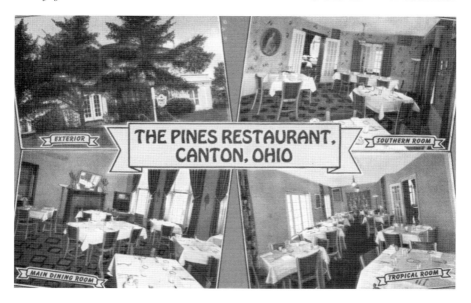

1989, Ron Kern ran a restaurant called Whitehouse Chicken in the space. Diners enjoyed chicken in a basket, fresh-baked sticky buns and fruit shrub, which was a glass of Hawaiian Punch with a scoop of sherbet floating in it. A traditional shrub is a vinegar-based drink with sugar and fruit added. Michelle and Shawn McCartney purchased the building in 1991. After a six-month renovation, they re-reopened as Chateau Michele on their wedding

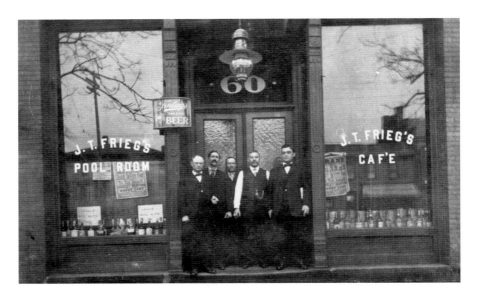

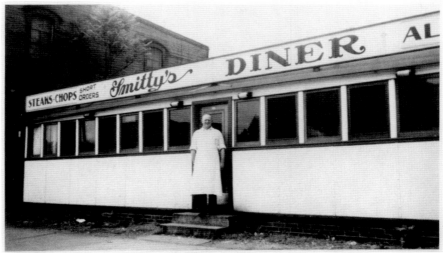

Top: Frieg's Restaurant, located at 255 Lincoln Way West in Massillon, began as a saloon in Beech Grove in 1887. The restaurant was a Massillon favorite from 1897 to 1990. *Courtesy of the Massillon Museum.*

Bottom: Smitty's Diner, called a "dining car" when it opened in May 1942, was located on Lincoln Way West between Second and Third Streets. It served meals twenty-four hours a day to customers seated at seventeen stools along the lunch counter. In 1947, W.A. "Smitty" Smith ordered a new prefabricated diner that was shipped on four flatcars, which was the first of its kind in Ohio. The diner closed in 1970. *Courtesy of the Massillon Museum.*

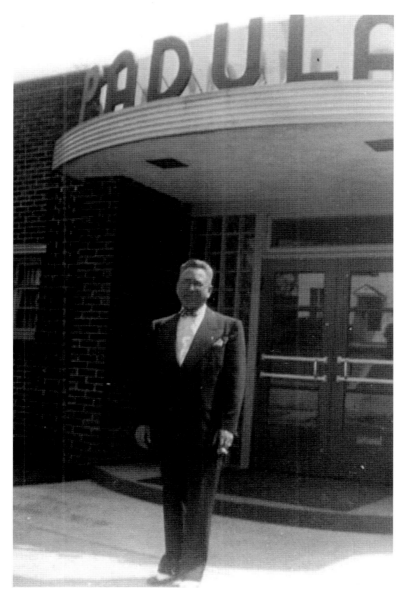

Joseph Padula established Padula's in 1917. It was originally combined with a boardinghouse for railroad workers at 501 Cherry Road Northwest. It was relocated to a brand-new building at 1328 First Street Northeast in Massillon after the Massillon Conservancy District construction project for flood control forced the restaurant to move. An undated postcard read, "The Finest in Cuisine, Atmosphere and Service. Liquor, Cocktails Served at Table Only." Padula's closed in 1990. *Courtesy of the Massillon Museum.*

day, February 14, 1992. Today, the banquet hall is a popular spot for wedding receptions, parties, meetings and catering.

Some of Stark County's restaurants became iconic teen hangouts in the 1950s and 1960s. The first drive-in "carhop" in town was the Avalon, located at the time quite a distance out of town on Cleveland Avenue, north of 30th Street. Brothers A.A. "Sykes" and Gerald Thoma built it in 1935 and named it after a Pacific Island paradise they had heard about on a visit to the West Coast. The original menu featured frozen custard (a novelty at the time), sundaes, pies and sandwiches served on butter-toasted buns. In the early 1950s, Thoma introduced his signature burger, the "Big Sis," described in a 1953 menu: "Made as Only We Know How—Two Patties of Freshly Ground Hamburger, Served on a Special Baked Toasted Bun with Lettuce, Cheese and Topped with Our Own Sauce." To this day, the sauce recipe remains a closely guarded family secret.

Cruising was elevated to an art form in the 1950s, and kids would "Buzz the A" to see what was going on, even if they didn't have any money or weren't particularly hungry. Billboards located on the hill behind the restaurant featured all the local products used in preparing the menu items. The original Avalon closed in 1972 and became a Wendy's.

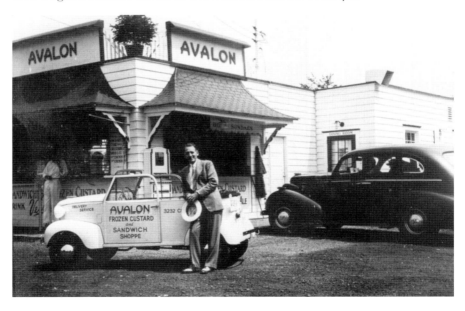

The Avalon began as a small custard stand at 3232 Cleveland Avenue Northwest in 1935. *Courtesy of Cheryl Thoma Hutcheson.*

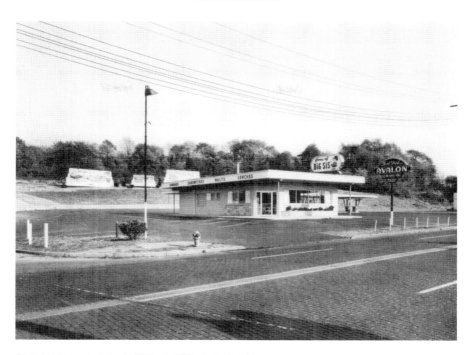

Above: The Avalon drive-in opened at the same location as the original custard stand in the late 1940s. Billboards behind the restaurant advertised the local companies from which Thoma purchased his ingredients. *Courtesy of Cheryl Thoma Hutcheson.*

Left: Thoma introduced his signature burger the "Big Sis" in the early 1950s. *Courtesy of Cheryl Thoma Hutcheson.*

Thoma also operated the Sky View, named by his wife, June, as the first restaurant at the Akron-Canton Airport when it opened in 1964. It was located on the top floor and featured many windows so the diners could watch the planes landing and taking off. Thoma was also the caterer for in-flight meals for United Airlines at the airport. *Courtesy of Cheryl Thoma Hutcheson.*

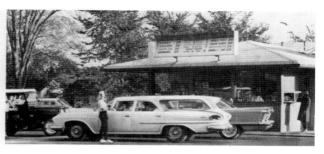

For a refreshing rootbeer and delicious food, students find that **STEWART'S DRIVE-IN,** 12080 Lincoln Way, W., is the place to go.

Stewart's Drive-In at 12080 Lincoln Way was one of the hot spots for Massillon's teens in the 1950s and 1960s. This image is from the 1960 Washington High School yearbook.

There were two other Avalon locations at 9th Street and North Market Avenue and at Dueber Avenue and West Tuscarawas Street. Thoma's daughter, Cheryl Hutcheson, remembered that the Market Avenue location was very busy on Sundays with the after-church crowd. The West Tuscarawas Street location later became Lindsey's Restaurant. Thoma also ran the Sky View, the restaurant at the Akron Canton Airport, which was located on the top floor of the terminal with lots of windows so diners could watch planes land and take off. Thoma also served as the caterer of boxed lunches for United Airlines flights at the airport.

At the Linway, you could order "a complete meal or just a snack." Located one mile west of Canton at 5103 West Tuscarawas Street, it was well known for its fresh-baked pastries. It appeared in the Canton City Directory from 1942 to 1956. Eckard's, located at the corner of West Tuscarawas Street and Linwood Avenue Southwest, was a popular hangout for Lincoln High School kids. In 1949, Eckard's became the first in the area to have carhops on roller skates who served patrons in their cars, or you could go inside and eat at a booth. In the 1960s, you could get a Coke and French fries for thirty-five cents. Eckard's closed in 1968, when drive-ins were beginning to be replaced by drive-thrus. Fast food as we know it today arrived in 1958, when the first McDonald's opened in Canton on Cleveland Avenue Northwest.

Founded as a small carry-out on West Tuscarawas Street by Joe and Georgia DiPeitro in 1956, the Pizza Oven is one of Stark County's most beloved pizza parlors. When people move away from the area, they often insist on having a Pizza Oven pizza when they are in town. In fact, the pizza is so popular with expats that the Pizza Oven's website has a special tab to "send a pizza" anywhere in the country. Today, there are eight Pizza Oven locations in Canton, North Canton and Massillon.

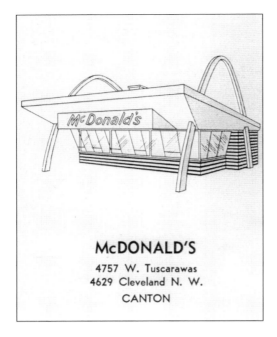

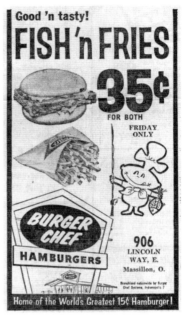

Left: The first McDonald's in Canton opened in November 1958 at 4629 Cleveland Avenue Northwest. It was listed as "McDonald System Hamburgers" in the 1960 Canton City Directory. In 1975, Cicchini Enterprises purchased five McDonald's franchises in Stark County, and by 1994, the company owned and operated a total of sixteen restaurants. By 2014, it had sold all but four of them.

Right: Burger Chef was a regional fast-food chain with a local franchise location at 906 Lincoln Way in Massillon. According to a *Time* magazine article from May 19, 2014, the name was chosen as a "more highbrow version of Burger King." The company was sold to Hardee's in 1982. This ad appeared in the November 25, 1964 issue of the *Independent* in Massillon.

Several ice cream parlors and candy shops have catered to the sweet tooths of young and old alike in Stark County. Among the earliest recorded in the area was Pietsckers, a confectionery located in downtown Massillon and mentioned in a Civil War–era letter written by Margaret Hardgrove. She wrote about having a dish of ice cream, which was certainly a special treat in the days before the invention of refrigeration. Banquet menus throughout the nineteenth century often listed ice cream as the dessert course. It might seem rather mundane to the modern diner, but ice cream was not something most people ate on a regular basis before home freezers.

In the early twentieth century, Roth & Hug was a popular corner drugstore and soda fountain in the region. In 1899, Charles R. Roth and Casimer K.

In 1899, Charles R. Roth and Casimer K. Hug bought a small drugstore at 333 East Tuscarawas Street from H.H. Ink. The partners quickly expanded their business into a local chain of drugstores and soda fountains. Each Roth & Hug location had a counter like this one, where a "soda jerk" served flavored carbonated drinks and ice cream sodas.

Hug bought a small drugstore at 333 East Tuscarawas Street from H.H. Ink. The partners quickly expanded their business into a local chain. By 1922, there was a total of seven Roth & Hug locations in Canton: East Tuscarawas Street and Cherry Street Northeast, Market Avenue and 2nd Street Northeast, Cleveland Avenue and 12th Street Northwest, the Harris Arcade Building, Cherry Street and 2nd Street Northeast, Market and 6th Street Northwest and Tuscarawas Street and High Street Southwest. There was also a location in North Canton. In 1917, Roth & Hug ran the following ad: "We have sold 5-cent soda for seventeen years and it is with regret that we find a good ice-cream soda can no longer be served for that amount. Fruit, fruit juices, flavors, sugar, ice cream, service, all have been steadily advancing for years…we have to do one of two things—cheapen quality or raise the price…so we are forced to serve 10-cent soda."

An undated menu from the McKinley Candy Shop featured toasted Philadelphia cream cheese and jelly sandwiches, hot lemonade and cold drinks like egg lemonade, Boston cooler and a grape highball.

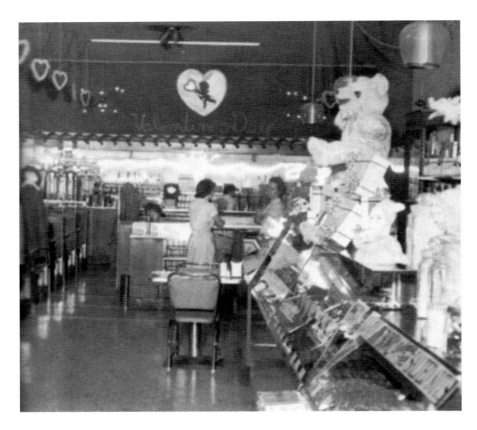

EXCLUSIVELY FEATURING

BARRiCiNi

"World famous Miniature Chocolates"

The Candy Bowl

330 Market Ave., N.

when shopping downtown, dine at the Candy Bowl

Above: The Candy Bowl was located at 330 North Market Avenue from 1950 to 1973.

Left: The Candy Bowl was a popular stop when shopping in the many department stores that lined the streets of downtown Canton. *Courtesy of the Stark County District Library.*

The Candy Bowl was a favorite stop after a long day of shopping or catching a movie in one of the downtown Canton theaters. The sandwich shop and ice cream parlor was located at 330 North Market Avenue and was open from 1950 to 1973. In addition to its dessert menu, favorite menu items included egg salad sandwiches and hot dogs served on buttery, crispy buns.

Originally opened as a Barnhill's franchise in 1970, the ice cream parlor at 4216 Hills & Dales Road Northwest became Butler's in 1975. The restaurant was decorated in 1890s style, with wrought-iron chairs, marble top tables and Tiffany lamps. The restaurant was known for its extra-large menu items. A "Party Soda" was served in a one- or two-gallon brandy snifter with a thirty-six-inch-long straw for each person. The "Sociable Soda" was available for two, four, eight or twelve people. And the colossal "Hall of Fame Sundae" fed fifty to seventy-five people, with nine gallons of ice cream, one and a half gallons of syrup and toppings, four cans of whipped cream, a quart of cherries and a dozen bananas. Butler's closed in 1988.

Taggart's Ice Cream Parlor was founded in 1926 at 1401 Fulton Road Northwest, where it still operates today. It is unusual in that it's situated

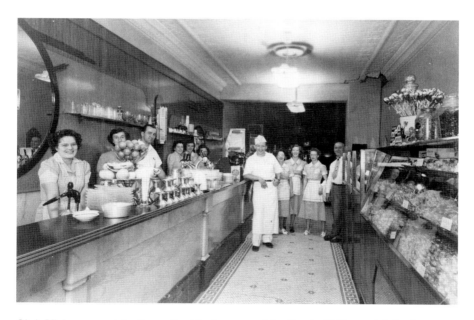

Chris Vlahos opened the Sugar Bowl in downtown Massillon in 1905, specializing in homemade candy and ice cream. Peter George, an immigrant from Greece, purchased the business in 1915. All of the candy was made at the store, including hand-dipped chocolates. The Sugar Bowl closed in 1989. *Courtesy of the Massillon Museum.*

HEGGY'S
3200 Tuscarawas Street W.
CANTON

Left: Heggy's has been a fixture in Canton since the late 1930s, when Harry Heggy opened Harry's Nut House on East Tuscarawas Street in downtown Canton, serving fresh roasted nuts and his brother Ben's chocolates. In 1950, Bill Heggy and Bob Weber opened Heggy's Nut Shop at 3200 West Tuscarawas Street in 1950, which is still in operation today.

Below: Eddy's Dairy Bar—a lunch counter and ice cream shop that served food, soft drinks and dairy products— was located at 426 South Market Avenue in the 1940s.

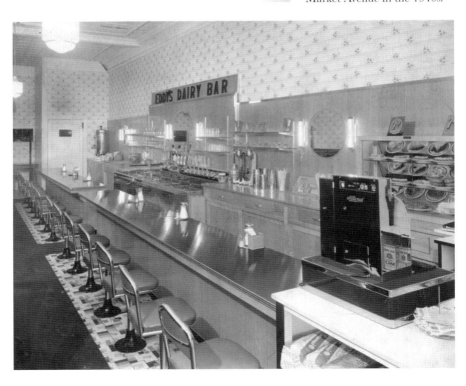

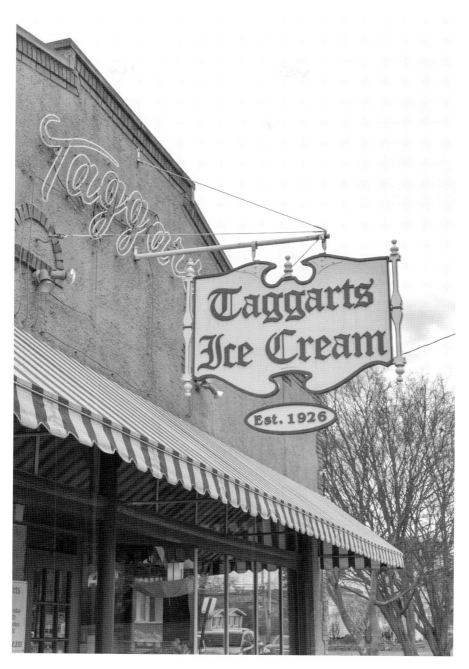

Taggart's was founded in 1926 and is a popular ice cream shop in Canton. *Authors' collection.*

in the middle of an urban neighborhood. According to Ernie Schott, the current owner, the storefront was constructed in 1903 by Dr. Joe Taggart as an addition to a duplex dating to the 1890s. The steps of the original house, which previously led to the front lawn, are still embedded in the existing space. Dr. Taggart was a well-known dentist in town, but he did not use the space for his practice. Dr. Taggart divided the storefront into two shops, as evidenced from the double doors at today's entryway. The door on the right would have led to a bicycle and radio repair shop. The door on the left, the one currently used as the main entrance, would have led to a soda fountain shop called Stewarts Ice Cream. It operated as such for more than twenty years, until Dr. Taggart's son, Joe Taggart, took over.

Joe Taggart Jr. had gone to the Ohio State University and obtained a degree in agriculture, and upon returning to Canton in the early 1920s, he worked at the Sanitary Dairy Company, which was located on Cherry Avenue in downtown Canton. While working there, Joe concocted many delicious ice cream recipes. He eventually decided to open up his own ice cream shop by taking over his father's building in 1926 and renaming it Taggart's. Joe partially removed a section of the wall that had divided the two spaces. In addition to ice cream, a variety of soups, sandwiches and salads was added to the menu. "He put the dining room and the arches in, and all of the high-backed wooden booths," said Ernie. The marble counter in the front room came from a bank. Ernie added, "It's so heavy, we've never moved it."

Since the beginning, Taggart's ice cream has been made on the premises, with original recipes. "All 14% butter fat," Ernie states proudly. "The ice cream is made right behind the counter, then it's quickly moved to the original hardening room, which keeps the ice cream very cold."

The most popular and well-known item on the ice cream menu is the Bittner, a whopping three-fourths pound of vanilla ice cream mixed with homemade chocolate sauce, topped with double buttered/double salted pecans and whipped cream. The dessert is similar to the consistency of a milkshake but thick enough to eat with a spoon. Over

The Bittner is the most popular item at Taggart's Ice Cream Parlor. *Photo by Shane Wynn.*

128

the years, there have been varying stories as to its origin. According to Ernie, there was a Bittner Hardware Store, located on the corner of 30th Street and Cleveland Avenue. The store sponsored a ball team. "The boys would come in, and they wanted something heavier than a milkshake. They kept taking the milk out until the iced tea spoon would stand up in it and not fall over." They named it after the ball team's sponsor.

Joe Taggart got out of the business in 1958, and Taggart's went through several owners from the 1960s through 1998, when Ernie and Patty Schott acquired the business. Ernie said that the building needed a lot of attention. "Every other main window at street level was boarded up, and all the top windows were boarded up. Steve Coon [local contractor] did an amazing job restoring the building, and when we opened back up, we went from 12 employees to 41 really quick." Ernie has recently turned over operations to his daughter, Mindy, who keeps the 1926 business going strong. It's a popular place for young and old, and it stays open during the winter months as well. The family also owns and operates Kennedy's Bar-B-Que and a second Taggart's location at the historic Isaac Miller Inn in Magnolia.

Restaurant menus from the past often shed some light on what kinds of foods used to be popular. Some of the options are indeed strange to the modern diner. On Thanksgiving Day 1900, the Hotel Yohe was open for dinner with a lengthy selection of menu items, including Broiled Quail on Toast, Fried Rabbit, Braised Calf Sweet Bread au Petit Pois, Roast Young Goose, Shrimp Salad and New York Cream Cheese. The Purple Cow, located at Hotel Belden, had several unique items on a menu dated around the 1940s: Sauerkraut Juice, Braunschweiger Liver Sandwich, Pickled Red Beets, Buttermilk (as a beverage option) and Sliced Corned Beef or Tongue Sandwich. An undated menu from Mergus includes the following items: Tender Frog Legs, Fresh Calves Sweetbreads and Mushrooms. An undated menu from the Hofbrau restaurant at Meyers Lake featured the following unusual sandwich fillings: Limberger, Goose Liver and Fried Egg & Lettuce.

Some of the best insight about what people were eating in Stark County comes not from restaurant menus and advertisements, but from banquet menus, which were held at both restaurants and rented halls with catering services. Unlike restaurant menus, which people are not supposed to take home and, if they still exist, rarely have a date printed on them, banquet menus are a keepsake from a specific event that was often saved.

On March 15, 1890, Alpha Tau Omega fraternity at Mount Union in Alliance held a mid-year banquet that included the following menu items:

chicken broth, white plume celery, pickles, olives, chow chow, baked white fish, Lake Superior trout, tomato catsup, Halford sauce, chili sauce, Armour's tenderloin of beef with mushrooms, young chicken fried, Lyonnaise potatoes, mallard duck, lamb chops, current jelly, French peas, Saratoga chips, chicken salad, bananas, Catawba grapes, Florida oranges, ice cream, strawberry short cake and assorted cake, tea and coffee. Guests sat down to their feast at midnight.

The menu of the Semi-Annual Social Session of the Canton Medical Club at the Hurford House on November 11, 1895, included broiled quail on toast. At the Annual Christmas Dinner for the News Exchange Company's Carriers on Christmas Day 1895, also at the Hurford House, the menu included small patties of chicken, pineapple beignets with rum sauce, Christmas plum pudding with a brandy sauce and wine jelly. The High School Alumni Fourth Annual Dinner, held on June 16, 1898, featured Roman Punch, sweetbread patties ("sweetbread" is the culinary name for the thymus gland or the pancreas, especially of calf and lamb) and ham, turkey and tongue sandwiches.

At the Board of Trade Banquet on February 22, 1898, menu items included California salmon with hollandaise sauce and Nesselrode pudding, a frozen ice cream dish named for nineteenth-century Russian diplomat Count Nesselrode, according to the James Beard Foundation. The foundation's recipe calls for currants, raisins, cognac, egg yolks, sugar, heavy cream, candied chestnuts and vanilla. Highlights of the Board of Trade's 1900 banquet menu were French lobster, pistachio ice cream and something called "Magnetic Magnesia Water." According to an article in the *Stark County Democrat* on April 27, 1900, the use of this locally occurring magnetic magnesia water "has been recommended, on account of its medicinal qualities for many disorders of the stomach, and general toning up of the system." The article described the many transfers of the land on which the spring was located, with many familiar names owning it at one time or another, including Bezaleel Wells, the founder of Canton, and James Saxton, Ida McKinley's father. In 1884, the owners drilled for gas, but instead "a fine spring of water gushed forth which is running today." The well was located in the southeast section of Canton. Even President McKinley believed in the benefits of this amazing locally sourced water. A May 1, 1900 article in the *Stark County Democrat* noted:

> *While President McKinley was in Canton he used Magnetic Magnesia Well Water. The president when he formerly lived in Canton used the*

water and knew of its excellent qualities. Thursday, when his private car Olympia, left Canton, four cases of the water were on board and from what the president stated regarding the water it will likely be used on the White House tables.

Dr. Rixey, Mrs. McKinley's physician, who accompanied the president on his visit examined the water and looked up the analysis. He pronounced the water as being most excellent for table use.

There have been many restaurants in Stark County over the years. Some have stood the test of time, while others were little more than a flash in the pan. The ephemeral nature of restaurant menus means that most are lost to history, leaving no archival evidence of their existence. Others may have placed ads in local newspapers, capturing a snapshot of the food they served. Today, Stark County boasts hundreds of restaurants, ranging from quick bites to fine dining and everything in between.

FAMILY RECIPES AND AMATEUR COOKBOOKS

For many home cooks, providing tasty and nutritious meals for their families is the ultimate expression of love. Although family recipes are not generally considered "secret," they are definitely "hidden" in the historical record. A limited number of handwritten, kitchen-splattered recipe cards and notebooks have been preserved in museum collections, but these treasured tastes of home emerge every so often in the cookbooks compiled by community organizations over the years, such as *Palate Pleasers* (Canton Fine Arts Associates, circa 1985), *100 Years of Good Taste* (Stern & Mann, 1987), *Aultman Health Foundation Employee Cookbook* (1996) and *Cooking for the Spirit, Mind & Body* (North Canton YMCA, 2002).

In today's technologically savvy world, most people store recipes on Pinterest or in "virtual recipe boxes" on sites like Allrecipes and Taste of Home. Historically, the home cook collected her best and most favorite recipes on paper, usually in her own handwriting. Betty Odar, a longtime Canton resident, donated her wooden recipe box filled with handwritten recipe cards to the McKinley Presidential Library & Museum several years ago. Neatly organized with tab dividers, Odar's recipes are recorded on 4x6 notecards, some handwritten and some typed on a typewriter. They are well used. Many are splattered with ingredients or ink smeared from an accidental splash from the sink. The recipes are personal, chronicling the kitchen life of one twentieth-century home cook. She has pasted a clipping for "Foamy Sauce" onto a card that reads "English Plum Pudding." At the end of a recipe for Bread and Butter Pickles is a note that reads, "The lady

who gave me this said not to use too strong vinegar but I'd rather use an extra cup of sugar and leave the vinegar as is." One curious card preserves pasted clippings that read "Try This Simple Method for Blackheads," "Smeary Mahogany," "Curling Fluid for the Hair" and "Baked Cabbage."

In the early 1920s, Gertrude Gnagy collected her recipes in a small, plain notebook, in which she handwrote recipes, helpful hints and notes about balanced meals. On an early page, pencil worn from age, Gnagy drew and numbered the parts of a cow: neck, chuck, ribs, shoulder, fore shank, brisket, cross ribs, plate, navel, loin, flank, rump, round, second cut round and hind shank. Her carefully recorded recipes include Scalloped Ham and Potatoes, Fricasse Chicken, Swiss Stake (*sic*), Chicken and Sweet Potatoe (*sic*) Casserole, Cream of Pea Soup, Raisin Bread, Mayonnaise Dressing, Waldorf Salad with Cheese, Apple Butter and Tomato Jelly. Judging by the amount of splatter on the pages, she used her cookbook for pies more than anything else: Raisin, Cocoanut (*sic*) Cream, Nut, Butterscotch, Chocolate, Peach Custard, Green Tomato and Pumpkin. Other dessert recipes included Busy Day Cheesecake, Tropical Jell-o, Heavenly Hash, Sponge Cake and Oatmeal Cookies. There are a few rather odd recipes to the modern palate in Gnagy's recipe book, such as the following:

BANANA SALAD
Place a lettuce leaf on a salad plate, cut each banana in 2 in the middle, split each half, lay 2 pieces flat side up on the lettuce leaf. Pour on a small quantity of salad dressing and sprinkle generously with ground peanuts.

POTATOE [sic] *PINEAPPLE SALAD*
4 c. cooked potatoes—diced
2 c. fresh pineapple—diced
¼ c. onion—minced
½ c. cooked salad dressing
1 tsp salt
¼ tsp celery salt
lettuce

Combine all the ingredients but the lettuce and mix well. Serve on lettuce. Serves 6.

She hand-numbered the pages and created a brief index on the last page so she could find her favorites quickly and easily.

Although many home cooks created recipes copied by hand in some fashion, cookbook collections were equally popular, particularly in the twentieth century. Michelle Moon, author of *Interpreting Food at Museums and Historic Sites*, warns us about what she calls "the cookbook trap." Just because someone has purchased a fancy Martha Stewart or Williams-Sonoma cookbook, it does not mean that they actually cooked from it. Many home cooks aspire to such recipes but may or may not attempt to make them. The mere presence of a cookbook in a home cook's collection does not provide sufficient evidence that he or she actually mastered Julia Child's Boeuf Bourguignon, for example. But recipes carefully chosen for inclusion in a cookbook to be shared with the community are by their very nature "tried and true." These cookbooks offer us a glimpse of what our community was eating at the time they were created.

One of the earliest amateur cookbooks published in Stark County is *The Canton Favorite Cook Book*, compiled by the Ladies of the First Baptist Church in Canton in 1896. The Ramsayer Research Library's copy of the book is inscribed, "Miss Francis Smith, Christmas 1896." The "Greeting" begins with the following poem by Owen Meredith: "Man may live without friends, man may live without books, / But civilized man cannot live without cooks."

The recipes are presented in paragraph form, without the standard ingredient list and step-by-step instructions modern cooks have come to expect. There are no illustrations, only advertisements for local businesses that likely financed the cookbook's printing. Each recipe is attributed to its creator, although she is identified only by her husband's name if married and usually by her initials if single. The recipes are divided into chapters, some familiar and some lost to time, including: Breads; Biscuits, Gems and Muffins; Beverages; Cakes; Frosting; Catsups; Cookies, Snaps &c; Custards, Creams and Desserts; Confectionary; Doughnuts and Jumbles; Fish, Oysters and Game; Fragments; Ice Cream and Ices; Jellies and Jams; Meats; Meat and Fish Sauces; Pancakes and Waffles; Poultry; Pies; Puddings and Sauces; Sauces; Pickles; Soups; Salads and Salad Dressings; Sandwiches and Eggs; Vegetables; and Miscellaneous.

The chapter on cakes begins with the unattributed quote, "Let appetite yield to reason." Delectable recipes for all sorts of treats follow, including Chocolate Cocoanut (*sic*) Cake, Ice Cream Cake, Never Fail Cup Cake, Economical Layer Cake, Gentleman's Favorite Cake, Rough and Ready Cake, Poor Man's Pound Cake and multiple versions of Fruit Cake and Hickory Nut Cake. A curious recipe is attributed to McKinley, yet it was not contributed by the president's wife or mother:

McKinley Food
One-fourth cake baker's chocolate, grated, one-half cup boiling water over chocolate, one teaspoon soda; mix and let stand while preparing the rest; two cups brown sugar, two eggs beaten separately, one-half cup butter, one-half cup sour milk; two and one-half cups flour, mix and stir in the chocolate and bake. Filling: Two cups brown sugar, two-thirds cup sweet cream. Flavor to taste and cook like taffy. This makes three layers. Emma Zopf.

No baking instructions are included in this recipe, or most of the others, which means the writer assumed the cook was already familiar with the basics of baking. An experienced cook would know how hot to bake something and for how long.

Although this recipe was not contributed by the McKinley family, First Lady Ida McKinley and Nancy Allison McKinley, the president's mother, each contributed multiple recipes. Mrs. William McKinley Sr. (Nancy) shared her recipes for Johnny Cake, Rolls, Hickory Nut Cake, Soft Ginger Bread, Charlotte Russe, Flannel Cakes, Plum Pudding and Tapioca Pudding. Mrs. William McKinley (Ida) submitted her recipes for Corn Muffins, White Layer Cake and Chicken Croquettes, which was republished in the *Honolulu (HI) Star-Bulletin* on September 7, 1962: "To the chopped chicken add a little sage, then stir in the chicken gravy and some fine cracker crumbs, dip in beaten egg, then in cracker crumbs, and fry in hot lard."

Journalist June Crosby recalled that the recipe was the first entry in her grandmother's cooking scrapbook, which she began compiling as a new immigrant from Sweden. Mrs. McKinley's recipe was vague, like the other recipes in the cookbook, so Crosby modernized it for her readers:

Chicken Croquettes

2 cups cooked chicken, finely chopped or minced
1 tsp powdered sage
1 cup chicken gravy, thick type
2 cups fine cracker crumbs
1 egg, slightly beaten
2 Tbsp water or milk

My suggestion to modernize and clarify the recipe are: Use about half of the cracker crumbs to blend with the chicken and gravy mixture, enough to make a substantial pyramid or cone-shaped croquette when patted together.

Then dip in beaten egg, which has been diluted with water or milk, making sure you cover the entire area with the egg mixture to prevent the fat from penetrating. Then roll in the remaining crumbs, coating well. Dry the croquettes and chill for about two hours. Place 4 or 5 croquettes in a frying basket at a time (no more) and fry in shortening or other deep fat, which has been preheated to 385 degrees, until they are a delicate brown. Drain them on brown paper and serve with additional gravy or mushroom sauce. To reheat them, place in a 400 degree oven for a few minutes. This recipe will make about one dozen small croquettes.

Many of the recipes have exotic-sounding names that were once commonplace or ingredients that were standard fare in 1896 that have since fallen out of favor. Some of the most unusual recipes found in *The Canton Favorite Cook Book* include the following:

Ripe Grape Catsup
Five pounds grapes, one pound sugar, one pint vinegar, one tablespoonful salt, one tablespoonful pepper, one teaspoon each of allspice, cloves, and cinnamon. Cover the grapes with water, cook ten minutes, then rub through a sieve so as to remove all skin and seed. Add the ingredients and boil twenty minutes or until a little thicker than a cream. Bottle and seal. Mrs. G.M. Wood.

Schmierkase
One gallon sour milk, place where it will keep warm until the water draws all over the top, then pour in a three-cornered bag and let drip for twelve hours, turn out in a bowl, mash fine, salt to taste, then beat light with one pint of sweet cream and serve. H.R. Schweitzer.

Calf's Brain with Tomato Sauce
Clean and par-boil two sets of calf brains, put in cold water and lay on sieve to dry; when dry roll in seasoned egg and dry bread-crumbs, and fry in boiling fat. Sauce: One quart of tomatoes, cook until tender, strain through sieve, mashing pulp through also; roll one tablespoonful of butter in one tablespoonful of flour, add to tomato while only warm, then return to stove and stir constantly until thickened; set on back of stove and cook slowly for five or ten minutes, add salt and pepper to taste, pour over brains and serve immediately. H.R. Schweitzer.

In 1909, Canton Home Candy Makers published an expanded and illustrated second edition of its cookbook, *The Art of Home Candy Making*. Not only did the book include candy recipes, but it also provided detailed instructions on several methods of candy making—plus "the causes of failures explained" after each section. "It is our desire to teach each patron the art of candy making, and we hope that you will not hesitate to take advantage of our generosity in assisting you over the little troubles that may arise."

The first paragraph of the section titled "General Instructions" acknowledges the difficulty of learning to make candy: "Candy making is usually associated with memories of burnt fingers, ruffled temper and worn-out physique, because past attempts have been unsatisfactory and wearisome. We have solved the problem for you, and your failures will be turned into a never-ending list of successes. We teach you a practical, reliable method, such as is used by the professional candy maker." The writers encourage home candy makers to examine the recipe after a failure, to ensure that every step has been performed perfectly. In the event that she could not figure out her mistake, the writers encourage her to write to them, enclosing a stamp for a reply. Toward the end of this section, the writers offer perhaps the most sage advice regarding candy making: "Do not attempt to cook candy and do something else at the same time, but give it your undivided attention, as that is much better than cooking a batch a second time."

Next, the Canton Home Candy Makers list essential candy making tools, including a thermometer, marble slab, scraper, wooden paddle, spatula, kettle, funnel, candy hook, gloves, double boiler, dipping wire and molds. The following section explains the ingredients needed for the recipes: sugar, confectioner's sugar, water, milk, glucose, corn syrup, chocolate, flavors and colored pastes. The cookbook contains recipes for a wonderful array of sweets, including bon bons, wafers, caramels, taffy, brittles and fudge.

In keeping with their goal of explaining the process to their readers, in a section on how to coat chocolates the writers point out how the weather can influence your results: "Dry weather is by far the most satisfactory. The chocolate is easier to handle, works better and coats with more luster. Rainy days are disastrous to the chocolate candies. Do not attempt to coat on a rainy day. The coating becomes grey and as the moisture in the air prevents the chocolate from setting quickly, the results are discouraging to the amateur. Even the professional chocolate coater looks with disfavor on rainy days."

Around 1920, the Canton Branch No. 23 Catholic Ladies of Columbia published a *Cook Book and Directory*. On the first page, the committee noted,

"Cook books have two reasons for existing, first, that those who have to prepare food for the Family may know what dishes to serve, second, that they may know by what methods they can prepare these dishes. It is hoped that this Book will be helpful to those that receive it." In addition to the group's favorite recipes, the *Cook Book* provided important health guidelines for its readers, including an outline of "Daily Food Needs."

The *Cook Book* also contains some unusual recipes for sandwiches:

HOT LETTUCE SANDWICHES
Spread two slices of bread with bacon fat. Brown in a skillet. When done quickly dip a few leaves of lettuce or dandelion in vinegar. Sprinkle with minced onion and lay between slices of toasted bread. Serve immediately.

ORANGE SANDWICHES
1 cup powdered sugar
1 tablespoon orange juice
1 cup crystallized orange peel

Moisten sugar with orange juice, add finely cut crystallized orange peel. Spread thinly cut slices of bread with creamed butter, and then with the mixture. Combine slices to make sandwiches. 6 sandwiches.

A section called "Frozen Salads" also has some curious recipes, including this one:

FROZEN TOMATO SALAD

1 can tomatoes
1 onion (small)
1 teaspoon sugar
½ teaspoon salt
1 peppercorn
1 teaspoon pepper
Bit of bay leaf
2 teaspoons granulated gelatine
2 tablespoons cold water
1 tablespoon cider vinegar (mild)

Cook tomatoes with onion, sugar, salt, peppercorn, pepper and bay leaf. When thoroughly cooked, strain the mixture over the gelatine which has been soaked 5 minutes in the water. Stir until the gelatine is dissolved. Add the vinegar. Turn into a mold, pack in ice and salt and freeze. Serves 6.

The Welcome Class of St. Paul's U.B. Church published its cookbook, *Cooking Recipes*, in 1928. A curious recipe for Ice Cream Cake did not actually contain ice cream at all:

ICE CREAM CAKE
2 cups granulated sugar, ⅔ cup butter, 1 cup sweet milk, 3 cups flour (sifted), 3 tablespoons baking powder (sift with flour), whites of 3 eggs beaten light, vanilla. Mrs. Dieringer.

The recipe contains no instructions for baking the cake, relying on the homemaker's general kitchen knowledge. Other peculiar recipes included Mashed Potato Doughnuts, which called for equal parts mashed potatoes and brown sugar (2 cups each); Vegetable Loaf, with "ground round steak" listed as the first ingredient; and Toothsome Sandwiches, whose ingredients weren't that odd (it was basically egg salad with nuts and pickle relish), but the title is.

In 1937, the Children's Mission Inc. of Canton published *The Children's Mission Cook Book*. It contained the usual variety of recipes one would expect to see, but two sections in the back of the cookbook were rather unique. Attributed to Mrs. T.K. Harris, "Suggestions to Tempt an Invalid or Convalescent" begins with the introduction, "Through the kindness of the Dieticians of Aultman and Mercy Hospitals we offer the following suggestions to assist you in serving attractive trays to the normal patient. It is always wise, however, to consult your physician about special diets." Dietary recommendations followed, including suggestions for a Liquid Diet, Soft Diet and Light Diet, with recipes for Gruel, Barley Broth, Beef Tea, Chicken Broth and Creamed Chicken.

The second interesting section focused on foods to prepare especially for children. It begins with "Luncheon Party Menus for Children Six to Twelve Years of Age," submitted by Mildred MacKenzie. The menu suggestions are far from what one would expect at a modern children's party: Creamed Chicken, Lamb Chops, Buttered Peas, Creamed Carrots, Salmon Molds and Lettuce with Deviled Eggs.

Amateur cookbooks are often used as fundraisers for their organizations, but in times of crisis, cookbooks can be used to help mobilize home cooks to support a cause. During World War II, the Demonstration Committee of the Canton Women's Council of National Defense issued a cookbook called *War Service Recipes: Food Will Win the War*. The introduction stressed the impact a woman could have on the war by following the guidelines set forth by the government and taking it a step further on her own:

> *You would give your life for your country. You would scorn an American whose patriotism ended with waving flags, cheering the troops and standing up when the band plays. You want to serve your country. Are you willing to do what your Government asks? Are you willing to follow directions? It is the patriotic duty of every woman to follow the advice and recipes contained in this book. The price of 10 cents covers the actual cost of printing and paper.*

The pages were filled with recipes for "meat extenders" and meatless entrées such as Baked Eggs with Cheese, Cabbage Rolls with Rice and Welsh Rarebit. Women were urged to use less sugar in their tea or coffee and not to "let sugar remain in the bottom of your tea cup." Suggested sugar substitutes included molasses, honey and syrups. Women were urged to "save sugar and fats all the time." The Girl Scouts were in charge of collecting kitchen fats.

The cookbook called on women to give up meat at least once a week, even going as far as to dictate that the meatless day should be Tuesday. "This means no meat of any kind on that day," the cookbook instructed. Research showed at the time that Americans were eating three times the amount of meat that they actually needed in their diets. Fish and poultry were recommended instead because they could not be easily shipped overseas.

The cookbook also encouraged the use of corn in cooking because America was producing thirty bushels of corn per capita but was only eating one. "Corn is cheapest of all cereals with regard to nutritive values," the cookbook said. "The more corn we use the more wheat we have to send across the water." All of these sacrifices were framed within a heavy cloak of patriotism:

> *The man ruled by appetite is not the free man. Perhaps the Kaiser thought we were ruled by appetite. If he did, no wonder he thought we were conquerable. We not only think, but know that we are unconquerable, that*

we will never acknowledge, nor submit appetite or Kaiserism, or any other power save that of self-government, which is the gift of Almighty God, the Everlasting Father, the Prince of Peace.

Nationally, cookbooks and pamphlets were widely available to help home cooks stretch their food budget with patriotic flare. For example, a Royal Baking Powder cookbook offered a recipe for "One Egg Victory Cake," while the *Modern Hostess Cookbook* featured "Economy Loaf," a mixture of potatoes, vegetables, bread crumbs and canned tomato soup.

Eating together as a family was standard in the mid-twentieth century, but today so many Americans have moved away from the act of sitting down to eat together that an entire nonprofit organization has been created and devoted exclusively to family dinners called The Family Dinner Project. In 2018, the website touted its founders as "men and women from a variety of personal and professional backgrounds who are brought together by a shared belief in the power of family dinners."

The website listed an array of drop-down menus, such as "How to Get Started," "Topics for Conversation," "Videos," "Before and After Photos," "Parenting Groups" and "4 Weeks to Better Family Dinners." A thorough list of Frequently Asked Questions answer basic inquiries such as, "Why should we eat dinner together more often?" or the more specific, "Do you have any conversation ideas for children ages 9–13?"

Last but not least, or rather first and foremost, is the attention-getting bullet points on the home page—a list of the benefits of family dinners:

- *Better academic performance*
- *Higher self-esteem*
- *Greater sense of resilience*
- *Lower risk of substance abuse*
- *Lower risk of teen pregnancy*
- *Lower risk of depression*
- *Lower likelihood of developing eating disorders*
- *Lower rates of obesity*

In an article called "Why We Eat Together" in the November 26, 2015 issue of *The Atlantic*, Louise O. Fresco noted, "The human is the only animal species that surrounds its food with rituals and takes account of hunger among others who are not direct relatives. The table makes us human." But practices have veered away from that, largely to save time. Prepackaged or

frozen, ready-to-go meals are widely available and only require a few pushes of microwave buttons to reheat. The only thing needed after that is a fork and a napkin. Oftentimes, not even a table or chair is required.

In 2018, the television show *Portlandia* created a sketch based on an imaginary restaurant where people dine standing up, leaning over individual kitchen sinks, complete with background "music" resembling the humming noise of a refrigerator. The sketch, done in the form of a commercial, pokes fun at the fact that people with busy and hectic schedules come home hungry, have no other dining companions and aren't willing to spend time putting together a decent meal for themselves or washing dishes. The sketch starts out with actor Fred Armisen filling his arms with myriad items from the refrigerator and taking them over to the kitchen sink, with a dramatic voiceover stating, "You're home, you're hungry, but you're too lazy to properly make a meal or set the table for yourself. So you decide to stand by the sink and wolf down whatever resembles a meal. It's an isolating experience—but *now* you can enjoy eating with others in a way you enjoy eating it most: single and hunched over a sink!"

The sketch goes on to show a restaurant with individual diners standing up and eating items such as restaurant carry-out, peanut butter on crackers and deli meat, all while leaning over individual sinks. This parody plays on what Sophie Egan lays out in her book, *Devoured*. "The idea of snacking as a meal has become reality," she said, because "we need immediate gratification…we feel so pressed for time, we will go so far as to purchase a four-minute microwave entrée over a five-minute microwave entrée." This need for efficiency, she said, has contributed to a decline in home-cooked meals. She points out that instead of "cooking" at home, it is often mere "assembly." Americans spend less time cooking than people in any OECD countries (Organization for Economic Co-Operation)—just thirty minutes per day. In 2014, under 60 percent of the dinners we ate at home were actually made at home. In 1984, it was nearly 75 percent. Of all our eating occasions, nearly half involve exclusively prepared foods and most involve at least some prepared foods.

Although home-cooked food trends have drastically changed over time, enjoying a meal together as a family is universally a cherished memory, even if busy modern families only make time for such an event for a holiday or special occasion. While we might not choose to make Calf's Brain with Tomato Sauce, Quail on Toast or Hot Lettuce Sandwiches, almost every family has one or two recipes that have stood the test of time and continue to provide comfort and nourishment to all who share a meal together.

ETHNIC INFLUENCES

Although modern demographics show that Stark County is 87 percent Caucasian, 8 percent African American, 2 percent Hispanic and 1 percent Asian, a great deal of diversity is hidden within those statistics. "Caucasian" encompasses many nationalities that were once considered "foreign." As these groups moved into Stark County, particularly at beginning of the twentieth century, they brought with them their culture, customs and food traditions.

Most of Stark County's early settlers were of German descent, known as the "Pennsylvania Dutch." English settlers came here primarily from Maryland and Virginia, with some from Philadelphia and Connecticut. French settlers arrived in Stark County in 1826. "Five French families of Alsace, agriculturalists by occupation, came by way of New York, the Hudson River, the Erie Canal to Buffalo schooner to Cleveland and overland to Canton," said E.T. Heald in *A Brief History of Stark County*. They established themselves in Harrisburg, Louisville, Strasburg, Maximo and Canton. Little is known about the foodways of these early settlers, but the German influence continues to the present day with, for example, the tradition of pork and sauerkraut at midnight on New Year's Eve. When Bender's changed its menu in October 1909, an ad in the September 5 issue of *The Repository* described it as a "New German Restaurant." There were still a few restaurants featuring German fare into the twenty-first century, including Mozart's and the Geisen Haus, but both have since closed.

At the turn of the twentieth century, Stark County's industries were booming, and business leaders needed more workers to fill the increasing number of factory jobs available. "To supply workers for its growing industries Stark County had to do what the rest of America was doing," said Heald, "put on a giant recruiting campaign for workers. As a result the foreign white stock shifted from north-western Europe to an increase recruited wholly from southern, central and eastern Europe."

Travel agencies formed primarily to facilitate the transportation of new immigrants to Stark County. Organized in 1909, the John Jacob Insurance and Travel Agency "chartered railroad cars to transport 30 to 40 immigrants at a clip from Ellis Island to Canton," said Heald. "The Agency sold prepaid tickets to friends or relatives in this country and sent the tickets to prospective immigrants. Agency representatives met the immigrants at the boats.... They soon found employment as the rapidly growing industries were clamoring for labor." The average cost for a steerage ticket from Italy to New York was twenty-seven dollars, not a small sum in the early 1900s.

From 1900 to 1920, the foreign-born population of Stark County increased from 10,838 to 24,396. The countries of origin dramatically changed as well. The following tables show the number of immigrants and their countries of origin in 1900 and 1920, according to Heald:

1900

Germany	5,074
England	1,214
Switzerland	1,167
Wales	597
France	572
Ireland	498
Scotland	309
Austria	293
Russia	191
Italy	166
Hungary	164

	1920
Italy	3,151
Germany	3054
Austria	2,642
Greece	2,494

Hungary	1,934
Romania	1,520
England	1,328
Russia	1,070
Switzerland	1,070
Yugoslavia	680
Poland	667
Wales	595
France	521
Czechoslovakia	496
Ireland	436
Scotland	355
Syria	221
Sweden	204

From 1900 to 1920, Stark County's population increased by 87 percent, from 94,747 to 177,218. Not only did the number of immigrants more than double, but there were also now more countries of origin represented than at any time in Stark County's history. Most of these new arrivals settled in Canton, although Massillon and Alliance also became home to some. One hundred years later, descendants of these immigrant groups are still preserving their culinary traditions through festivals and monthly meal events.

Syrian Americans at St. George's Antiochian Orthodox Church in Canton gather once a month to prepare traditional foods for sale at lunch or dinner on the second Friday of the month, except Good Friday. It used to be an annual event, but twenty years ago they made it a monthly affair. It takes a dedicated group of volunteers several days to prepare all of the food items for the menu. Some of the offerings are familiar dishes that have "gone mainstream," such as hummus and tabouli, but others might surprise a first-time visitor. Kibbe, for example, is uncooked fresh ground round steak meat, which contains no fat and is ground twice. The traditional recipe calls for salt, pepper, cinnamon, allspice, grated onion and bulgur. It is mixed by hand, and no measuring cups are needed—the women rely on years of experience in making kibbe. A cross is indented on the top of each batch, before it is divided into portions for sale. For the less adventurous, kibbe is also served cooked.

Other traditional dishes include laban (yogurt); cheese pie; looby, a green bean mixture with tomato sauce and optional beef tips served over

Left: Sadie Kannam makes traditional grape leaves for the St. George's Antiochian Orthodox Church's monthly dinner. They are a seasonal offering on the menu and are only available three times a year. The rest of the year, an eggplant dish is substituted. The grape leaves themselves come from vines grown in the backyards of many of the volunteers. The filling is made of meat, rice and special seasonings, rolled tight and drenched in lemon juice. The grape leaves are cooked with a platter placed on top of them to hold them in place as they steam. *Authors' collection.*

Right: Volunteer Rosemary Shaheen makes several twelve-cup batches of rice, the traditional accompaniment of many of the dishes served at St. George's. She always rinses the starch off of the rice before cooking it, which she notes is "something our people have always done." *Authors' collection.*

rice; and baba ghanoush, a vegetarian dip or spread made from roasted eggplant, tahini and garlic. The desserts are not always traditional items, although baklava is always on the menu. Farina, made with milk, sugar, eggs and flavorings, is served with a simple syrup poured over the top. Other homemade desserts vary month to month but usually include things you'd find at a church bake sale, like brownies and chocolate cake. During Lent, a special meatless menu is served, which includes a lentil and wheat dish, cheese pies and potato salad made with lemon, oil and parsley instead of eggs and mayonnaise.

The meal preparation at St. George's is a well-oiled machine. A laminated grocery list is taped inside the cupboard, where spices are stored in bulk. Meat pies—made with tomato, onion celery, spices, pomegranate,

molasses and pine nuts—are made ahead of time and frozen until Friday. The dough is made from scratch by hand early in the morning to give it time to rise. Each month they make more than two hundred meat pies. Kibbe that will be cooked is usually made one month ahead of time and is also frozen. Chicken, beef and shrimp are seasoned two days ahead of time to make kebabs.

Some foods need to be prepared fresh on the same day they will be served. Recently, by popular demand, an iceberg lettuce salad was added to the regular menu, although not everyone in the group was in favor of it since it is not traditionally Syrian. Salads are prepared fresh in the morning. Around 11:00 a.m., the pace really picks up in advance of the first lunch customers. Veggie burgers—made of chopped zucchini, eggs, flour and seasoning—are fried up just before they open. Kebabs are assembled with meat, onions and green peppers, and chilled dishes are moved from the giant walk-in refrigerator to the buffet line in the church hall. Customers are already lined up when the volunteers are ready to open for business.

The biggest challenge the group faces is getting young people to come in and learn the old ways of cooking. "When someone passes on, someone else starts wearing more hats," said Joe Helaney. The original group of cooks were first-generation Americans, but most of the volunteers today were born here. Arabic is still often spoken between the ladies as they mix kibbe and stuff grape leaves. Almost everyone brings a treat with them for the other volunteers, such as watermelon, fresh figs, spice cake or cheese made from homemade yogurt. The monthly meals connect the cooks to one another and to their church. They bring in a lot of money, replacing bingo as the church's main fundraiser. There is a loyal following of people who come every month, many of whom are not of Syrian descent.

The Ladies Club at St. George's published a cookbook called *From Our Table to Yours* in 2012, which featured both "American" and traditional Middle Eastern recipes, including these two dishes made for the monthly dinners:

RAW KIBBE

1 c. burgul (No. 1)
1 lb. lamb or beef (very lean), ground fine
⅛ tsp pepper
1 Tbsp salt
⅛ tsp cinnamon
1 medium onion, grated

Cover burgul with cold water. Soak for 10 minutes. Work spices, onions, and meat together with fingers; knead thoroughly. Add burgul and continue kneading. Dip hands in ice cold water while kneading in order to soften kibbe (ingredients must be kept cold). Kibbe could be run through a meat grinder once or twice for a finer consistency (this is optional). Place on a platter and serve. Sadie Shaheen.

STUFFED GRAPE LEAVES

grape leaves
2 cups rice
2 lb. ground beef
salt and pepper to taste
1 tsp. dry mint leaves
3 Tbsp. butter
4 cups water

Mix rice, beef, salt, pepper, mint leaves, and butter in large bowl. Set aside. If grape leaves are fresh from the vine, rinse and stack. Boil water in saucepan; remove from stove when water comes to a rolling boil. Put grape leaves, a little at a time, in the hot water for about 3 seconds. Drain and let cool. Take about 1 teaspoon of meat and rice mixture; put on a leaf and roll. Make sure the underside of the leaf is facing up when rolling them. Repeat until there are no more leaves or rice. Lay rolled leaves side to side in large saucepan. Sprinkle about 2 teaspoons salt on top. Lay an inverted dish on top of the grape leaves so they will not unroll while cooking. Add 4 cups cold water. Cover and cook on medium heat on stove for about 45 minutes to an hour. Melia Michael.

Holy Trinity Greek Orthodox Church started its annual Grecian Festival in 1976 to both celebrate the nation's bicentennial and honor Greek heritage. Although the three-day festival includes traditional dance and music, the focal point is always the food. All the culinary delights at the Taverna (restaurant), Gyro Booth and Drive-Thru are 100 percent made from scratch, including all the pastries. Four generations of Greek Americans work together to organize the Grecian Festival each year. The younger generations learn from the older generations by watching them cook.

Food is central to Greek culture, which is one of the reasons many Greek immigrants came to America and ended up in the food business. Larry

Anastas, co-owner of Anastasiades Exclusive Chocolates with his brother, Sam, believes that Greek immigrants came to America and started diners, restaurants, candy shops and ice cream parlors in communities across the country because they came with the skills they needed to succeed in an industry that is always going to be viable. "People have to eat," Larry said. He and Sam have both served as chairperson of the Grecian Festival multiple times over the years. In their book *Greeks of Stark County*, William and Regina Samonides noted, "Early immigrants would often start by selling fruits and vegetables from pushcarts, then open a grocery. Some…also became involved in the confectionary business." They list several examples, including Harry, Jim and George Trifelos, who opened a confectionery on South Market Avenue in the 1920s that sold ice cream and candy with a produce stand in front; Panagiotitsa Biris Eustathios operated Mary's Grocery from her home and later purchased one of the oldest confectioneries in Canton at 330 North Market, which was remodeled in 1949 and renamed the Candy Bowl; George Goglos ran a poultry shop and grocery at 733 Cherry Avenue in the 1920s and later opened Quality Poultry Market at 602 East Tuscarawas Street with his sister-in-law, Margaret; Peter Norris ran a lunchroom on East Tuscarawas Street during the 1930s; William and Sophia Effantis ran the Tip Top Grille at 235 East Tuscarawas Street from 1929 to 1945; Michael Vianos owned a restaurant called Vianos No. 2 at 216 South Market, which was a confectionery and ice cream parlor that also served a light lunch; and John Andreadis opened the first grocery store in the Carnahan neighborhood in the 1910s. In Massillon, James Copanos ran Jimmy's Candy Shop, Steve Nosis owned the Park Way Grille, the Rizos family owned a steakhouse, the Liossis brothers opened a restaurant on the ground floor of the Hotel Vendome and Christ Vlachos opened the Sugar Bowl in 1905.

The Grecian Festival honors the legacy of these early twentieth-century immigrants to Stark County. Many of the traditional dishes sold at the festival can be found in the cookbook *Greek Cuisine*, first published by the Koraes Ladies Society of Holy Trinity Orthodox Church in 1969, a decade before the Grecian Festival began. In 2010, the seventh printing of the cookbook, subtitled the "Memory Edition," was published, which included a rosemary sprig, for remembrance, next to the names of any recipe contributors who had passed away.

In the cookbook's introduction, the ladies wrote, "We take pride in our community as we have many excellent cooks! Each of them adds their own flair in preparation and ingredients to tantalize your taste buds. Orthodox family life encompasses both Faith and Feast, and the cuisine reflects the

sacramental rituals and traditions of the Church. Following periods of fasting, the festive holidays are celebrated with family and friends around tables bountifully laden with rich and elaborate dishes." In the cookbook, Lenten recipes are marked with a cross.

In the foreword, the ladies explain the meaning of food in Greek culture:

When Greeks immigrated to America in the late 1800s and early 1900s, they brought with them their culture, religion, customs, traditions, and their culinary art. Greeks do not consider cooking a chore—it is an ART! Greek cooking and hospitality go hand-in-hand. Hospitality is extended to friends and strangers alike, and it always includes a happy ritual of eating and drinking!

And so, in Greek we say, "KALI OREXI!" Hearty Appetite!

A chef's hat appears next to each recipe that is also an item available for sale at the Grecian Festival, including the following:

LAMB SHANK

6 lamb shanks
1 large onion, diced
2 bay leaves
3 garlic cloves, minced
½ tsp. oregano
½ tsp. black pepper
1 tsp. salt
3 cups beef broth
3 cups ketchup
3 cups tomato juice

Coat shanks in flour and bake for 1 hour at 450 degrees to braise. Add diced onion, bay leaves, minced garlic, oregano, pepper and salt to taste. Cook for additional 15–20 minutes but be careful not to burn onions and garlic. Add broth, ketchup and tomato juice and cook for another 1½ hours. Test meat with a fork to see if it stays on the bone (it should not fall off but be very tender). Serve over rice pilaf. Pete Pappas.

POWDERED SUGAR BUTTER COOKIES (KOURAMBIETHES)

1 lb sweet butter
½ cup granulated sugar
1 egg
1 cup chopped almonds
5–6 cups flour
powdered sugar

Toast the almonds for enhanced flavor. Mix butter and sugar until creamy; add egg and beat thoroughly. Add flour to butter mixture and knead by hand to form a stiff dough; add nuts and knead again. Shape into half moons or roll into balls. Arrange on ungreased cookie sheet and bake in preheated 350 degree oven for about 20 minutes or until lightly browned. Remove from oven and sprinkle with powdered sugar while cookies are still hot. Cool; then sprinkle with more powdered sugar. Helen Tsaftarides.

Other menu items at the Grecian Festival include Fish Plaki, Souvlaki (Shish Kabob), Chicken Oregano, Greek Pita Pizza, Saganaki Platter (fried cheese), Smelts, Greek Fries, Baklava, Tsoureki (Greek sweet bread) and Bougatsa (filo soufflé with syrup).

A second Greek festival, known as Canton GreekFest, is hosted by St. Haralambos Greek Orthodox Church. The church had run Canton Summerfest for thirty years and in 2014 created a brand-new event focused on Greek culture and culinary traditions, which is held on the church grounds in June. The St. George Romanian Orthodox Church's Romanian Festival is also held in June.

In 1986, seven members from the United Italian Central Committee met to develop the Italian American Festival in Canton. The founders included Dominic Bagnoli, Nick Boscia, Mike DeGirolamo, Nick DiSimone, Vince Lemmo, Armen Pileggi and "Coach" Shori. Seventeen Italian American organizations in Stark County sent representatives to help plan the new festival, which was held in downtown Canton from 1987 to 1990. It moved to the Stark County Fairgrounds in 1991 but returned to downtown Canton in 2017. The *festa* celebrates Italian culture through a bocce tournament, an Italian car show and, of course, food. The signature fundraising objective of the festival is to fund scholarships for graduating high school seniors.

Above and opposite: The International Festival of Stark County grew out of Canton's participation in the bicentennial celebration of 1976. Ethnic cultures from twenty-two nations were highlighted in a two-day festival of international folkways. Some of the booths featured ethnic foods, including those representing Africa, Korea, Slovakia and the Ukraine.

In addition to the ethnic festivals held in Stark County, there are several specialty markets that continue to preserve culinary traditions. In the November 8, 2017 issue of *The Repository*, reporter Denise Sautters highlighted many of the ethnic stores in Stark County. Canton Importing, located at 1136 Wertz Avenue Northwest, was founded by present owner Nick Regas's father in 1960 and specializes in Greek and Italian food. "We have a lot of Greek- and Italian-descent customers, but since the Food Network started, foodies of all nationalities come to the store because they want to learn about the foods and taste them," Regas told *The Repository*. "Many of our customers come for the cheese and olives. We sell about 12 to 15 different kinds of olives out of our deli case." Young Oriental Food and Gift Mart, located at 6644 Wise Avenue Northwest in North Canton, has been in business for about twenty-five years, although the present owners just purchased the store in September 2017. "We sell mostly Korean, but we

have introduced more Filipino food since we took over," said owner Shawn Cochran. "Surprisingly, there are a lot of Americans who shop here. We also have a lot of Asians who come." Indo-Asian Foods at 3215 West Tuscarawas Street sells Indian spices, curries and condiments. LaReyna Mexicana at 1123 12th Street Northwest sells authentic sauces, peppers and spices, as well as prepared Mexican foods.

For more than one hundred years, DioGuardi's Italian Market and Deli has provided Italian ingredients and specialty foods for home cooks. In 1906, Antonio DioGuardi opened up a small Italian market in Canton under the family's last name. It was located at the southeast end of the city at 714 10th Street Southeast. This region of the city was known at the time as "Little Italy." The shop enjoyed plenty of customers with a vibrant Italian community in proximity. The market sold freshly made sauce, sausage and meatballs. It also carried imported products and house-made deli salads.

Antonio operated the market for seven years by himself, until his brother, Biagio, came to the United States in 1913 to help him out. Biagio had only been married one year when he came to America, but his wife, Angelina, stayed back in Greci, Italy. They corresponded often by letter, and Biagio

A photo of Biagio and Angelina DioGuardi with a reflection of their name on a freezer case. The photo hangs in DioGuardi's Italian Market. *Authors' collection.*

sent money when he could. In 1920, Angelina, with son Michael in tow, reunited with her husband in Canton. That same year, Biagio purchased the store from his brother, Antonio, who returned to Italy. Biagio and Angelina set up their home in the back of the store and raised seven children, four boys and three girls, while operating the market.

One of the DioGuardi children, Dorothy (who refused to reveal her age in 2018), offered further details. "My mother and dad were born in Greci, Italy, got married there, then my dad came over here to help his brother at the store. By the time my mom came over in 1920, Antonio went back to Italy. From 1920 until my dad passed away in 1961, they operated the store side by side." Dorothy, leafing through photos, paused at the Certificate of Citizenship her father received in 1938. "He was so proud, so proud of this," she said. The certificate, with a small photo of Biagio in the lower left-hand corner, reads that he was forty-nine years of age and 155 pounds, with brown eyes, black hair and a "small scar over [his] right eye." On the line after "former nationality," there is one word in swirly script: "Italy."

Mr. Biagio Dioguardi

Cordially Invites You To Attend

Grand Opening

of the

Heights Super Market

3116 Market Avenue North

Sept. 3rd and 4th 9 A. M. to 9 P. M.

In 1948, for the opening of its new store in the Market Heights neighborhood of Canton, DioGuardi's issued these invitations. *Courtesy of Dorothy DioGuardi.*

Even before he became a U.S. citizen, he greatly helped members of the Canton community during the Depression. Dorothy recalled that her mom and dad would offer items "on credit" since customers did not have the means to pay at that time. She demurred that most of the money was never collected, but "it was okay" she emphasized, since people were down on their luck. "We lived in the back of the store, and all of us helped out as we were growing up." The siblings split duties. Michael was the butcher and made the sausage, Florence cleaned, Virginia made the sauce and "I did the books," Dorothy noted.

In 1941, the family moved from the back of their downtown shop into a home at 26th Street Northwest and Cleveland, in the city's north end. They saw potential in the area, and in 1948, Biagio built a brand-new store at 3116 Market Avenue North because, as Dorothy put it, "everybody was coming up north." An advertisement announcing the grand opening read, "Grand Opening of the Heights Super Market." It operated under that name for more than a decade until, as Dorothy said, "People kept asking if it was the DioGuardi store; they wanted to know if it was the same family, so we put our name back on it." The advertisement lists all the firms that took part in the construction of the building and offered opening day enticements such as "roses for the ladies, cigars for the men, and candy for the kids."

The DioGuardi children grew up, and some moved on to different careers or got married. But some of the girls stayed and continued to help their mom and dad in the grocery business. In 1957, Biagio built a new family home across the street from the store, so they could again be close to the business. Dorothy still lives there. Her father lived there less than five years before he passed away in 1961. Michael took over as manager, and "Mama" DioGuardi, as she came to be known, continued to work there every day.

"She was our supervisor," said Dorothy, emphasizing that Angelina refused to close the store after Biagio passed away.

Dorothy didn't have photos of the earlier store, in the south end of Canton, but she had plenty of photos of her mother, who became very well known during her lifetime for her unending energy and high spirits. In 1991, when Angelina turned one hundred, students at Dueber Elementary interviewed her for a school project. They found her secrets to a long life: "Eat pasta daily, work hard, think happy thoughts, take a walk daily, and don't smoke or drink."

Dorothy took over as manager when Michael passed away in 1987, but in 1991, the remaining family members made a tough decision. They sold the store to Nick and Carol Sylvester so they could take care of their mother, who had been slowing down. The children didn't want to put their mother in a nursing home, so they cared for her in the house until in 1995, when Angelina DioGuardi passed away at age 105.

In 2001, the store was sold to Socrates Karagiannides, but it was taken up again by the Sylvesters when Socrates passed away in 2005. The Sylvesters sold it in 2009 to Gary Mallory, and in 2014, it changed hands to the current owner, Jeff Labowitz. During an interview at the store in 2018, Jeff sat behind a desk in the office, two jars of red pasta sauce the only items of decoration. He explained that the building we were sitting in, which is adjacent to the original store, was purchased only recently. The new addition affords more room and a storage area. We eventually walked through to the original part of the store, passing through the small kitchen, where all the sauce and meatballs are still made fresh several times per week. The sausage is made daily in the basement. These are all made with the original recipes passed down from Angelina DioGuardi. The only thing that Jeff has changed with those three best sellers is the size of the meatballs—they are larger today. The original recipes and ingredient lists for the sauce, meatballs and sausage have remained the same since 1920.

According to owner Jeff, about half of the store's clientele are people who claim at least partial Italian heritage. With millennials cooking less than previous generations, most of the customers are baby boomers. Regardless of age or heritage, everyone who shops at DioGuardi's has an appreciation for fine food. High-quality balsamic vinegar, flavored olive oils, fresh ricotta and mozzarella cheese and six different kinds of salami are just a few of the items available. "This is where good cooks come to get their secret ingredient," Labowitz said.

Stark County is rich with culinary traditions from a variety of ethnic groups that came here for a chance to create a better life for themselves and their families. Through festivals and monthly dinners, Syrians, Greeks, Romanians, Italians and other ethnic groups share their unique recipes and cooking methods for the rest of the county's residents to enjoy. Specialty shops ensure that everyone has access to that "special ingredient" that takes a traditional dish to the next level. As these culinary traditions are passed from generation to generation, the old ways of cooking are preserved for the future.

LEGACY FAMILIES

There is a select group of families in Stark County who have contributed more than most to the culinary fabric of our society. Families who have created a legacy that stretches back generations include the descendants of Max P. Radloff at Minerva Dairy, the Jacob family of Bender's Tavern, the Millers of Hartville Kitchen and the Zellers, who farm Hartville's muck. These families were eager to share their stories, exploring the tenacity of their founders, the vision of each new generation and the ways in which they have continued to stay in business year after year.

Minerva Dairy

You can't drive past Minerva Dairy, off Route 30 in the southeast end of Stark County, without noticing the giant cow. Her name is "Lacey May." She stands at the corner of the Lincoln Highway and Radloff Avenue, symbolizing the dairy legacy of the company she represents.

In the late 1800s, the family of Max P. Radloff emigrated from Prussia and settled in the small town of Hustisford, Wisconsin. At age fifteen, uninterested in learning the family's furniture business, Max left the house to work for different regional cheesemakers. At age twenty, he came back and purchased the Hustisford Creamery, changed the name to Radloff Cheese and incorporated the business in 1894.

Left: Max P. Radloff started Radloff Cheese in 1894. Today, we know the company as Minerva Dairy. *Courtesy of Minerva Dairy.*

Below: Lacey May stands at the entrance to Minerva Dairy. *Courtesy of Minerva Dairy.*

More than a century later, in a small office at Minerva Dairy, the great-great-grandchildren of Max P. Radloff, Adam Mueller and Venae Watts, talked about their family's rich history. From its start in 1894, the company would diversify and innovate through five generations into what it is today: America's oldest family-owned cheese and butter dairy. Adam explained that early success stemmed from Max's problem-solving ability: "Transporting of milk was very difficult in those days. Max taught the farmers to make cheese on-site at their farms, or in nearby facilities." Then Max transported the products. This solved issues on both ends. The farmer could keep the whey, a byproduct of cheese production, and use it in other ways. The farmer also didn't have to worry about transportation.

Throughout the first three decades of the twentieth century, Max built or acquired dozens of cheese-making locations and, at its peak, managed twenty-six sites. Most produced both cheese and butter. A key acquisition in 1935 stemmed from a vacant building in Ohio and concerned businessmen who traveled a long way to find a viable tenant. The PET Milk Company in Minerva had shuttered during the Great Depression. Businessmen from the village made the trip to Wisconsin to see if cheese making would be a good fit. They connected with Max, who purchased the building in Ohio. The site would become known as Minerva Dairy.

Refrigeration and transportation improved in the 1930s and early 1940s, allowing Max to consolidate facilities and focus on just two locations: Minerva, Ohio, and Hustisford, Wisconsin. Two of Max's children, Max Jr. and Roland, would follow their father into the dairy business. The company name changed to Radloff Cheese & Sons. Max Jr. moved to Ohio and became the first cheesemaker at the new facility in Minerva. However, after his wife died unexpectedly in 1938 from complications stemming from the flu, he went back to Wisconsin. In Ohio, it was time for the third generation to step in.

Max's granddaughter, Lorraine, and her husband, Delbert Mueller, got married in Hustisford, Wisconsin, in 1939. Immediately after the ceremony, they put to use one of their wedding gifts, a Model T given to them by Max. The same day as the wedding ceremony, the pair crammed as much as they could into the small car and made the harrowing journey from Wisconsin to Ohio. Adam recalled stories his grandmother used to tell about the trip. They "broke down more than once, and grandma remembers crying on the side of the road while Delbert dealt with tire issues and other problems." Once they reached Minerva, they set up their home in a section of the dairy plant.

Delbert and Lorraine Mueller, circa late 1940s. Lorraine's grandfather Max P. Radloff started Radloff Cheese (Minerva Dairy). *Courtesy of Minerva Dairy.*

They had a rough start. The Minerva plant was dilapidated and in need of much repair, and neither Lorraine nor Delbert could speak English. This shouldn't have been an issue for long, since early America was a melting pot and most ethnic pockets found their niche. But they were in a new town, speaking German, at the height of World War II. Adam emphasized the dire situation this put them in: "Here they are, in a new town, setting up a new business, and they are only able to speak German" at a time when the country was fighting against Germany. During World War I, when Germany was also the enemy, New Berlin became North Canton, and many German-speaking newspapers ceased publication. Anti-German sentiment rose again during the next world war. In order to be accepted into the community, the Muellers quickly learned English and gifted land surrounding the plant to the city to be designated as a park. These and other extensions of goodwill went far to build bridges and warm relations with neighbors and people in town. Adam lamented, "Because of that experience, no generation of ours beyond my grandmother's was ever taught the German language."

They got down to business right away and produced staples like bottled milk, cheese and butter. Lorraine also started an ice cream and sandwich bar called the Minerva Dairy Bar. This was something unique for the area at the time, and townspeople looked forward to its opening with so much anticipation that even though the store opened on March 10, 1939, during a blinding snowstorm, they took in $100 on their first day in business, which

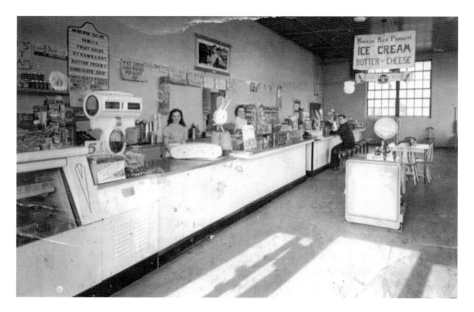

Minerva Dairy Store / Restaurant, circa 1941. *Courtesy of Minerva Dairy.*

they touted as a wild success. That shop would eventually become the present-day retail store.

In 1962, Lorraine inherited ownership of the business when her grandfather Max passed away. The name of the company was changed from Radloff & Sons Inc. to Minerva Dairy Inc. Delbert's death in 1976 spurred Lorraine to begin the process of passing the business on to her son, Phil Mueller. At the time, he was twenty-eight years old with young children—Venae was two years old and Adam had just been born. He took his father's words to heart: "When times get tough, put your head down and work longer hours."

During these years, Phil got up early every morning, went to work, came home to have supper with his wife, Polly, and the kids and then went back to work until 11:00 p.m. The family only lived two blocks away from the plant, so it was easy to go back and forth. Adam and Venae fondly recall swimming at their Grandma Lorraine's house, across an alley from the plant, while their dad was at work, as well as on weekends.

Phil's work ethic and vision led to a major expansion in 1987. The company peaked at 120 employees in the 1990s. Minerva Dairy–labeled products were introduced, including two specialty cheeses: Minerva Lace

and Signature Raw Cheddar. Polly's Parlor—a shop that served sandwiches, hamburgers, ice cream and sodas—operated for about ten years from the 1970s into the 1980s. Outside of the company, Phil created a 4-H program for young farmers to educate them about their cows and production capabilities, which is still ongoing today.

Around 2000, Phil began to hand the reins of the family business over to his children. With fifth-generation Adam Mueller and Venae Watts at the helm, production has continued to increase even though the company averages seventy employees. Adam explained that it's largely due to automation. "We make our butter the same way it would have been made hundreds of years ago. On the cheese side," he said, "we're very automated."

Most people who eat the cheese never know it's from Minerva Dairy because it's used in the food service industry or sold under store brand names. Butter, on the other hand, goes to end users via grocery stores, where it prominently carries the Minerva name. The company's reach is between four and five thousand stores, with core distribution in the Northeast United States. Venae said, "Butter is our baby."

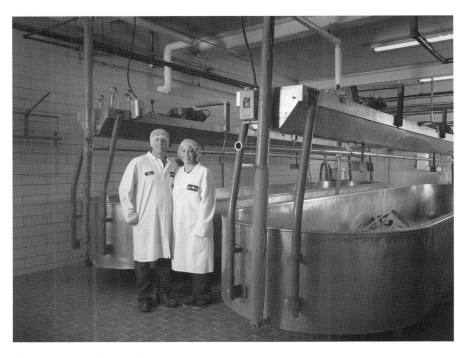

Fifth-generation Minerva Dairy family members Adam Mueller and his sister, Venae Watts. *Courtesy of Minerva Dairy.*

In the Southeast, distribution thins to isolated pockets in Texas and St. Louis, Missouri, although Venae is bent on expanding that reach. "What's trendy now is what we've been doing forever," she said. "We just need to tell people. We're here, and we're in the cool club now." Venae is referring to the fact that butter's popularity waned in the 1970s through the 1990s due to perspectives on health and diet. Butter was a kitchen staple through the 1800s and mid-1900s. Even through the 1960s, as Venae explained, "Pam wasn't yet a thing. It was butter or lard." Adam added, "It's come full circle with our butter….At one point," he said, "Nobody wanted to eat butter. Fat was viewed as a bad thing." Artificial products that didn't have a lot of fat or calories became popular. "Now good fats, dairy fats, have made a comeback." He put it bluntly: "The flavor is in the fat." Current consumers no longer want overly processed foods, and chefs and bakers know that high-content butterfat is more flavorful and stays emulsified when making sauces. Referring to percentage of butterfat, Adam explained, "Commodity butter is 80 percent, European butter is 82 percent and Minerva Dairy Amish Butter is 85 percent." Butter consumption nationwide has grown 10 to 15 percent annually, while margarine consumption has gone down by the same percentage.

While the company's most popular items are private label products and butters in general, the "two pound Minerva Dairy Amish Rolled Butter is the best seller out of all of the butters, or anything with the Minerva label," Adam said. "That's what we're known for." The term "Amish butter" refers to the fat content, and "rolled" stems from the rationing of foods during World War II. "You had butter rationed in 2-pound blocks. Our plant rolled and wrapped it for the customer, and the product stuck even after the war was over."

Adam and Venae value a strong work ethic. "What every generation passes down to the next," Adam started, "is that, 'You are an extension of the dairy farm.' We were instilled with this, and we pass this down to our kids. All kids have chores. At the dairy, we started at a young age." Venae then chimed in, "So when we were little and got in trouble at home or at school, we got grounded. But not 'grounded' in the traditional sense, like, 'go to your room.' No, that would have been a treat! It was, 'You're going to work [at the dairy] *this* day. And *this* day and *this* day!'" For Venae, that often meant washing dishes at the store, even though she was too little to reach the faucet. She remembers dragging over a stool to reach the sink. For Adam, being grounded meant trimming bushes or painting.

For Venae's kids, work is not very far away. The family lives in her Grandma Lorraine's house, which is a few steps from the plant. A larger "family"

The Minerva Dairy family: three generations, including Phil Mueller, son Adam Mueller and daughter Venae Watts. *Courtesy of Minerva Dairy.*

constitutes the many farmers the business relies on for milk. Minerva Dairy takes in raw milk from sixty to seventy farms, most of them within a thirty-mile radius of the plant. The largest farm has more than two hundred cows, but most have fewer than one hundred and some have fewer than ten. Once the milk is transferred from farm to the dairy plant, the cream is separated from the milk and churned into butter, while the milk that's left is used to make cheeses.

"That's an important piece of our operation," said Adam. "The family farms, the pastured cows. We make a lot of decisions thinking about the sixth and seventh generation. We want to make sure that our operation is still here for the next 125 years. And that means we need to make sure that so are the small family farms."

BENDER'S TAVERN

"No more colorful figure ever lived in Canton," read Ed Bender's obituary in *The Repository* on August 20, 1929. He had died unexpectedly while on a fishing trip. "His geniality and rare personality made him known from coast to coast among those who had eaten in the Bender restaurants, or who had heard of them, many people coming from long distances to eat one of the famous Bender Hafbrau meals."

Ed Bender's grandfather emigrated from Germany, settled in Bolivar, Ohio, and then moved the family to Canton. Ed was born in Stark County in 1871 and would marry Anna Behm, whose father served in the Civil War. Ed began building his persona early in life. As a young man, he became enamored of the carnival when Coney Island shipped its end-of-season attractions to Canton and set them up on the space where the Auditorium would later be built. When the festivities ended, Ed, along with partners, purchased the major attractions and started a carnival company. Ed did everything from water the elephants to work in the concession stands.

When he ended his wanderlust days, Ed settled back down in Canton and entered the restaurant business. He took over ownership of a German restaurant owned by John Brobst at 313 East Tuscarawas Street. The already solid reputation of the restaurant mushroomed under Ed's ownership and acquired a following from all over the United States. Ed sold that restaurant and in 1902 opened what we now know as Bender's Tavern at the intersection of Market and 2nd Street South, in downtown Canton, along Court Avenue.

In 1903, Ed opened Bender's Cafeteria at 118 Market Avenue South. An advertisement leading up to the grand opening noted that it is "one of the largest most modern cafeterias in the state" and can efficiently serve eight hundred people with its "battery of pastry ovens, big Garland Ranges, mammoth Refrigerators, Dish Washing and Sterilizing Machines…and best of all…ample storehouses where all the goodies are to be kept."

A large section of the advertisement focused on pie, urging those who don't like it to "get a specialist to examine you, there's something wrong." The ad went on to declare that the French pastry maker they hired "will turn out pies that are like poems, gastronomic symphonies, that will make every turning of your face toward Bender's Cafeteria a happy one." In bold letters at the bottom of the ad, words reassured the public that "The Bender Restaurant on Court Ave and 2nd Street South will not close and will operate exactly as it is now."

The Belmont Building houses Bender's Tavern at 137 Court Avenue Southwest. It was constructed in 1899 and designed by architect Guy Tilden. *Courtesy of the Jacob family.*

Ed was very well known in Stark County. He was the original owner of the Canton Palace Theatre, and he worked with John Abrams to open the first motion picture business in Canton, the Nickelodeon. In 1913, Bender and Abrams opened the Lyceum vaudeville theater. Ed was a member of the Congress Lake Country Club and the "Not Nac" Club, an organization of young men who took the name "Canton" and reversed it. When these same men organized the Camp Kagle group, Ed was one of the leading figures in the organization. Ed was also a director of the George D. Harter Bank. When Ed Bender passed away, his wife, Anna, maintained the restaurant for a few years before John Jacob and his son, Wilber, took over the restaurant in 1932. Wilber's sons, Jerry and Jim, entered the business in the late 1960s. Jerry's son, Jon, came on board in the late 1980s.

In a 2018 interview, Jim, Jerry and Jon Jacob talked about what it means to be the third- and fourth-generation owners of Bender's Tavern and how the restaurant has changed—and how it's stayed the same—over the past 115 years.

Jim recalled how his grandfather John Jacob got started in the restaurant business. "He was a banker in town, and a friend of Ed Bender," Jim said. He took part in the famous Camp Kagle fishing expeditions. "Camp Kagle,

An early photo of the Jacob family. Seated in the middle is John Jacob. Standing second from the left is Wilbur Jacob. Jerry and Jim Jacob are seated on their grandparents' laps in the front row, middle. *Courtesy of the Jacob family.*

2017 photo of the Jacob family. *Front row, left to right*: Joshua, Jessica and Jonas Jacob. *Second row, left to right* Josephine, Jerry, Leslie, Elizabeth and Jon Jacob. Bender's is currently owned and operated by third-generation Jerry Jacob and fourth-generation Jon Jacob. Third-generation brother Jim Jacob retired/ sold in 2002. *Courtesy of the Jacob family.*

Camp Kagle, a fishing camp in the Lower Peninsula in Michigan. John Jacob stands in the center. Camp Kagle walleye is still a popular menu item at Bender's Tavern. *Courtesy of the Jacob family.*

that's where Grandpa would go," he continued. "It was in Michigan. The Lower Peninsula but way up north. This is how we got in the restaurant business: My grandfather used to put on dinners for all his banking customers. They did Camp Kagle Dinners, with walleye, and they'd bring in lobsters and clams." At the camp, they would flour the catch of the day and lightly pan fry it outside with butter, salt, pepper and paprika. Camp Kagle–style walleye is still one of the most popular items on today's menu.

When John Jacob and his son, Wilber, took over the restaurant, they kept the name and major menu items and did not touch the interior décor, which has remained largely the same since 1902. The Tiger wood, mahogany and marble wainscoting are all original. A Dutch painter, in exchange for room and board, painted the murals in the bar area (taproom) as he was traveling through the area. The originals were damaged by smoke from the fire of 1988. An Akron painter, Cal Weinbrenner, restored them in 1991.

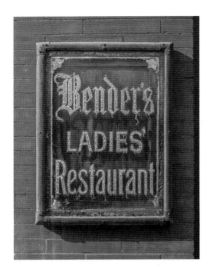

The original "Ladies' Restaurant" sign still hangs at Bender's Tavern. In the early 1900s, high-end restaurants had separate entrances for men and women. The practice was abandoned in the late '30s or early '40s. *Photo by Shane Wynn.*

Also original to the building are signs that read, "Bender's Men's Restaurant" and "Ladies' Restaurant," harkening back to a period of time in the early 1900s when it would have been improper for women to enter through the main door of the restaurant. The "Men's Restaurant" sign was erected at the main entrance, where it hangs today, along Court Avenue. A "Ladies' Restaurant" sign was affixed to the wall at the north end of the building. It has since been moved to the south side of the building, along 2nd Street. An account from the website *History Today* summarizes the culture surrounding separate entrances for men and women at the turn of the twentieth century:

> *In urban America from 1890 to 1920, working-class taverns were known as "saloons" (derived from the French "salon"). Most customers were men who passed through the main door to join their male comrades in the bar-room proper. Many saloons also had a side door known as the "ladies' entrance." The side door for women afforded them quick and convenient access both to the far end of the bar, where they could enjoy lunch and socialize, and eliminated the necessity of their running the gauntlet through the establishment's front room—the bar-room proper—which in this era was still undisputed male territory with its stand-up bar, spittoons, moustache towels, brass foot rails, and other symbols of masculinity. Adventuresome though most saloon-going women were, they were not agitators; their aim was sociability, and their stepping out did not include stepping into bar areas where they were not welcome.*

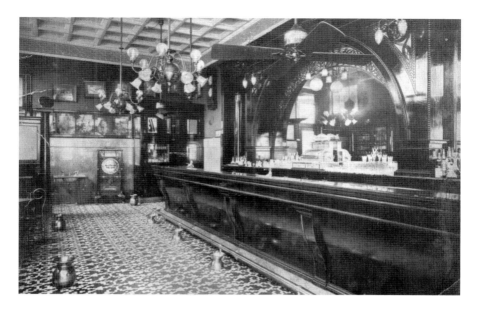

Photo from the early 1900s: Bender's Tavern taproom with spittoons and foot rail on the bar. *Courtesy of the Jacob family.*

Jim Jacob, during the 2018 interview, which was conducted in the bar area of Bender's Tavern, flatly stated, "Women were not allowed in this room. They were allowed in the next room [the main dining room] as long as they were accompanied by a man, and in the far room [referring to the Ladies' Dining Room] they could dine on their own." Both Jim and Jerry estimated that the practice changed in the late 1930s or early 1940s. The family retained the signs on the buildings due to their historical significance and nostalgia. Over the years, they have become a point of intrigue and, sometimes, contention—especially the Men's Restaurant sign, which was, and still is, located at the main entrance.

Neither Jim nor Jerry knew much about how the restaurant operated during Prohibition since operations would have largely still been under Ed Bender's ownership. John Jacob took over the restaurant in 1932, one year before Prohibition ended. Jim did give one interesting tidbit of information, though: "Grandpa had dinners where off-duty policeman were at the door so they could serve liquor."

In a *Repository* article published in 1952, three restaurant owners who began their careers as waiters at Bender's talked about their memories of Ed Bender and the early years at the restaurant. "In those days, as long as Ed Bender was here, liquor was never served to a woman, and he wouldn't allow

EAT AT BENDER'S

MEN'S RESTAURANT LUNCH COUNTER

LADIES RESTAURANT

Positively no Liquors served in Lunch Counter or Ladies Restaurant

An advertisement from 1918 points out that "positively no liquors" were served in the Ladies Restaurant.

them to smoke in here either," said Lester Russell, who worked at Bender's from 1913 to 1920.

"Waiters in those days were required to do a lot more for the customers than they are today," said Richard Massouh, who worked at Bender's from 1925 to 1930. "We used to carve their steaks and their chickens too. Then on Friday, when we served fish, we had to be able to cut it for them so the bones could be easily removed." All the waiters were men in the early years. Women weren't hired until male help became scarce during World War I.

Jerry noted, "When we were little, we used to come in to the restaurant with my dad. We would stay in the Ladies Dining Room while he was working. Access was only through the kitchen at that time." Jerry recalled taking customers through the kitchen in the 1960s and 1970s, until the current hallway was implemented to allow better flow through the main restaurant. Jim's earliest memories of coming into the restaurant included being enamored of the bartenders. "I remember coming in here and watching them work. They were all men at that time. They wore big long aprons and crisp white jackets…and we always had the hand written menu inserts."

As Bender's has transitioned to its third- and fourth-generation ownerships, the spirit of the tavern remains strong as the Jacob family continues to preserve the quality and consistency that Bender's has always achieved. Jerry Jacob, with a Bachelor of Science and food management degree from Miami University, and son, Jon Jacob, who graduated valedictorian with a major in restaurant management from Pennsylvania Culinary Institute, continually guide Bender's restaurant toward a strong future while adding their unique elements, such as Jerry's focus on quality wines.

Some things don't change, however. Walleye, Benders Fries and Turtle Soup are still popular menu items. These have been served in the restaurant, unchanged, for decades. Jon Jacob also added, "Everything was center of

the plate. Salad or vegetable, and then starch. All on different plates....You still see that in this restaurant. It's not common in most." He added, "The best part is the seasonality. Local, seasonal, sustainable....People want to know where their fish is coming from. Where their beef is coming from." The well-worn sandstone threshold into Bender's Tavern is testament to the sign on the building, "Bender's Tavern—Canton's Oldest and Finest."

HARTVILLE KITCHEN

Two acres, one barn and an aspiring auctioneer. In the 1930s, Sol Miller purchased two acres on the corner of Route 619 and Market Avenue in Hartville. His goal was to operate a livestock auction, but the property needed a barn. According to Howard Miller Sr.'s handwritten notes, his father got a lot of help in putting up that barn. His grandfather Menno Miller provided the timber from trees on his farm. A local sawmill cut the lumber. Most of the people who built the barn worked for free, and only two carpenters required payment, in the amount of thirty-five cents per hour. Construction was completed in two weeks.

Once the barn was up, the auction could get started. The main item for sale at that time was livestock. In the mid-1940s, eggs were added, and then people began to inquire if they could sell their produce there. A small flea market was set up, with various stands to accommodate vendors. Both sellers and buyers grew hungry as they worked and shopped. Sol said, "We have to feed them!" His wife, Soloma, set up a lunch counter on the second floor of the barn, where she sold homemade soup and baked goods.

When Sol passed away in 1958, Howard R. Miller Sr. continued to run the auction. In 1962, he purchased the business from his mother and opened up a dry goods store and a coin shop. In 1966, major changes took place. The livestock auction, dry goods store and lunch counter closed, the latter due to a health department inspection that concluded that food could not be prepared and served above livestock pens. These changes paved the way for a decision that would lead to a lasting legacy.

In 1966, Howard Sr. opened up a restaurant called Country Kitchen. It was quaint and cozy, with a lunch counter and seating for seventy-five people. A menu from that period lists dinner costs ranging from $1.25 to $1.50. Children under twelve years of age could eat for $0.75.

Around this time, Vernon Sommers Jr. was dating Howard Miller Sr.'s oldest daughter, Carol. Sommers recalled, "I was dating Carol at the time,

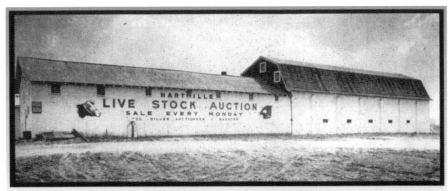

With a lot of help from the community, Sol built his first auction barn. It was only a few cattle pens and an arena, but it was a start.

Above: Livestock Auction Barn, circa 1939. Downstairs was a Live Stock & Egg Auction. The Lunch Stand evolved into a restaurant that would become known as the Hartville Kitchen. The wording on the side of the barn is now a sign displayed inside the Hartville Hardware. *Courtesy of the Miller family.*

Right: Soloma Miller, wife of Sol Miller, who started the Hartville Live Stock & Egg Auction, ran the lunch stand until it became the Country Kitchen Restaurant (later renamed the Hartville Kitchen). *Courtesy of the Miller family.*

Receipt from June 25, 1966, for payment from Howard Miller Sr. to his mother, Soloma Miller, for the pies that she baked at home for the Country Kitchen (later the Hartville Kitchen). *Courtesy of the Miller family.*

Howard Miller Sr. at the egg auction. *Courtesy of the Miller family.*

Country Kitchen menu (later the Hartville Kitchen), circa 1966. *Courtesy of the Miller family.*

and Howard needed someone to run the restaurant. He asked me to take charge of it. I had no background as a restaurant manager, but I liked numbers so I jumped right in." Sommers described how the flea market grew organically. "People would just bring everything." At one point, he ran what they internally called the "junk line," or as Sommers described the scene back then, "People would arrive and there would be so much stuff in their trucks.…We quickly marked some lines on the ground to designate boundaries, they would lay out their items in the grass, and we would auction it right just like that." Sommers would end up marrying Carol. Today, he is president of the Hartville Kitchen. Some of their six grown children work for the company in various capacities.

Into the 1970s, the Country Kitchen became more popular, the flea market and auction were thriving and the Millers also became busy operating the True Value Hardware store they had purchased in 1972. With expansions into other areas, the egg auction closed in 1976 after more than thirty years in operation. According to Howard Miller Sr.'s personal notes, at the height of sales, they auctioned off eighteen thousand eggs per week.

Country Kitchen dining room guests, circa 1966. *Courtesy of the Miller family.*

Lines grew longer at the Country Kitchen, but the name caused major confusion. As Sommers recalled, "There was a 'Country Kitchen' chain of restaurants based out of Cincinnati. One of the restaurants was situated on Waterloo Road in Akron, not too far from Hartville. The confusion came about because my father-in-law didn't believe in having a listed phone at our restaurant. His reasoning was, 'We can't spend time talking on the phone. We need to focus on the customers.'" So people called the Country Kitchen on Waterloo Road, which did have a phone, and thought they were making reservations for the Hartville restaurant. This resulted in confused customers who arrived at the Hartville location thinking they had a reservation but did not. And frustrated staff at the Waterloo Road location wondering why their reservations never showed up. Vernon concluded, "We changed our name to 'Hartville Kitchen,' and it worked out very well."

Another pivotal turning point for the business resulted from a simple inquiry from John Olzeski, who at the time operated an IGA grocery store up the road. The homemade salad dressing at the Hartville Kitchen had become so popular that restaurant staff would spoon it into Styrofoam cups

to satisfy customers who wanted to purchase some to take home. Olzeski recognized the opportunity and asked the Miller family to let him sell the dressings at his store. Sommers recalled, "We thought, OK, we'll give it a try, but we didn't know how to package it for retail. We initially put the dressing in small Dixie cups with lids." The product took off. In 1978, Hartville Kitchen began bottling the dressing in glass jars to sell both on-site and in retail outlets. The original glass mason jar concept is similar to today's packaging. Today, fifteen varieties of salad dressing and two flavors of marinades are manufactured in a plant located behind the Hartville Kitchen.

Throughout the 1970s, the Hartville Kitchen and flea market were so popular that they ran out of parking on busy days. Sommers reflected, "If it hadn't been for neighboring farms offering use of their property for parking, I don't know what we would have done." In 1980, a major land acquisition took place. The Millers purchased 180 acres of farmland to the west of their businesses, with plans to combine all business entities onto one property. In the late 1980s and early 1990s, the Millers' businesses continued to diversify and expand. Hartville Tool, a mail-order business, and Hartville Building Center were developed, in addition to the other established businesses.

In the 1990s, it was time to bring everything together at one site. An article published in July 1992 in *Small Business News/Stark County* focused on the anticipated move. Kimberly M. Dimond, the reporter who wrote the article, quoted Sommers as saying, "Our goal is enlarging, not changing. Everything will be the same, except for the banquet room." Enlarging for the Miller family meant going from 75 seats in a quaint restaurant to 440 seats in a brand-new eighty-six-thousand-square-foot facility with a total of 1,120 seats, including the eight banquet rooms. The article emphasized that the generous portions and home cooking customers had come to love would not change. In 1992, a full meal, including the customer's choice of three side dishes, averaged $6.25.

Hartville Kitchen is remarkable in the restaurant business for a number of reasons. A vast majority of the food that is served in the restaurant and bakery is still, after more than fifty years, handmade on-site with simple, fresh ingredients—even when quantities reach staggering numbers. Sommers said, "Gerber chickens from Holmes County arrive daily. All parts of the chicken are used. What doesn't end up as a main entrée goes into broth kettles" to produce delicious and healthy basic stock to be used for chicken noodle soup or as a base for the other homemade soups that they offer. The chicken stock is also used as a base for their homemade gravy. Potatoes are peeled, sliced and diced for recipes that call for baking—

or are boiled and mashed for their famous homemade mashed potatoes. Sommers lamented, "It'll be a sad day when people don't know what real mashed potatoes taste like."

Pies, bread and rolls are made in-house, even when the quantities of flour, sugar and salt are pre-measured in bucket-size containers versus single-cup scoops. On average, the bakery regularly churns out around twenty varieties of pies. They are all baked on premises, an average of 375 per day, more during the holidays (up to 5,000 for Thanksgiving alone) and not sold anywhere else. The most popular pie is the coconut cream, and the most popular cake is the coconut cake. In 2018, for the first time in restaurant history, a second bakery shift was added due to demand.

Recipes at Hartville Kitchen have stood the test of time and have also stood the test of dieters, food trends and picky eaters. Sommers said, "We are consistent. We offer simple, delicious homemade meals and baked goods, made with fresh ingredients." Many of the soups and pies are made from Soloma Miller's 1930s recipes. At the same time the family honors its roots, the company pays close attention to modern needs and trends. "Today, people are busy, and they are in a hurry," noted Sommers. Prepared meals and carry-out have increased and expanded over the years. A major renovation to the entryway of the Hartville Kitchen in 2017–18 put "grab and go" items front and center when people walk through the main door. The concept of ready-to-go "dinners" has been popular for the past ten to fifteen years. Offerings include packages that serve six, twelve or twenty-four people ranging from full meals to just sides or desserts. Made-from-scratch family meal packages are available Easter, Mother's Day, Thanksgiving and Christmas. "Everything they need is there," said Sommers. "That way they can enjoy a great meal in the comfort of their home with their family, instead of coming out to the restaurant." Online carryout is launching in 2019.

Healthier items have been added to the menu over the years, such as broiled chicken, and the number and variety of salad options has increased. Sommers said the company has also responded to 'Americans' need for choices" and "changing demographics," such as smaller family sizes and married couples who both work and may not have children yet. These customers are looking for something that doesn't need to feed a family of six, and they are looking for options. To accommodate these expectations, the bakery offers cookies in smaller packages, and pies are offered in smaller sizes. That way, Sommers said, "If you like coconut cream pie and your husband likes strawberry, you can take home smaller quantities of each, and both enjoy it."

Even though menu items have remained the same for decades, and the business owners, including *eighty* family members in 2018, have a notorious reputation for humility and modesty, the Hartville Kitchen brand and marketing activities are vibrant, fresh and relevant. YouTube videos walk viewers through various processes, such as boiling down fresh fruit for pie fillings or mixing up a batch of cookies. Some are basic, but some are decidedly humorous and fast-paced: staff goofing off and badgering one another while packaging products for resale or staff being "reprimanded" for "running in the warehouse" while lively music plays in the background. For ownership, just a generation ago, to have thwarted having such "technology" as a land-line phone, the Hartville Kitchen website is easy to navigate and mobile-friendly. The Instagram page offers plenty of mouthwatering foodie shots.

Sommers stated that it is not easy to maintain a made-from-scratch kitchen to feed so many people consistently. But they wouldn't have it any other way. "Nothing is freezer to fryer." It's not easy, he said, because with quality output, "we depend on dedicated, skilled employees." Currently, the Hartville Kitchen employees roughly forty people in its bakery alone, including three full-time cake decorators. To house all of those workers, Sommers said, "Our kitchen is as big as our dining room, and our warehouse is that large as well."

The modest start in 1939 has led to a destination "campus" containing a restaurant, a collectible retail shop, a bakery, a year-round flea market and the country's largest independent hardware store. In 2018, a second Hartville Hardware store opened in Tallmadge. The HRM campus continues to be family owned and operated, has thirteen acres under roof and employs 680 workers, including Miller family members representing the third and fourth generations. As Vernon Sommers stated, "Build a good business on a solid foundation, and people will come."

K.W. Zellers & Son Farms

"If you get off the highway, aside from the alligators, you'd think you were right here on our farms." Jeff Zellers is talking about the unique, rich black soil in parts of Florida and at his farm in Hartville. Muck farms are found in North America throughout the Great Lakes region and in Florida. In Ohio, according to OARDC (The Ohio State University's Ohio Agriculture

Research and Development Center) the state has forty-seven thousand acres dedicated to vegetable farming. According to E.T. Heald's *Stark County Story*, Hartville's muck production started in 1877, after which more farmers followed, eventually clearing nearly two thousand acres of swamp. K.W. Zellers & Son Farms has been in operation since 1926. Jeff Zellers is now one of the third-generation owners. The business side of the story starts with four and a half acres of land. The family side of the story starts in a one-room schoolhouse.

In the early 1900s, Kenneth Wendell Zellers and Helen Laubert were classmates. They attended the same school, situated between New Baltimore and Randolph. When the bell rang to signify the end of the school day, they went their separate ways to help out on their family dairy farms in Marlboro Township, Stark County (K.W.'s family), and Randolph Township in Portage County (Helen's family).

According to handwritten Zellers family notes, while still in high school, K.W. purchased four and a half acres of muck on Pinedale Street from his parents and farmed that land before attending Mount Union College for one year. He would return to Hartville to focus on farming. His attention would also turn back to his grade school classmate. K.W. and Helen reconnected and were married in 1928. The following year, they purchased forty-three acres of land that would become known to multiple generations as the "Home" farm.

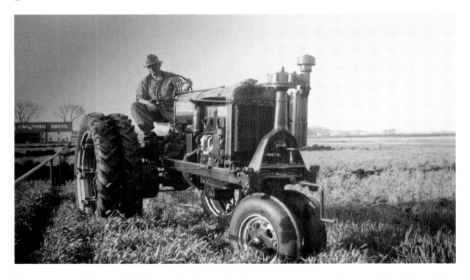

Early photo of Kenneth Zellers laying irrigation lines above ground. *Courtesy of the Zellers family.*

It was a rough start. Part of the acreage K.W. had purchased was still swamp. K.W. cleared and drained the land by hand, with help from neighbors and friends. Family notes state, "The men hand-dug ditches, then would utilize horses, and later a tractor, to pull a wooden panel to scrape the muck back into the ditches."

As the men cleared the swamp, felled tamarack trees were cut and the trunks laid down perpendicular to travel along access trails. These pathways, known as corduroy roads, afforded men and equipment movement through the sticky swamp. They formed the base of many of the roads we travel on today. Street names are descriptive of native conditions, like Swamp and Pinedale, or reflect landownership, such as Duquette and Graening.

K.W. Zellers nearly lost it all when, during the Depression, he and Helen couldn't scrape up enough money to make the final $5,000 payment owed on their property. They eventually found the money, somehow, and K.W. Zellers would start to reap the benefits of their hard work. Celery was a successful early crop, as were turnips, radishes, carrots, parsnips and dry onions. In family notes, K.W. recalled one autumn in the 1940s when they "sent solid truckloads of spinach to Philadelphia."

In the years leading up to World War II, there were thirty to forty growers in the main swamp, plus fifteen to twenty others in small pockets of muck scattered around Hartville. Many growers raised large families on four or five acres of muck. In the 1940s, K.W. and Helen purchased eighty acres of "high ground." They forayed into other crops, such as potatoes, and even raised hogs, at one time selling five hundred hogs per year.

K.W.'s son, Dick, was brought into the business in 1953, and they formed a partnership doing business as K.W. Zellers & Son, Inc. Over the next few decades, numerous changes would occur both on the K.W. Zellers & Son Farm and in the surrounding area. Drainage was a constantly evolving issue to tackle, and of course there was the weather.

In Dick Zellers's personal notes, he recalled, "1957 and 1958 were very bad years. We had heavy flooding rains along with a national economic recession. We had no surface drainage at that time. Also we had about a 50% loss of radishes to fusarium yellows and about a 50% loss of green onions to onion maggots." A decade later, a shift in the company's focus took place. In 1967, it was decided that the high ground acreage was too inefficient. They discontinued potato and hog farming. The company concentrated efforts on the production of leafy vegetables and green onions. The company also started packing cello radishes. In 1970, Ken Zellers, Dick's brother, returned to the business after spending seven years in Florida with Pratt-Wittney

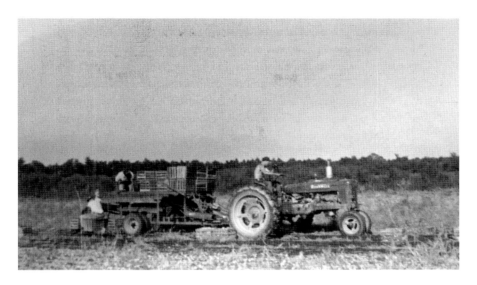

Harvesting dry onions, K.W. Zellers & Son Farms. *Courtesy of the Zellers family.*

aircraft engines. That was also the year that a 2,100-square-foot greenhouse was constructed. This led to a successful bedding plant production still in operation today that has since expanded to more than180,000 square feet.

K.W. Zellers passed away in 1980, and seven years later, Ken's son, Jeff, came into the business at age twenty-one. He took over the business when his father stepped aside in 2004. Jeff emphasizes that K.W. Zellers is a grower, packer and shipper all in one. This gives the company an advantage, and it has continued to invest in its operations over the years including its own cooling and ice plant. It has also developed important relationships with major retailers. This summer, when vegetables are harvested from the Zellers farm, they may end up a few miles away, on the shelves of Fishers Foods or Buehler's in Stark County or they may travel far distances to grocery stores on the East Coast; to Publix or Winn-Dixie in the South; to Walmarts in Wisconsin; to Krogers in Kentucky and Indiana; or to stores such as Meijer, Heinens or Giant Eagle.

"We are everywhere east of the Mississippi River," Jeff stated succinctly, "and we do quite a bit down south. They can't grow these types of vegetables in the summer. It's too warm." The vegetables that Zellers concentrates on include lettuces, beets, kale, radishes, cilantro and green onions. Items may vary from year to year, or according to what retailers want. Zellers has growing down to a science.

"We grow for various traits in different produce items," Jeff said. He conducts trials during the off season and talks to retailers to determine what to grow the following year. For example, "One romaine lettuce trial may include 15 different varieties." Then that fifteen boils down to maybe three varieties that are grown in one season. Zellers looks for traits such as frost tolerance for early plantings, heat tolerance for mid-summer plantings and other characteristics that produce a vibrant, tasty vegetable. Retailers look for other features as well, such as color, core size, stem length, temperature and, in the case of romaine or leaf lettuce, whether it grows straight and thin or stocky and open. "Our standards are so high when we go into a retail warehouse," Jeff said.

As Jeff makes plans for what will be grown each season, he is also making plans to accommodate the 200-plus workers who will temporarily take up residence on the farm. These workers will travel from the southern United States, Mexico or other Latin American countries. They begin arriving in April and stay until October. According to the most recently available Ohio Department of Job and Family Services report, in 2016 there were 106 migrant agricultural labor camps in Ohio. Most camps provide housing for single men, but Zellers provides housing for entire families, thus making it possible for husbands, wives and children to travel, live and, if children are old enough, work together. Some return year after year. These seasonal, largely Hispanic laborers, will plant, water, weed and harvest row after row of vegetables. In 2018, Zellers planted 1,250 to 1,300 acres of crops.

It's arduous work, and Jeff emphasized that "there is not enough manual labor in this country" to carry out the type of work that needs to be done. Workers on the farm toil in weather that can go from below freezing in April to searing hot in July and August. Into the 1980s, Jamaican and African American migrant workers farmed at Zellers. Hispanics have been doing a lot of the country's manual labor for more than a generation now, and they comprise most of the current population of workers at Zellers.

Author David Hassler, together with photographer Gary Harwood, extensively documented the experiences of these migrant families on the Zellers farm from 2004 to 2006. Their resulting 160-page hardback book, *The Growing Season*, provides a glimpse into what life is like when families travel sometimes thousands of miles from their homes to spend half a year in Stark County, Ohio.

In an excerpt from the book, Beatrice Gutierrez, mother of four, described her week:

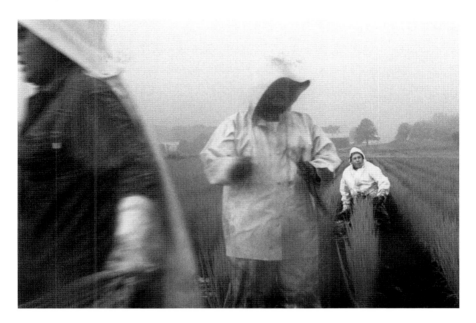

Marianna Delgado and others in her crew rush to complete an order in heavy rain. Marianna is now a foreman in the packinghouse. *Courtesy of Gary Harwood.*

Christian Vela, Jose Medina and Erik Flores participate in a team-building exercise during a field trip. K.W. Zellers & Son Farms house seasonal workers and their families. *Courtesy of Gary Harwood.*

My day starts at about 4:50 in morning. I get up and make some tortillas. Then I make some tacos to take out to the fields for our 10 o'clock break.... I'm the only woman in our crew, but I'm the crew leader. I get the report of where we're going to work before I drop off my kids to catch their school bus. Mostly everybody on our crew is a family member from my husband's side of the family. We block the kale and romaine and red leaf lettuce and make sure the plants have enough distance to grow, so when they're harvested they are big enough to cut and send out to the stores. And the red beets, cilantro, parsley, and onions we weed.

We've been coming to the Zellers farm for 12 years now....That's what we like about it. We feel more comfortable not having to move around every season. On Saturdays our work ends at noon. As soon as it ends, we come in and take a shower. Sometimes we go shopping. Sundays I still get up early, seven at the latest, so I can start washing all the clothes. I usually don't finish until 3:00 or 4:00 in the evening. And when I'm done, I sit down and rest, and I don't want nobody bothering me.

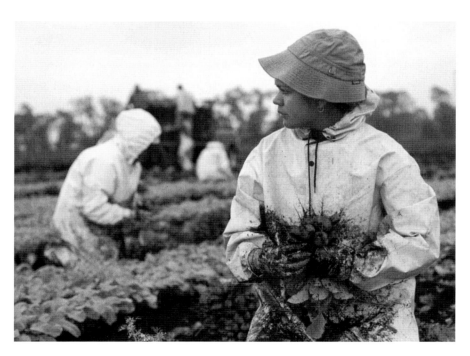

Patricia Prieto and her crew harvest radishes at K.W. & Son Farms. *Courtesy of Gary Harwood.*

Multiple generations of the Zellers family. *Courtesy of the Zellers family.*

The Hartville Migrant Ministry assists the seasonal workers in many ways. The ministry is housed in a brightly colored building that sits at the intersection of Swamp and Duquette Roads, within walking distance of farm fields and workers' houses. The ministry's website states that it is a not-for-profit organization started in the 1940s, making it "the oldest standing free clinic in Ohio." The center offers "a free medical clinic, educational programs for children and adults, a computer center, Bible study, and legal assistance," along with other services. Numerous community volunteers assist the ministry spring through autumn each year.

The next generation of the Zellers family is being groomed to learn the business. Daniel, Jeff's cousin's son, is twenty-three years old. He recently graduated from The Ohio State University and is back working for Zellers. Jeff's son, Andrew, age twenty, may get into the business also. In 2018, Andrew spent his spring break traveling with Jeff to visit farmers in Florida.

What does Jeff focus on for future success? "You're only as good as the next thing you do," he said. Zellers maintains high standards for food safety and quality of production. The black gold that lies beneath their feet is also very important, and every season a little bit more leaves with the vegetables that are grown on it. The levels of peat are going down. A quarter mile

behind the house, Jeff noted, some of the peat is very thin, from nothing to one foot. In the center of some of the farms, the peat is still six to eight feet deep. But Jeff emphasized, "It's not an infinite resource." Jeff has had to move to the thinner outer areas, places he wouldn't think of farming before. The challenge is that different types of soil yield different types of crops.

Jeff knows the value of the unique soil on his farms, and he knows the importance of the workers. "The bottom line is this," Jeff said. "There are two things we can't do without: Our land and our people. We need to treat both of them very well."

COMMUNITY ORGANIZATIONS

In our world today, fine dining, posting food photos on Instagram and baking elaborate birthday cakes for kids' birthday parties have become commonplace. But on the opposite end of people who pay a small fortune to venture on food-filled travels or regularly drop triple digits on date night, there are those whose daily focus is getting *enough* food to keep them and their children from going hungry. It's a dichotomy that appears across the United States, and Stark County is no exception. It wasn't until 2006 that the USDA introduced new language to better describe the state of those Americans who don't have regular access to nutritious food. The definition of food insecurity is "a household-level economic or social condition of limited or uncertain access to adequate food."

A study conducted in 2014 by Brad Masi and funded by the Stark Community Foundation, titled *The Future of Food Security in Stark County*, lists an estimated 15.3 percent of Stark County's population and 23.8 percent of children as "food insecure." U.S. statistics for that same period show a slightly better percentage rate for those labeled "food insecure" across the nation. In a 2016 USDA Household Food Security report, results showed an estimated 12.3 percent of American households were food insecure at least some time during the year. The previous year, 2015, was similar at 12.7 percent. Over twenty years of studying food insecurity, from 1996 to 2016, researchers found that while fluctuation occurred over that period, 2011 saw the highest percentage of U.S. households labeled as "food insecure" (14.9 percent), while the year 2000 marked the lowest percentage (just above 10 percent).

In Stark County, when there is a need to be fulfilled or a problem to be solved, especially when it comes to food, there typically arises a group of compassionate people to come up with solutions. Diverse agencies—including Refuge of Hope, Meals on Wheels, the Akron Canton Regional Food Bank, Stark County Hunger Task Force and StarkFresh—assist those in need of food security.

Located in downtown Canton, Refuge of Hope is the only agency in Stark County with overnight facilities devoted exclusively for homeless men. In addition to providing overnight shelter for men, the agency serves free hot meals eight times per week, year round, for anyone in need, including women and children. Refuge of Hope began in 2001 as an offshoot of the original Open Door Chapel organization that had been in operation since 1986.

JoAnn Carpenter, director of development, concluded that it is usually "bad personal decisions" or "circumstances beyond their control" that bring men to the agency. The most difficult thing about her job, she said, is knowing that some of the men have simply followed bad examples set forth by their own parents. To see hungry children coming into the shelter at meal times makes an impact on her, but she noted, "I know they've gotten at least one warm meal that day."

Food is a big part of the agency's services. Duane Wykoff, executive director, said that Refuge of Hope serves more meals per week, year-round, than any other such organization in Stark County. The object, however, is not to replicate or overlap what other agencies do but to identify community needs, best provide solutions as a whole and work together to achieve them. Throughout Canton, free meals are served somewhere in town every day of the week. This steadiness of food service is significant because one in six adults in Stark County are food insecure, one in four children go to sleep hungry and 32 percent of Stark County's population is at poverty level.

At Refuge of Hope, lunches are served at 11:00 a.m. on Tuesday, Friday and Saturday; dinners are served at two shifts, 4:30 p.m. and 5:30 p.m., Monday through Friday. Volunteers who serve the meals come from all walks of life. On any given day, some may be fulfilling community service hours, others may be family members who want to give their kids a different perspective on life and some may even be former residents. Each volunteer is handed a plate from the kitchen, which they take and serve directly to those seated. JoAnn stated that for this reason, Refuge of Hope is not a soup kitchen. She further explained that volunteers serving plated food to seated clients is what makes Refuge of Hope different than a cafeteria-style

setup, where people pick up a plate and walk through a serving line. In 2017, Refuge of Hope served ninety-five thousand meals.

While the organization opens its doors to the homeless, the ultimate goal is to get them back out again, to become productive members of the community. Everyone is different. Some bounce back fairly quickly, and some take longer. The average stay for residents in 2017 was 120 days.

Funds for Refuge of Hope come from foundations, area churches, individuals, businesses and civic organizations. The agency does not receive government assistance. Eighty-one cents out of every dollar goes toward Refuge of Hope services. From 2014 to 2017, more than four hundred shelter residents moved into permanent housing.

Even though the agency completed a facility expansion in 2011, the need has continued to outpace the structure. In 2017, the agency housed forty-six to forty-eight people per night, even though capacity is thirty-four beds. Cots are placed on the floor or wherever they can find space. In 2018, they broke ground on a new building, within two blocks of the existing facility, to expand services.

Meals on Wheels of Stark and Wayne Counties was established in 1973 as a senior meal program called the Stark Nutrition Program. Originally billed as a service provided under the umbrella of the United Way of Central Stark County, the agency became independent in 1991. It is a nonprofit agency that provides meals in a social or home setting to assist individuals in remaining healthy, active and independent of extended care facilities.

Since its inception, Meals on Wheels has served more than 13 million meals to clients of the two counties. Today, according to company history, volunteers deliver about 1,500 hot meals every Monday through Friday, via seventeen distribution sites, covering sixty-five routes. A licensed dietician, to ensure balanced nutrition, oversees meal planning. Since the food is prepared daily and delivered warm and fresh, no further preparation is needed. It is ready to eat upon arrival.

Client cost for a meal delivered to their home is five dollars, although there are numerous sources available at both the state and federal level to assist those in financial need. If clients are able, they can travel to a congregate dining site, about a dozen of which are situated throughout the two counties. This affords socialization opportunities, and also costs less, at a recommended three dollars donation per meal. Dining sites are typically located in churches or senior housing. There is no age or income requirement needed to qualify for Meals on Wheels services. Anyone who is homebound may receive services. There is also no waiting list, and after

completing a referral form, clients can often begin receiving meals within two business days.

The Akron-Canton Regional Foodbank was formed in 1982 by a group of community leaders that made a commitment to provide emergency food for people in need. With a home base in Akron, this small group has grown into an organization that provides food and essential items to hunger-relief programs in eight Northeast Ohio counties: Carroll, Holmes, Medina, Portage, Stark, Summit, Tuscarawas and Wayne. These member programs operate nearly five hundred food pantries, hot meal sites, shelters and other hunger-relief programs in communities where people need food.

Looking at the flow chart on the website of the food bank seems pretty simple: food is donated, stored and distributed. This three-step process belies the complexity of an operation that takes eighty-seven employees and nearly ten thousand volunteers to oversee. Food must first be acquired, inspected, sorted and stored before distribution. An eighty-three-thousand-square-foot warehouse includes eight thousand square feet of refrigeration and freezer space. The food that arrives here comes in the form of donations from corporate food donors, state and federal food assistance programs and Feeding America, a national food bank network. Food is also obtained through a purchase program where large quantities of food are purchased at reduced prices to offer to its network of hunger-relief programs. The purchase program is supported by financial donations. Much of the donated and purchased food is brought to the warehouse by the food bank's own fleet of trucks. Every day, the food bank's hunger-relief programs place food orders and pick up these orders at the warehouse in Akron. Food is then distributed to those in need.

A March 12, 2018 *Akron Beacon Journal* article highlighted 2016 statistics, as these tax documents were most recently available. $35.5 million was received in contributions and grants, which accounted for 93.2 percent of annual revenue. The other 6.6 percent of revenue came from a variety of sources, including program services. Dan Flowers, president and CEO of the food bank, stated that the $35.5 million reflects the value of donated foods. In 2016, the food bank provided access to food for more than 23.8 million meals and distributed 8.4 million pounds of fresh produce.

In the article, Flowers stated that a merger with Community Harvest, an organization that collects extra prepared or perishable foods, allowed an additional 619,000 pounds of produce for the food bank to stay in Stark County in 2017. Community Harvest was originally formed through a partnership with the Tri-County Restaurant Association to combat excess

food waste. Its popular event Celebrity Cuisine, held annually in the Canton Civic Center, features national and local celebrities. Guests who attend the event, which celebrated its twenty-fifth anniversary in 2017, are treated to unlimited access to appetizers, entrée samples, beer, wine and desserts, all showcased by participating restaurants and purveyors.

Stark County Hunger Task Force, a nonprofit agency headquartered in downtown Canton, began operations in 1981. The agency provides support and food assistance to a network of more than thirty food pantries throughout Stark County, according to the organization's website. In 2009, an emergency food pantry was established that is open five days a week.

The number of people seeking food assistance from SCHTF has swelled from three thousand people per month in 1981 to thirty thousand people per month in 2017. The agency gets nearly all programming funds through monetary and food donations and operates with a staff of fewer than five people, as well as numerous volunteers. SCHTF receives around 8 percent of its annual budget from the federal Emergency Food and Shelter Program.

The Backpack for Kids program provides weekend meals to area children. Every Friday during the school year, students enrolled in the program receive a bag of food that includes two snacks, two breakfasts and two lunches. This helps to carry them through the weekend. In 2017, 625 students were enrolled in the Backpack program in seven elementary schools in Stark County. Volunteers throughout the community set up, sort, count and fill the backpacks every week when school is in session.

StarkFresh is a unique grassroots collaboration, born out of the need to address food insecurity by identifying niche regions and neighborhoods in Stark County that find themselves situated in a food desert ("an urban area in which it is difficult to buy affordable or good-quality fresh food"). Once areas of need are identified, workers and volunteers determine the solution that fits and can establish community gardens or farmers' markets or even send in a mobile grocer unit, all of which result in offering residents of that area the opportunity to purchase, at low cost, fresh produce, meats and pantry items.

Established in 2012, StarkFresh is a nonprofit organization that operates on a much smaller scale than the other well-known and long-established food assistance agencies in the county. Two employees of StarkFresh, Tom Phillips and Teresa Kaminski, work under a board of directors and coordinate programming and projects that are carried out by themselves and a team of volunteers.

The organization emphasizes education so that families can learn how to select, store and prepare the items offered for sale, which are often locally grown fruits and vegetables that change from season to season. Nutrition and cooking classes are offered that encourage families to become self-sufficient meal planners. Knowing how to use various foods in recipes and having access to common food-prep tools empowers a family to create home-cooked meals. Making a meal together, or at least spending some time around the table to consume it together as a family, affords the opportunity for bonding and socialization.

CULINARY TOURISM

*Whether it's the other side of the planet or just down the street,
we want to dig deeper, seeking authenticity and a real sense of connection
at every step along the way.*
—*Pepijn Rijvers, chief marketing officer at Bookings.com*

Culinary tourism makes connections through food and drink, connecting travelers to the place they are visiting and locals to their communities. The simple definition of culinary tourism, as defined by the World Food Travel Association, is "the pursuit and enjoyment of memorable food and drink experiences." A "food tourist" is the name attributed to those taking part.

"What are food tourists like?" was the question posed in a 2012 Global Report on Food Tourism. Their answer: "Tourists who take part in the new trends of cultural consumption. They are travelers seeking the authenticity of the places they visit through food. They are concerned about the origin of products. They recognize the value of gastronomy as a means of socializing, as a space for sharing life with others, for exchanging experiences. Such tourists have higher-than-average expenditures, they are demanding and appreciative, and they eschew uniformity."

In the United States, food tourism began in the 1990s, along both the East and West Coasts. New York's oldest food tour company, Foods of NY Tours, started in the spring of 1998 when two dozen guests enjoyed a curated "walking and tasting tour" in Greenwich Village. Twenty years

The Ferrante family enjoys a Canton Food Tour meal. *Authors' collection.*

and 300,000-plus tour guests later, Foods of NY Tours still remains a top-rated experience among a sea of other food tour operators in the city. In 2018, there were more than twenty different food tour operators in New York City alone.

Even though Foods of NY Tours found early success, it took the rest of the nation a few years to catch up. Ohio's first food tour operator, Bethia Wolff, started Columbus Food Adventures in 2010. Canton Food Tours started in 2012, making it one of the first five tour operators in the state and the first in Stark County.

Each food tour operator can do what he or she wants, in any city or region around the world, so experiences will vary from place to place. However, in general, food tours meet the following criteria:

- *Walking tours highlight the unique history and restaurants of a particular region, town or district.*
- *Guests visit multiple venues to sample food and beverages. These samples typically add up to replace a meal.*
- *A food tour is guided, interactive and fun.*
- *Duration is three hours, and average cost is sixty-five dollars/person.*

Above: Interns from Goodyear
Tire & Rubber Company learn
about Canton on a food tour.
Authors' collection.

Right: Chef-selected small
plate entrées are served at
four different restaurants on a
food tour, giving attendees the
opportunity to try a variety
of foods in one afternoon or
evening. *Authors' collection.*

Right: History is a big part of food tours. Food tour guide Claudette Hankins speaks to a group of tour attendees in downtown Canton. *Authors' collection.*

Below: George's Lounge in Canton shows off its famous burgers and hand-cut fries for attendees on a food tour. Tom Hale speaks to the group about the history of George's. *Authors' collection.*

In Stark County, Canton Food Tours averages three to five tours per week, May through November. Average group size is ten people, although sizes have ranged from two to seventy-five people. Attendees are young professionals through retirees, families, friends, supper clubs, staff appreciation days out, team building and celebrations such as birthdays or anniversaries.

Food tourism has enjoyed an increase in recent years. The Bureau of Labor Statistics figures from the August 2017 "Consumer Expenditures" report found expenditures from 2016 in the discretionary categories of "food away from home and entertainment" continued increasing in 2016, up 4.9 percent and 2.5 percent, respectively, after increasing 7.9 percent and 4.2 percent the year before. The Barcelona Field Studies Centre identified five consumer trends that have driven this recent rise in food tourism:

1. *We spend more on quality food.*
2. *Demographics and household change.*
3. *Rejection of foods that are mass-produced.*
4. *The emergence of multi-cultural consumers.*
5. *The creation and impact of the Celebrity Chef.*

Although culinary tourism is relatively new, popular interest in food has existed for decades. In the United States, long before her face graced General Mills' product packaging, the fictional Betty Crocker hosted her own radio show, the first American food broadcast. Initially aired in Minnesota in 1924, the program was nationwide by 1926, and *The Betty Crocker Cooking School of the Air* ran for almost twenty-five years. Apparently, thirteen actresses at different radio stations around the country performed as Betty, answering questions, providing tips and generally giving listeners confidence about cooking.

Whether the Betty Crocker show was heard in Stark County is unknown. While WHBC in Canton did start in the era of food broadcasting, the topic was likely too secular for the programming lineup since the original license for WHBC was granted in 1925 to Father Edward P. Graham and the St. John Catholic Church. Betty Crocker would have been an unlikely candidate for programming on the first Catholic radio station broadcast in the United States. In 1936, the station was sold to Brush-Moore Newspapers, then owners of *The Repository*.

"Aunt Sammy" and her program *Housekeeper's Chat* had a better chance of being heard in Stark County. Aunt Sammy was a character created by the U.S. Department of Agriculture Bureau of Home Economics in 1926.

The show targeted Depression-era homemakers. Providing advice about nourishing meals, canning, preserving and gardening, Aunt Sammy was actually fifty women reading the same USDA scripts from fifty different radio stations. The popular booklet *Aunt Sammy's Radio Recipes* was published, revised and reprinted three times before 1931.

Many other national food radio personalities also found popularity from the 1930s to the 1950s. Then came television. Nationwide, there is a multitude of celebrity chefs who make it easier for audiences to appreciate quality food, how it's prepared and where it comes from. Food Network was a pioneer when it started in 1993. Stars like Emeril Lagasse, Paula Deen, Anthony Bourdain, Giada De Laurentiis, Bobby Flay, Guy Fieri and Mario Batali are just some of the television chefs who became household names. Cleveland, Ohio, sixty miles to the north of Stark County, boasts its own celebrity chefs. Award-winning chefs Jonathon Sawyer and Michael Symon are among the most well-known, nationally recognized TV personalities, authors of numerous books and owners of a variety of restaurants.

The sheer volume of choices has created a general increase in our interest in food and helped culinary tourism carve out its niche. Today, we have a mind-boggling array of foods to choose from every single day, both in the grocery store and at a restaurant. Author Sophie Egan, in her book *Devoured: How What We Eat Defines Who We Are*, reminds us that McDonald's used to serve only 4 items—hamburgers, French fries, milkshakes and soft drinks—on their menu. In 2018, there were approximately 107. There are eighty-six thousand variations of coffee at Starbucks. And then there's the whole "Have it your way" trend, which started as a Burger King slogan.

Even as our interest in food has increased, the meal itself has changed over the years, reflecting our fast-paced work schedule that no longer has a set clock-in/clock-out time. These changes are also caused by the fact that Mom is no longer the only one in the kitchen preparing the evening meal, nor is she exclusively the one packing next-day lunches for her husband and children. A meal is defined as "a combination of foods, home-cooked and plated." For many, meals have been replaced by snacking throughout the day. Americans lead busy lives, have no time to prepare or sit down for a home-cooked meal and have numerous fast-food or fast-casual choices waiting for them along the route home.

Americans eat more total food than we did before, even though the traditional sit-down dinner has fallen by the wayside. Egan noted between 1978 and 1996, even though calories consumed at dinner decreased 37 percent, calories consumed from breakfast increased 16 percent, calories

from lunch increased 21 percent and calories from snacking increased 101 percent. Snacking has morphed into mini meals rather than as supplemental boosts intended to bridge the tummy-rumbling gap from breakfast to lunch or lunch to dinner.

The year 2015 was a milestone in America. For the first time in our history, people spent more money dining out than on preparing meals at home, according to a Bloomberg Business Report. Stark County is not quite up to that mark, but it's heading that way. A 2014 report, *The Future of Food Security* by Brad Masi, found that residents of Stark County spend an estimated $925 million on food annually. Of this, $531 million is spent on food at home and $394 million is spent on meals eaten out. Residents of the city of Canton represent the largest demand center in Stark County for food purchasing, spending $180 million on food annually. Residents in Massillon come in second, spending $79 million annually, followed by Alliance, which spends about $55 million annually. The residents of North Canton spend $43 million on food, Louisville spends $23 million and Canal Fulton spends $13 million annually. Combined, the larger urban centers of Stark County spend $414 million, slightly less than half of the overall food spending for the county. According to the 2014 report, the overall distribution of food spending by household shows that 43 percent of all spending goes toward meals eaten out at restaurants or institutional dining. The remaining 57 percent of food spending goes toward food from grocers or other retail food outlets.

Within the context of an increased interest in food, Gervasi Vineyard, Maize Valley and Canton Food Tours have taken culinary tourism to new levels in Stark County. Since opening Gervasi Vineyard in 2010, the small winery quickly expanded to a destination winery, Italian bistro, a retail marketplace and an outdoor pavilion. Further developments included a conference center, overnight villas, a state-of-the-art winery and a pub-style restaurant called the Crush House. In 2014, Theodore "Ted" Swaldo purchased property in Green and repurposed a former home on the property into another restaurant, the Twisted Olive. It was not Ted's intention to create such unique and amazing culinary destinations, but that's exactly what he's done.

Ted grew up in New Philadelphia the eighth of ten children in a small household. "We were not wealthy," Ted told *The Repository* reporter Denise Sautters in a 2015 interview. "We grew up very poor. My parents only went to the fifth grade, but they valued hard work, determination and they gave me strong principles that have guided me through my life." Through

a co-op program with the Timken Company, Ted graduated with honors from Tri-State College (now Trine University) with a degree in mechanical engineering. After graduating, he went back to the Timken Company and worked there for nine years.

"One day I felt I needed to do something else," Ted said in a 2018 interview. "I think my entrepreneurial juices were flowing." He and three friends from college cofounded a high-voltage electrical manufacturing company, American Switchgear Corporation, based in North Canton. Ted eventually took over the company and sold the high voltage division. In a short period of time, ASC went from the smallest water pump manufacturer in the United States to the largest water pump manufacturer in the world. At one point, Ted oversaw a team of 2,200 employees, with factories in Spain, Mexico and China. After running ASC for thirty-two years, he sold the business in 2009 and retired.

"We were going to be snowbirds," Ted said, of how he and his wife, Linda, envisioned they would spend their time. "We were going to build a house in Florida, maybe play some golf. That lasted all of forty-five days. I was eager to start something new." His thoughts turned to the fifty-five-acre farm in North Canton that he had purchased just before retiring. Ted said that he went through various scenarios in his head of possible uses of the land. "I didn't want to farm, I didn't want to raise cows or horses. I went through all sorts of ideas."

The farm had a long history. It used to be a sawmill, then a tree farm and, for a time, contained a small apple orchard. Ted's vision turned to a different kind of fruit: grapes. "I thought it might be fun to be a winemaker. Maybe make a couple thousand gallons a year and sell some trail bologna and cheese out of the barn. Maybe I'll grow some grapes…."

The beauty of the fifty-five-acre property is what sold Ted, but it didn't have much on it—an old barn that was constructed around 1830 and an overgrown lake. "The barn was falling down," he noted. "The building was leaning badly. A big wind would have taken it down."

Around that time, Ted's son, Scott, who had worked with him at ASC, let Ted know that he was interested in running a restaurant. Ted was grateful for the opportunity. "I enjoy creativity. I enjoy growing and building things," Ted said. "I love doing things that people say I can't do." Ted didn't care for day-to-day operations, and with Scott at the helm, Ted could continue his big-picture planning. The transformation of the 1830s barn into the Bistro restaurant was their first successful project. Their first executive chef, who is still with them today, was Jerry Risner.

Success came one step at a time. Scott said, "We didn't really have the vision of what you see today. We had a 'build it and they will come' mentality. If you do it right, make it special, don't cut corners, even in Stark County, even in Canton, Ohio, build it and they will come. Did we know at that time that it would be a regional experience? No. But we wanted to deliver the best product."

Scott went on to say that it bothers him when people don't take pride in their own town. "I hate when people feel like nice things are for somewhere else, that you have to travel to go to a nice restaurant or hotel. I just don't accept that. You can have beautiful, world-class things right here. We built our business around believing that."

Ted continued, "It was all about listening to customers." In the early days, as they were clearing about three hundred trees off the farm, one day he was out in the field and a young girl drove up, rolled down her window and said she had always wanted to get married at a vineyard. They had just planted it. Ted thought, "Lady, you're crazy—we don't even know if we're going to be done next year." But he took her name and number. Another and another and another person asked. That spawned the idea for the pavilion. Then that led to the idea of an event space. Then people

An old barn, circa 1830, was converted into the Bistro at Gervasi Vineyard. Seen here is the back of the Bistro, showing the outdoor patio and the lake. *Courtesy of Gervasi Vineyard.*

Front view of the Bistro at Gervasi Vineyard. *Courtesy of Gervasi Vineyard.*

said, "We have out of town guests, where can they stay?" That led to the idea of the Villas.

Regarding the wine, Ted chuckled. "I quickly realized that I could not be a winemaker." Ted did some research and spoke with members of the Ohio Wine Growers Association. Ted's friend and colleague Andy Codispoti came in to develop the wine. "Andy is so detail oriented," Ted said. "He develops taste and consistency."

Ted recalled being told by Ohio Wine Association members, "If you can produce five thousand gallons of wine by year five, you have a good chance of success." Ted designed capacity for fifteen thousand gallons. "We went through five thousand gallons of wine in about the first six months." By the end of the first year, Gervasi was producing ten thousand gallons, and by year three, twenty-two thousand gallons. They quickly determined the need for increased capacity, and plans for the Crush House were born. "Strategic opportunities arise, and we move quickly," Ted emphasized.

Gervasi grows three varietals on their property that make up about 8 percent of sales. Five to six wines, imported directly from Italy, are made for them and represent 8 percent of sales. The main wines, around eighteen kinds, are made on the property with grapes and juice that come from Ohio, the Finger Lakes Region of New York State and California. The company

Gervasi wines have received Ohio Wine Competition awards every year consecutively from 2013 to 2018.

started out with eight wines when it opened in 2010. Ted laid out the winery and bought all the original equipment before Andy came on board. "I told Andy he would work ten to fifteen hours per week. He probably works ten to fifteen hours a week overtime."

Gervasi makes all of their own pastas and breads. They built another kitchen space to accommodate the extra baking, then, once they had that, they thought, "Let's do some cooking classes." "Every component was added because we recognized a need and fulfilled it," Ted said.

Ted and Scott both traveled for business, and that's what inspired their vision. Ted loves to go to Rome. It's his favorite city. "My mother was born in Italy," said Ted. In fact, Gervasi is his mother's maiden name. Scott added, "It's our heritage. As a family, what we've come to enjoy is Italian food, architecture. All those things fed into the style of what you see here."

Ted said that there is a lot of symbolism and meaning in what they do. "The whole concept is that the [Gervasi] property is laid out like a community, a village. It's got a certain feel to it. If you travel in Italy, in the center of every small town is a church. It's the focal point of the whole community." The Swaldos broke ground on Gervasi's focal point in 2018. The Still House, complete with bell tower and spire, opened in early 2019. It was patterned after the seventeenth-century St. Gervasio Church in Denno, Italy, where Ted's mother was baptized. This "church" sits on the south side of Gervasi property and houses a state-of-the-art distillery where whiskey, bourbon, gin, vodka and other specialty spirits will be made. The well-appointed seating area is welcoming and cozy. The Still House serves as a coffeehouse by day and a craft cocktail lounge by night.

Ted said, "A big part of this is family. We are very close as a family. We work together well and we spend a lot of time together. And when you have that closeness, you want everyone else to experience that. So our hospitality theme is 'Celebrate Life.'" Scott emphasized that spending time together

Swaldo family portrait. *Standing, left to right*: Ted Swaldo, Linda Swaldo, Scott Swaldo, Jeff Hicks, Sophia Blackerby, Christi Blackerby and Tom Blackerby. *Kneeling, left to right*: Lucas Blackerby and Austin Blackerby. *Courtesy of the Swaldo family.*

with family and friends is a key element of what Gervasi is all about. "We appreciate people bringing their kids here. We can be a special occasion place, but we also want to be here for families." The vision that blossomed from selling trail bologna out of a barn has turned into what is likely the biggest financial investment into a culinary-focused tourism destination that Stark County has ever seen.

The Swaldos have made something grand out of nothing, and so has Bill Bakan of Maize Valley. According to Maize Valley company history, the family's early ancestors were one of the first families to settle in Marlboro Township in the early 1800s. They were trappers, teachers, farmers and business owners. In the 1960s, Kay and Donna Vaughan settled on the three-thousand-acre farm that would become Maize Valley Farm Market in Hartville. Originally, they focused on hogs, grain, "super-sweet" corn, soybeans and wheat—in addition to 130 dairy cattle. The market concept began in the 1990s with Kay and Donna's daughter, Michelle, and her husband, Bill Bakan. The market started small, with a seasonal produce stand that also had a corn maze in the fall. In 2000, they purchased a 140-year-old barn located on an adjacent property.

The remodeled barn houses a bakery, a deli, home-grown produce and gourmet food items. Agritourism is defined by the USDA as "a form of commercial enterprise that links agricultural production and/or processing with tourism in order to attract visitors onto a farm, ranch, or other agricultural business for the purpose of entertaining and/or educating the visitors and generating income for the business owner." Bill Bakan, self-titled "Fun Czar," has taken this concept at Maize Valley to a new level. The farm, in recent years, has added numerous activities, including an eight-acre corn maze, wagon rides, a self-pick pumpkin patch and a kids' play area. Live animals, a pumpkin cannon that can launch a pumpkin half a mile and duck and pig races add to the eclectic mix of activities.

In 2005, Michelle's brother, Todd, joined the business to assist in winemaking. Maize Valley Farm Market and Winery attracts tens of thousands of visitors each year. The family currently farms around seven hundred acres, including growing crops such as asparagus, tomatoes, pumpkins and zucchini. Ten acres are devoted to vineyards, and in 2014, they opened a craft brewery that offers a rotation of sixteen craft beers.

Whether it's sipping wine at Gervasi Vineyard, watching a pumpkin being launched at Maize Valley or eating and drinking your way through downtown Canton on a food tour, the rich history of Stark County's food and beverage industries has become a draw for locals and out-of-town visitors alike. Food brings people together. It can be a simple fulfillment of hunger or it can be a one-of-a-kind, memorable experience.

ABOUT THE AUTHORS

KIM KENNEY earned her Master of Arts degree in history museum studies at the Cooperstown Graduate Program in New York. She became curator of the McKinley Presidential Library & Museum in 2001 and was promoted to executive director in 2019. She has authored six books, and her work has appeared in the *Public Historian*, *White House History*, *The Repository*, the *Boston Globe*, *Aviation History* and *Mused*. Kim has appeared on *The Daily Show*, *First Ladies: Influence & Images* and *Mysteries at the Museum*. Her program "The 1918 Influenza Pandemic" was featured on C-SPAN's series *American History TV*.

BARBARA ABBOTT graduated from the University of Akron in 1992 and began a career as a naturalist with the Ohio Department of Natural Resources. Traveling between state parks, she regularly published articles on history and wildlife for the Division of Parks and Division of Wildlife. She moved to Canton in 2004, and in 2012 started Canton Food Tours to showcase regional food and history. Named Entrepreneur of the Year by the Canton Regional Chamber of Commerce in 2013, Barbara was also inducted into the YWCA's Stark County Women's Hall of Fame and the Cleveland Chapter of Les Dames D'Escoffier.